IBERIAN AND LATIN AMERICAN STUDIES

Women in Mexican Folk Art

IBERIAN AND LATIN AMERICAN STUDIES

Women in Mexican Folk Art

Of Promises, Betrayals, Monsters and Celebrities

ELI BARTRA

UNIVERSITY OF WALES PRESS
CARDIFF
2011

www.uwp.co.uk

British Library CIP
A catalogue record for this book is available from the British Library.

ISBN 978-0-7083-2347-2 (hardback)
 978-0-7083-2364-9 (paperback)
e-ISBN 978-0-7083-2348-9

Photographs by Irma Villalobos
Translation by Christopher Follett and Richard Thomson

Typeset by Marie Doherty
Printed by Gutenberg Press, Tarxien, Malta

Contents

Series Editors' Foreword vi

Acknowledgements vii

Introduction 1

Chapter One: Folk Art and some of its Myths 11

Chapter Two: Women and Votive Paintings 27

Chapter Three: Judas was not a Woman, but... 47

Chapter Four: Fantastic Art: *Alebrijes* and *Ocumichos* 67

Chapter Five: Frida Kahlo on a Visit to Ocotlán:
'The Painting's One Thing, the Clay's Another' 97

Chapter Six: The Paintings on the Serapes of Teotitlán 115

Chapter Seven: From Humble Rag Dolls to *Zapatistas* 127

Chapter Eight: Embroiderers of Miracles 137

Epilogue 151

Notes 159

Bibliography 167

Index 177

Series Editors' Foreword

Over recent decades the traditional 'languages and literatures' model in Spanish departments in universities in the United Kingdom has been superceded by a contextual, interdisciplinary and 'area studies' approach to the study of the culture, history, society and politics of the Hispanic and Lusophone worlds – categories that extend far beyond the confines of the Iberian Peninsula, not only in Latin America but also to Spanish-speaking and Lusophone Africa.

In response to these dynamic trends in research priorities and curriculum development, this series is designed to present both disciplinary and interdisciplinary research within the general field of Iberian and Latin American Studies, particularly studies that explore all aspects of **Cultural Production** (inter alia literature, film, music, dance, sport) in Spanish, Portuguese, Basque, Catalan, Galician and indigenous languages of Latin America. The series also aims to publish research in the **History and Politics** of the Hispanic and Lusophone worlds, at the level of both the region and the nation-state, as well as on **Cultural Studies** that explore the shifting terrains of gender, sexual, racial and postcolonial identities in those same regions.

Acknowledgements

The field work for the chapter on *ocumichos* took place in 1991 and 1992, that for *Friditas* and serapes in August 1995, April 1996 and December 2006. I did the field work on the Judases from 1993 to 2009, *alebrijes* in 1992, 2004 and 2009, Zapatista dolls in 1998 and 2009; in San Miguel de Allende in 2002 and Zacatecas in 2008 and 2009. My thanks are due to all the people who told me about their experiences in Ocumicho, Ocotlán de Morelos, Teotitlán del Valle, San Miguel de Allende, Tacoaleche, as well as Mexico City, for all the time they devoted to me.

Thanks are also due to John, as always, for the full stops and commas in both the text and in my life, and much else besides. To my mother Anna Murià, unfortunately no longer among us today, who as on other occasions read and corrected the original with love and patience. To 'Curare', for financial assistance, and to the members of the seminar for their devastating, but useful, suggestions and corrections. I am also grateful to the members of my research area on 'Women, Identity and Power' of the Department of Politics and Culture at the Universidad Autónoma Metropolitana-Xochimilco for their comments, in particular to Mary Goldsmith for her acute observations.

To Sam Abrams, I am also indebted for his careful reading of the original, red pencil in hand, and his invaluable comments.

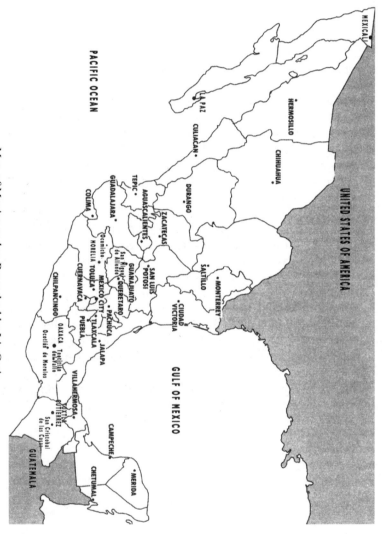

Map of Mexico today. Reworked by Isis Ortiz.

PACIFIC OCEAN

UNITED STATES OF AMERICA

GULF OF MEXICO

GUATEMALA

MEXICALI

LA PAZ

HERMOSILLO

CULIACÁN

CHIHUAHUA

DURANGO

ZACATECAS

TEPIC

GUADALAJARA

COLIMA

AGUASCALIENTES

SAN LUIS POTOSÍ

SALTILLO

MONTERREY

CIUDAD VICTORIA

Ocotlán

San Miguel de Allende

GUANAJUATO

QUERÉTARO

MORELIA

TOLUCA

MEXICO CITY

PACHUCA

TLAXCALA

CHILPANCINGO

CUERNAVACA

PUEBLA

OAXACA

Teotitlán del Valle

JALAPA

Ocotlán de Morelos

VILLAHERMOSA

TUXTLA GUTIÉRREZ

San Cristóbal de las Casas

CAMPECHE

CHETUMAL

MÉRIDA

Introduction

It appears no easy task to arrive at a gender-based perspective on folk art. After much careful searching, through all the many libraries I have visited and the many bookshops I have come across in Mexico and abroad, for texts on feminism and folk art – even including texts just on women and folk art – it must be said that the harvest has been meagre, although in recent years there has been a slight increase in output. The starting point for any study of the current situation ought to be the recognition of the fact that today's is a patriarchal society and that, for this reason, almost all knowledge is androcentric.

Much has been written already on feminism and art, feminist history and theory of art, yet, curiously, feminist thinking in the developed countries – which has made significant efforts to investigate art in general – has shown little interest in the field of folk art. This simply does not form part of 'The History of Art'. One of the reasons for its having been passed over by the new feminist historiographies may be the supposition that folk art is anonymous. It thus becomes difficult, often impossible, to uncover the identity of those who produced it, and thus we have no way to discover the place of women in the process. Or perhaps the explanation is to be found in the fact that a structured (and hence androcentrically-structured) history of folk art – such as could be compared to those dealing with elite art – does not exist; there is thus not much there to be taken apart or deconstructed. Or perhaps it is also because the folk arts of many developed countries lack richness in comparison with that produced in so many underdeveloped countries, with the exception of indigenous art. Or maybe even because feminist theories of art in Europe, the United States and Canada share the idea that folk art is lesser art, and therefore less important than the 'greater' art, and so undeserving of attention.

However, leaving speculation aside, the fact is that folk art has been practically ignored by feminist research. Overall, it has received relatively little attention compared with other aspects of culture, and such studies as exist are often tainted with the picturesque, with paternalistic attitudes and with androcentrism.

It is not only a matter of indifference and lack of interest where the folk arts are concerned. What is, however, patent is a devaluing attitude, whether intentional or not. Of course this in no way prevents items of folk art from being admired, appreciated, consumed, bought (at bargain prices), or used. They arouse wonder and enthusiasm but, ultimately, are undervalued and little studied.[1]

A particularly interesting aspect of Mexican folk art is the presence of certain forms whose situation seems rather exceptional – perhaps because they really are exceptional in more than one sense. These are, on the one hand, the painted and embroidered 'offerings' or ex-votos, the Judases, the *ocumichos*, the *alebrijes* and the Zapatista dolls, and on the other, the *Friditas* and the carpets of Teotitlán del Valle.

Reviewing the literature on the folk arts of Mexico – almost all of which consists of coffee-table books, books for adornment or for entertaining idle moments – we find that, with few exceptions,[2] the ex-votos are either not mentioned or receive no more than a paragraph; the Judases are either not taken into account or are dismissed with a few lines under the heading of cardboard crafts or toys. Both these forms of folk art are threatened with extinction. Ex-votos are religious art, naïve, figurative. Are they realistic? In a certain sense yes, in spite of all those beds, tables and chairs floating in the air, with those perspectives, proportions and compositions apparently so totally alien to any reality, not to mention the contents of the accompanying texts that, with their stories of individuals who died three times, even fall into the absurd. Roberto Montenegro, who has studied folk art, said of votive paintings that 'by their enigmatic conceptual approach, they touch the boundaries of hyper-realism'.[3]

The pottery of Ocumicho, like the *alebrijes*, is on the other hand a relatively recent art and that is why it has not been much studied: for the same reason these forms are not mentioned in the classic studies on Mexican folk art. Both *alebrijes* and *ocumichos* can be considered surrealist art;[4] or perhaps they are merely fantastic art, and then where is the boundary to be set? Or are they both? Of still more recent appearance are the *Friditas*: reproductions in clay of the paintings of Frida Kahlo. As Chibnik might put it, they are simply 'invented traditions'.[5]

It is interesting to note that the common element of five of the folk art forms to which I will be referring is their link to evil. The ex-votos are simply an expression of gratitude to divine forces for having intervened in the face of something bad: Evil. The Judases symbolize Judas Iscariot, the betrayer of Jesus: Evil. As such they are burnt. *Alebrijes*, according to their creator Pedro Linares,[6] have a magic power over

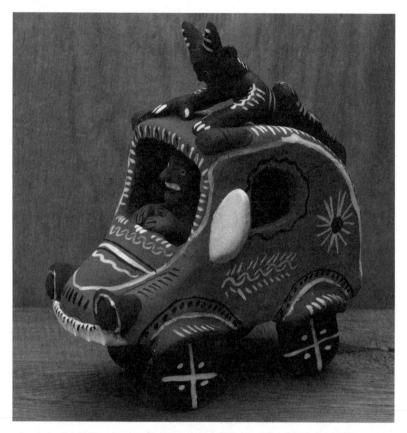

Devils in a car, polychromed clay, Ocumicho, Michoacán.

Evil, and the devils of Ocumicho like the *siurells* of Majorca, are another representation of Evil, perhaps comparable to the Judases: a playful representation which challenges and pokes fun at Evil. *Friditas* and serapes are, of course, another matter.

Unpicking the dense fabric of the folk arts in Mexico is a task that will need still more time to complete. It is a cloth woven, like many others, by female hands, and may perhaps serve to tailor a rich history of the folk arts from what we might call a non-sexist point of view. But this is only possible, obviously, if attention is paid to social division by genders, in other words the hierarchical division between men and women.

Of course, the folk arts and their making have indeed been documented, described and examined time and time again (although such treatment has been very far from exhaustive). There is a need, however, to approach it anew in order to see it with fresh eyes; with a more attentive gaze, to discover and uncover the presence of women in this process, to reveal what they are doing, how they are doing it – and at the same time, of course, what the men are doing and how they are going about it. Behind all this there is also a certain desire to find out whether, in present-day Mexico, folk art is a particular preserve of women, or of men, or if it is a field of activity that keeps both sexes busy equally. To discover this, all folk art production has to be studied little by little. At the same time, certain creations of folk art do need to be examined for the first time, either because they are new or because they have not been studied before. There is a need to build a panorama of Mexican folk art which takes into account the gender difference. We need to bury the notion of neutrality in art once and for all. Folk art is not a product of an abstract entity known as 'the folk', or 'the people'; it is made by particular individuals in specific places with well-defined cultural and gender characteristics.

I make use of the concept of 'folk art', but at the same time I believe it should be questioned and reviewed. Perhaps one day this class and often ethnicity-based conception of art that goes hand in hand with the division of society into separate strata will fall into disuse, and then this separation – at times forced and always hierarchical – between popular, lesser or folk art on the one hand, and 'high' art, i.e. the 'cultivated', 'erudite' art of the elites on the other, will also disappear. In general, when one speaks simply of 'art', it is this 'greater' or 'high' art one has in mind. For me, the word *art* must cover all artistic creation; art is plainly the universe of artistic creations. Nonetheless, in the present context I shall make the practical distinction between *folk art*, that created by people of the working classes, with scarce economic resources, and *elite art*, that created by persons belonging, generally speaking, to the urban middle and upper classes: in other words to a select and privileged minority within society as a whole. In a way that is not very explicit, each type of art, aside from its class origin, responds to a set of characteristics, codes, which places it in one or another category. Both elite and folk art are bought by minorities with their purchase power; however, while elite art is sold in galleries and exhibited in museums, folk art is sold in specialist markets and shops and only rarely reaches museums. All contemporary art (whether elitist or popular) can, of course, also be acquired direct from its creators.

A concept that I reject completely is that implied by the expression 'ethnic art', very fashionable in Europe and the United States as a denomination for all art created by non-white (that is to say 'other') people. I regard this as an eminently racist expression which is, besides, not even methodologically useful.[7]

The present work is situated at the crossroads of several different disciplines; it has to do with aesthetics; perhaps also with cultural anthropology, the anthropology of art, with women's studies and with art theory. This is what makes it different and, I hope, promising for the construction of a new area of knowledge, but it also limits it both theoretically and empirically. Despite its interdisciplinary nature, this work perhaps finds its most natural home within feminist research.

Folk art is often classified on the basis of the materials used to create it. One speaks for example of earthenware, of textiles, of glassware, or of cardboard figures. But it has also been classified with reference

Doll, paper, Celaya, Guanajuato.

to the principal function which it satisfies socially: whether utilitarian, ornamental, funerary, ludic, artistic, magic/religious. The examples I have selected are of four different materials: clay, cardboard, textiles, and paint on sheet metal. While some of them, such as the ex-votos, have a clear religious function, these may also be viewed, in the same way as others, in terms of their artistic function.

It is already a commonplace to speak of syncretism in manifestations of culture in societies like the Mexican. There is a type of production in the field of folk art which is especially indicative of the process I label syncretism (for lack of a more suitable expression) and which I shall be exploring in three examples. I use this word in the simple meaning of a recombination of elements of very different origin and with little apparently in common. Here, the concept has nothing directly to do with philosophical or religious systems which seek to combine different doctrines, but certainly shares with them the idea of reconciling disparate components. The combination of artistic elements originating in two different social spheres (the elite and the popular) gives rise to rather peculiar objects that are also interesting from an aesthetic point of view.

These syncretic creations to which I refer would appear to occupy a middle ground between folk art and so-called cultivated or high art. To a certain extent, they are of a type which could be characterized as hybrids responding to a process of cultural syncretism. Folk artists take 'models' from elite art and reproduce them within the artistic forms they are accustomed to creating. In a way, this is a similar process to that which led a painter like Picasso to take aspects of African folk art and integrate them into his own system of expression; elite artists who have taken up elements of folk art in order to make them part of their own artistic language are too numerous to be listed here.[8] However, elitist art copies elements from folk art in order to integrate them, rework them and then present them as part of a 'unique' and 'original' work of art. Of course folk art – in the cases we shall examine – also takes something from elite art and hands it back to us in various newly elaborated forms; but what we are looking at in this case is a series of reproductions from a model.

The phenomenon of hybridization in certain expressions of folk art has to do with the articulation of traditional cultures (whether indigenous or *mestiza*) with modern Western culture. It is this amalgamation of the traditional with the modern which leads to these cases of cultural syncretism that I regard as interesting. Among the many reasons for this process are the repeated economic crises – conjunctural

processes that require a renovation of creativity so as to stimulate the interest of the market. Nonetheless, the poverty of much of the population of Mexico is not merely a temporary or conjunctural issue but a structural one and this has not always or necessarily led to syncretism, although it does tend to stimulate a constant search for new ideas.

To illustrate this I shall refer to several different types of artistic creation. Firstly I shall deal with the earthenware pieces by Josefina Aguilar (Ocotlán, Oaxaca) which recreate the paintings of Frida Kahlo. I shall then look at the production of serapes from Teotitlán del Valle (Oaxaca), carried out by women and which reproduce paintings by famous elite artists. The third case I shall investigate in this context is the work of female potters at Ocumicho, Michoacán, which in part also takes its models from 'high' art.

In contrast with these examples I shall be considering two new modes of creation within the panorama of folk art which are highly singular expressions of creativity at the service of survival: these are the Zapatista textile dolls from Chiapas and the embroidered ex-votos of San Miguel de Allende in the state of Guanajuato. Both of these are innovatory forms of needlework, one of the most traditional activities of women. Both represent a process of recreation, but while one revives the tradition of the painted ex-votos, which had all but disappeared, the other presents images of a contemporary revolutionary leader.

It is important to point out at this juncture that one of the key concepts of this work is that of gender. By this I understand the whole set of ideas, judgements, attitudes, prejudices, fantasies, desires – that galaxy of invented elements within a culture which is applied to human males and females from the cradle, and which leads to the creation of men and women in society. We are dealing with attributes that 'correspond' to a sexed human body which continually learns both voluntarily and involuntarily throughout its life – in other words our way of acting, even of walking and dressing, of speaking, thinking, in short existing in the world, which all form part of the identity of a person. It can also be called the *gender identity*, bearing in mind that 'human identity is not only not natural and stable, but constructed and occasionally even invented outright'.[9]

Taking into consideration social division by genders represents the nodal point of the methodology used. It is my interest to find out what kind of folk art is produced by women, how and by whom it is marketed, who consumes it, and what the relationship is between genders throughout the process.

I regard art as a process consisting – as Donald Preziosi puts it with such precision – of five constitutive elements: the artist or person who makes the art; the process of production itself; the produced object; the process of reception (which ought to include the process of distribution, although Preziosi fails to mention this); and the person who uses or looks at it.[10]

Female participation (as well as that of children of both sexes) in the production of Mexican folk art is often concealed behind the neutrality of the concept of 'the people'. It is therefore necessary to reveal the presence of women in the creation, distribution and consumption of art.

It is fair to say that almost all texts dealing with folk art are basically gender blind, and women simply remain unseen. Such texts give a slanted impression since they present folk art as emanating, effortlessly as it were, from a sexless entity, 'the people' (where the focus, by default, is always on men). Thus the task of deconstruction and reconstruction is required.

Ex-voto lacking
any image of the
Virgin. Oil on metal.
Museum of the
Basílica of Guadalupe.
Text: Herminio Lara
was working on the
1st of October, 1924.
In the new mine of
San Francisco myself
and two companions
were arrested and one
of them was shot as a
result of calumnies,
and we, thanks to our
fervent invocation of
the Most Holy Virgin
of Guadalupe and
the Sacred Heart of
Jesus, were spared
such terrible injustice
and in gratitude for
such a sweet marvel
I dedicate the present
retablo. Mexico,
January 5, 1925.

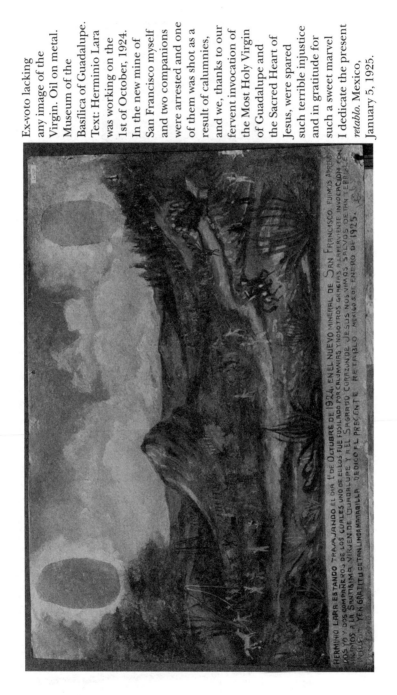

Miguel Linares's family workshop, Mexico City, 2004.

Chapter One

Folk Art and some of its Myths

Folk art, the art engaged in by all peoples of the earth, seems to be a never-ending source of surprises. For many people, whether or not they are connoisseurs or have studied the subject, handicrafts and folk art are one and the same. For the recognized art critic Marta Traba, for example, folk art is made up of handicrafts, folklore and primitive painting.[1] I believe, however, that handicrafts are one thing and folk art is another. All folk art can be considered to involve handicrafts, but not all handicrafts are folk art. A handmade palm fibre chair, even if it has a painted flower on it, or a baked clay mug, unexceptional apart from being handmade, perhaps should not be considered folk art. What is the difference? Handicrafts are generally more mass-produced and depend mainly on manual skill rather than creative imagination, often serving an immediate practical or religious function and tending to be extremely repetitive and made by means of a collective process. Folk art, one perhaps might say, is more creative, more individual, more imaginative: more 'art', in fact. It is certainly true that art, generally speaking, entails more of the collective than is often imagined. Mexican mural painting was not the work of single artists working alone, but was carried out by teams. Thus folk art, and not only handicraft, is also often the result of family-collective labour and, as we shall see, may also be repetitive.

This question of the identity of art is a matter for eternal controversy. Everybody in their respective cultures knows or feels what art is and what it is not and nevertheless, when we come to deliver judgement on the matter, our scruples fail us and we are afraid of acting like inquisitors deciding on the destiny of human creativity. Perhaps this is so because of the value our society bestows on art. It seems that if something is not art it is of no intrinsic value.

Folklore is quite different: it is made up, above all, of expressions of an oral and musical nature: tales, songs, legends, dances. This is

another type of artistic production which cannot be regarded as part
of folk art or handicrafts.

Our world is still built upon great hierarchical dichotomies: good
and bad, black and white, men and women, old and young, rich and
poor, rich art, poor art.

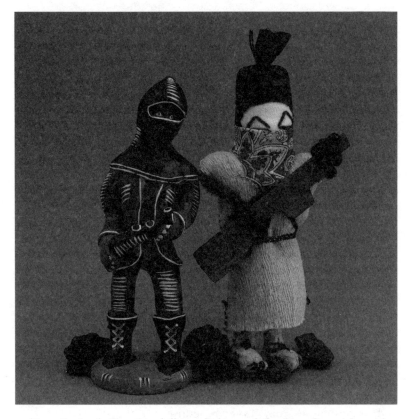

Marquitos (male Zapatista dolls), polychromed clay from Ocumicho and
cloth from Chiapas, *c*.2000.

Folk art is a creation of the folk, in other words the common
people, but who are these common people? One way of defining
them is as a heterogeneous group 'made up of all those occupying an
inferior position in the diverse existing relations of power, which are
polymorphous'.[2]

However, if that is the common people, women, as an inferior
social group in our society, must all be common people. We are all

well aware, however, that this is not so. On reflection, it is evident that the term 'common people', although one might prefer to characterize them in this more elegant and sophisticated manner, is simply another way of referring to the poor of society. Not all the marginalized and oppressed are common people – nor all the women, nor all of those referred to as black, yellow or brown – but only the poor among them. It may well be that there are many individuals or social groups in a subordinate position within power relations other than economic ones That, however, does not turn them into common people or members of the folk.

Of course, we can also approach the subject from the opposite side: there is nothing better for the purpose of making it quite clear what is meant by 'the people', than to let one of the characters from Umberto Eco's novel *The Name of the Rose* illustrate the point:

> By the term people, he said, it would be best to signify all citizens, but since among citizens children must be included, as well as idiots, malefactors and women, perhaps it would be possible to arrive reasonably at a definition of the people as the better part of the citizens, though he himself at the moment did not consider it opportune to assert who actually belonged to that part.[3]

It can therefore be said that folk art is poor art, and also the art of poor people. Its creators are poor and often the materials are also cheap and of poor quality. As its makers are poor, they also have little or no education. As they are generally uneducated they have been called primitive, and thus the art they produce has also been called primitive. Of course, there is always someone who tries to adorn poverty with good romantic intentions:

> Folk art is the art of the poor, in other words, of the immense majority of humanity, but folk art is not in itself a poor art, it has the immense wealth that can only come out of humility and love.[4]

At the same time this impoverished, 'primitive', popular and cheap art contrasts with art which is rich, refined, sophisticated, elitist, erudite, expensive and civilized. The artist/artisan and cultural figure Martín Letechipía put it this way:

> popular culture [...] is made by artists with a social disadvantage, by marginal groups from the countryside or the city, artisans that work for tradition with pleasure, passion and perhaps as a form of resistance.[5]

Also, of course, its being poor is one of the most important aspects of the process that has kept it systematically excluded from rich, elite,

erudite or 'high' art and, needless to say, from the traditional historiography of art.

There are numerous works that identify this fact and challenge it in very different ways.[6] Nevertheless, even those texts that discuss the class nature of the cataloguing of art never take into account division by gender; they do not pause to consider whether folk art is crossed by the hierarchic division of gender.

Folk art is often anonymous, for people outside the producing community or when it is from the distant past: there are exceptions of course, since some folk artists enjoy fame nationally and even internationally. Folk art is traditional: it does not change, or so it is alleged. An art that does not change must be regarded as static, and nothing could be further from the truth where folk art is concerned. Of course folk art undergoes change: often a slow transformation, very different from that of the art of the elites, but the change is constant. It appears, it transforms and it disappears. For example, votive paintings have undergone a gradual modification and, if the form has been most consistently maintained, the content has continued to change because such transformations respond to a constantly mutating reality; and this, today, is an art on its way towards extinction. The Judases, the production of which has diminished considerably, were always subject to change especially with regard to the images they reproduced, also generally taken from everyday life. The *ocumichos* and the *alebrijes* are much more recent forms, but even so they have already undergone every kind of transformation, especially the *ocumichos*. The case of paintings on bark or amate paper is similar: this is a new creation of folk art. *Amates* began to be painted in the 1950s, but they incorporate plastic elements adopted from the existing ceramics of the same region (Guerrero). The *Friditas* from Ocotlán are also still in their early youth and the incorporation of women into the work of weaving serapes at Teotitlán is a relatively recent process.

Another example of the transformation of folk art are the very famous ornamental Mexican ceramics created by internationally renowned artists such as Teodora Blanco (Oaxaca) and now her descendents, the Aguilar sisters (also from Oaxaca), as well as many other artists from other parts of the country, both male and female. These figures have undergone a process of perfection and at the same time have continually been adapted to the demands of the market.

But while capable of transformation, folk art does in effect tend to be conservative in both form and content. It changes constantly, but it maintains styles, motifs, symbols, forms or techniques. In elite art,

meanwhile, the urge is always to be innovatory and in the vanguard, original and unique.

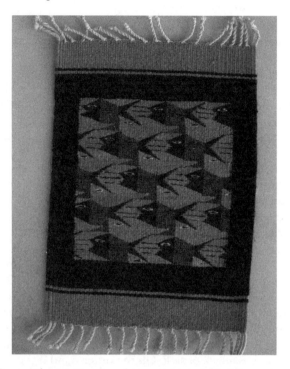

The 'Women who weave serapes' group, serape with fish, woolen textile, Teotitlán de Valle, Oaxaca, *c.*2000.

Ingenuousness, freshness and innocence are characteristics that are always, one way or another, associated with folk art. For this reason it is often also referred to as naïve art.

Primitive: folk art has always been regarded as primitive. What does this term mean? It was the very first, perhaps, or art that existed at the dawn of humanity, or it predates the Renaissance. But in a modern context? It means it is unrefined, not very well executed, unsophisticated, crude, simple. It means it is the art of the folk, of peoples, not of elites. Why not wild or savage art? Would this not amount to the same? Wild means without culture, not civilized, in other words primitive: uncultured, or uncultivated in the sense that humans cultivate soil. The concepts do seem very similar. But the word employed is primitive and not wild or savage art. By savage art, people understand

something different: they understand the art produced by the so-called savages of the world, the indigenous and often half-naked peoples who wear feathers.

For some centuries now, primitive art, the primitive in general, has been alternately admired and rejected in the part of the world known as the West. In the late eighteenth century the concept actually became fashionable and Goethe regarded primitive art as the only genuine art. For example Gauguin in the nineteenth century and Picasso in the twentieth were great admirers of primitive art and incorporated many elements of it into their own work. Primitive art was appreciated as representing an idea of purity: it was even said that it was superior, but it would seem that the superiority attributed to it was of a moral nature and had very little to do with any mastery of the subject. There has also been talk of the virtues of innocence and honesty in primitive art: it has also been said that its forms are elemental, but express great vitality.

In a series of articles, Ernst H. Gombrich analyses the concept of the primitive in Europe.[7] His statement – contrary to what is often assumed – that primitive art is not only *not like* children's art, but that the two are diametrically opposed, is of special interest. The art of children is basically spontaneous, he says. On the other hand, in primitive art there is much control over instruments and materials. There is a long and disciplined practice behind primitive art. It can be said that in children's art all the elements of the artistic process are very basic and there is a lack of skill. On the other hand it is possible that in primitive art some particular technique is not developed: it might lack perspective, for instance, but this does not indicate an absence of skill or mastery of technique, as is the case in children's art.

One can draw an analogy of folk art as walking and elite art as driving a car. This does not necessarily mean that primitive or folk art is more pedestrian, more rudimentary or less developed than elite art – although it may be so when one compares intentions. They could be seen simply as two different modes of expression, in the same way as walking or going by car are two different forms of transport. If one wishes to go from the kitchen to the bedroom it is most likely that the ideal means is on foot and nobody would regard this as a primitive form of motion. Of course to travel from Mexico City to New York or Yucatan it would be better to use another means, such as a car or a plane. Is the car a more primitive means than the plane? In some sense perhaps yes, but in another no. The same applies to the choice between walking and going by car. To cover relatively small distances

the plane is of no use. However, to manufacture an aircraft requires scientifically and technically highly prepared people as well as others not so highly trained, while walking requires a much simpler degree of learning. These comparisons might help us understand possible differences between elite and folk arts.

Primitivism has often become a cult, with followers exalting everything that comes from other cultures beyond the confines of the so-called civilized world, regarding it as better: a similar process

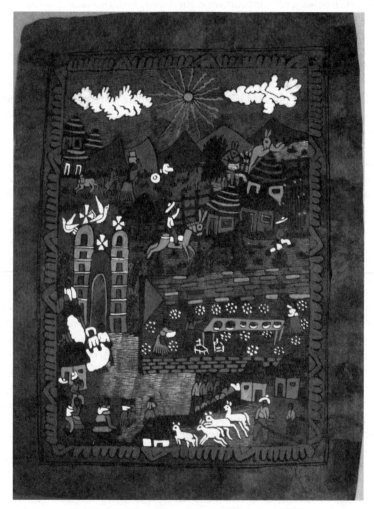

Unknown artist, painted *Amate*, Guerrero, 2009.

sometimes takes place with folk art, as we shall see further on. Folk art, it is said, must have some function apart from the aesthetic. This may be immediate and practical, or mediate and religious or ceremonial. It always has a utilitarian, functional character. (As with every rule there are exceptions, and there are various examples of folk art whose function is fundamentally aesthetic, such as *alebrijes*, *ocumichos*, *amates*, ornamental ceramics and others.)

It is well known that the search for national identity has been, and still is, of great importance for Latin America and particularly for Mexico. This concern has involved continual efforts to concoct something which has come to be named national culture and a fundamental ingredient for this has been folk art. In Mexico, the characterization of the folk and consequently of folk art is closely linked to the question of national culture and national identity. If national culture is the great myth of unity invented for the domination of people enclosed within certain political frontiers, within that culture one will find folk art to be a fundamental component.

The notion of Mexican national culture is intended, of course, to accommodate the authentic expressions of the Mexican people, elements and features which distinguish it from other peoples or nations and make it different, while unifying it within itself. This is the reason why folk art is considered a very important part of national culture and thus a fundamental element of national identity. Folk art and handicraft production in general represent, for national culture, the historical and cultural symbols of the pre-Hispanic roots of the modern nation. Of course the roots are often not pre-Hispanic but Hispanic: for instance, the origins of painted ex-votos, Judases, or fabrics woven on a upright loom with a foot-pedal are to be found in Spain. This is also true of many other kinds of textiles, pottery and a long et cetera.

National culture is obviously something that transcends the boundaries of class and ethnic identity. As such it appropriates what belongs to the proletariat, to the various peoples (the artisans, the indigenous): it is not only above class but also above different ethnic groups as well. Thus by definition it is what represents all the ethnic groups, converting them automatically into Mexicans, citizens of the nation. In the same way, within national culture there is no room for gender: men and women, subjects differentiated by history, do not exist.

Thus, in reply to the question of what genuine Mexican art is, the answer often is said to lie in folk art, this art being put forward as the authentic expression of the Mexican people and therefore glorified. In this way a myth is produced. Simultaneously with this process of

glorification of folk art, the art of the elites and the artistic vanguards is rejected as mere imitations of the art of Western colonialist nations.

It is said, for example, that the vanguard attitude of Latin American artists is simply a way of camouflaging their lack of creativity, disguising their inertia, their inability to create, or their laziness. But this way of thinking is really that of the colonizer which has been interiorized in the colonized: from the belief that cultural subordination is a consequence of creative impotence or laziness to the assertion of the natural incapacity of certain peoples or social groups (such as women) is only a small step.

If artistic creation is a product of social being (which has been conquered, reconquered, colonized and neocolonized), and if development in all aspects of existence has been determined or conditioned by the historic circumstances of a particular colonization (or of several), the Mexican in art will, precisely, be the result. If so much effort is apparently being poured into discovering the Mexican or the Latin American in art, it would be reasonable first to recognize the reality of the colonized.

Cultural colonization implies imposition – both in violent and peaceful, obvious and more subtle ways – of the cultural patterns of the colonizer and this naturally leads to a faster or slower, greater or lesser, destruction of the dominated social formation's culture. Nonetheless it is as a result of this colonization that the characteristics of the colonized culture will take shape. It seems, therefore, a form of stubbornness to insist on finding the authentically Mexican in the purest features of the indigenous, in the last burnt-out remnants of the pre-Hispanic world. To close one's eyes to reality and deny the Western in the Mexican is to deny, to a certain extent, one's very self: it is to deny what one is. From this point of view, the art of film directors may be just as Mexican as that of the Huichol Indians.

The starting point for any serious study is the knowledge and recognition of the true current position. One should not (as often happens) start from the negation of what we are in order to construct, with imagination, what we believe we ought to be – in fact what we would like to be. In this way one only constructs a false identity – first the concept of Mexicanness is invented and then one pretends that the reality looks like the invention.

It is necessary to recognize also that self-doubt is one of the characteristics of colonized peoples, something that splits them, introducing a division between what one is and what one wants to be, and moreover that this is applicable to women as a colonized social group.

One may also take into account that for some time now it has been clearly necessary to be aware of the common nature of individual countries' situations in Latin America: the general conditions of oppression. It is certainly desirable to be aware of how the past is shared and of why Latin American countries are so closely aligned at the present time, but without overlooking the multiple differences between countries and that also there is much in common with other peoples that do not form part of the Latin American world.

A Latin American consciousness is desirable in the same way that it seems desirable to be aware of what is genuinely Mexican, while attempting to avoid the obsession with and the ideology of Latin Americanism. Power groups always spread out their networks of alliances beyond national frontiers, while dominated men and women are kept in disunion: this is well known. Colonizers have a natural interest in achieving fragmentation among the colonized, and isolation and lack of communication among the dominated.

In the history of Latin American, and of Mexican art in particular, the myth of folk art as the most authentic art has seen several peaks. Perhaps one of the most significant periods was during the muralist movement in the second and third decades of the twentieth century. Diego Rivera in particular was one of the fiercest defenders of folk art, and this attitude often concealed a latent populism.

According to some, there are two types of art in Mexico: high – or cultivated – art, and folk art. Educated art, it is thought, is that produced by a minority for consumption by a minority. It is expressed in the language of the elites and expresses their interests. Characterizing folk art, however, seems not so simple. For many people it is the same as handicrafts or folklore, as already remarked: it is also sometimes identified with art which a minority produces for the population at large, often referred to as mass art.

Strictly from the point of view of production, there are two possible basic criteria for judging art to be folk art: on one hand, if it is the artistic creation of the people (supposedly the majority), and on the other if it represents the aspirations, concerns and interests of the people (even though produced by an educated minority).

In the concept of 'folk', the notion of demographic majority (never totality) is implicit. It is perhaps obvious to point out that the individuals devoted to the production of folk art are often a minority within their communities. Although there are some cases where almost the entire community is involved in some artistic activity, generally the community is represented by a minority of producers within the

abstract folk-majority. Nonetheless, it is generally considered that ultimately such creation expresses the desires, feelings and tastes belonging to the culture of the majority. We thus see that in fact the idea of majority artistic creation turns out to be (as in the case of the elites) also creation by a group that represents the interests of a majority.

If we then consider the consumption of folk art, we find that folk art is consumed by the majority (this assertion cannot be generalized and universalized since consumption varies considerably from one art form to another and from one community to another), but that folk art is also consumed by a minority (cultural, political or economic) which uses it in different ways, but mainly for aesthetic purposes. This means that people of all sectors of society consume folk art. And this is also true of elite art: although the poor do not buy elite paintings or sculptures, they do consume it in the form of printed reproductions or via television. In this sense, when discussing consumption one must always distinguish between whether one is referring to actual purchase or to the process of reception: who uses the art, looks at or enjoys it.

We find that the minorities able to purchase folk art are paradoxically responsible on one hand for undervaluing it, by refusing to regard it as real art, and on the other for ideologically overvaluing it, by regarding it as the unique, authentic and genuine artistic creation of the Mexican people, or rather the Mexican nation.

Generally, the consumption of folk art implicitly assumes its use and commercialization. Different policies, both governmental and private, tend to take this artistic creation out of its context, robbing it of its original meaning. Works of folk art converted into simple cheap merchandise are placed in shops, galleries, salons or even museums, and thus lose the meaning they had when and where they were produced – a meaning derived from the purposes, and the people, for whom they were created.[8] This affects much of Mexican folk art: today, however, a significant part of folk art production is done exclusively for consumption outside the community through national and international markets. This is the case, for example, of paintings on *amate* paper, the *diablitos* of Ocumicho, *Friditas* and many of the masks.

The meaning that a work of folk art may have in satisfying the needs of its producers–consumers is subject to constant modification as a result of extra-community consumption, in other words by the use made of it by the educated or wealthy minorities. At the same time the people who create items of folk art, whose original meaning was for example magical or religious, are now under pressure to sell their

works on the market, and so now, for their producers, the meaning of those works is their being sold. Consider the votive tablets (*nearikas*) of the Huichol Indians, made with coloured yarn and wax: a large part of this production, though not all, is intended for sale, despite their original meaning being in no sense commercial. (They had, and still have, the magical-religious function of thanking the gods.) The capitalist system has long imposed its laws on the production of folk art: the contents and forms have been, and continue to be, constantly modified by the demands of the market.

Artisans introduce changes in raw materials, design, form and in the original use of handicrafts: far from disappearing, artisanal activity adapts to the conditions imposed by the market, depending on the artisan's needs and his or her attempts to meet these through the commercialization of their products.[9]

Now I have painted myself into a corner. If folk art is that produced and consumed by the folk, and if the folk is understood as the demographic majority, we find that the majority of the folk, in the strict sense, does not produce art at all, neither popular nor elite. The artists are frequently a minority. Likewise, folk art is only partially consumed by majorities: it depends on the type of art produced, but the general tendency is for it to be consumed to an ever lesser degree by the folk.

Digressing somewhat at this point, populist art has also sometimes been referred to as folk art or popular art. This is art produced by an elite aware of social inequalities, and with the intention of using artistic communication as a means to demonstrate them: such elites put themselves forward as representating the interests of the majority, the people. On the basis of their supposed or genuine ability to comprehend social reality and express it in art, they accord themselves the privilege of speaking in the name of others, of that majority. These are artists who one supposes are not of the people, but who know what the people want, feel, desire or need. This kind of art is made with the people in mind: it attempts to communicate, sometimes, in a language that is not the artist's own but which aims to be that of the workers or peasants, taking up certain aspects of the problems affecting them and expressing these in its production, while at the same time often putting across the ideology of the power groups. Much of the work of Diego Rivera and other Mexican muralists and also many films, including those of filmmaker Ismael Rodríguez or the Cantinflas comedies, can be cited as examples.

When a cultural elite believes itself to have expert knowledge of the problems, feelings and interests of the people, and claims to produce popular art (whether populist or not), we face an extremely misleading and maybe even deceitful process – the creation of a new myth.

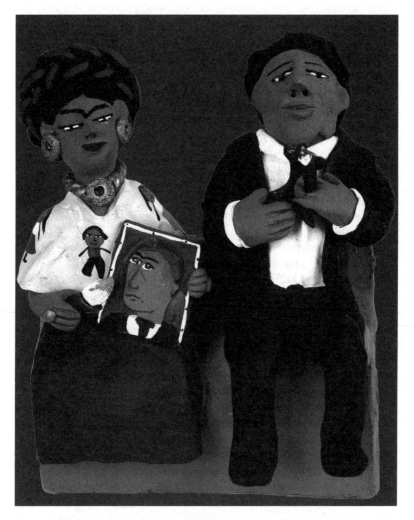

Josefina Aguilar, *Frida and Diego* imagined, polychromed clay, Ocotlán de Morelos, Oaxaca, *c*.2002.

Let me introduce here a few reflections on feminism in order to better understand my personal position within this political philosophy. The main task and specific function of feminism ought to be that of offering a radical critical consciousness, which would be something like the starting point for change in the situation of women's social subordination. Assistentialism in general – attention to and care for battered and raped women, help for those who wish to have an abortion – corresponds to state institutions and government programmes rather than feminist groups.[10] Feminist activities are those directed towards eradicating the existence of rapists, ensuring that men stop being violent, and changing attitudes and mentalities. Feminism is also concerned with revolutionizing private life, in order to change women's existence in a true manner. It envisages that men should share equally in domestic chores and the raising of children. This would ensure that women would no longer have such long double workdays. Women should accede to power, all social powers, but this fact in itself is not a feminist action. In short, the task of feminism is a long and hard one, but as mentioned, it lies mainly within the field of transforming mentalities that, for their part, will modify the habits, customs and manners of everyday life.

I do not think that all women are equal, not even biologically, and I do not believe that there is an essence (I do not believe in essences altogether) which all women share that is universal, static and timeless. 'Woman' can be a useful philosophical category, but when dealing with social and concrete reality it is important to use the concept in the plural: women. Nonetheless even the category of 'woman' is not a fixed one, with an essential identity, but is historical as well. When studying women one has to take into account the fact that each woman is different, but may share with others a historical situation and social conditions such as class, age and ethnicity, and therefore a specific situation of gender inequality. I do believe that all women belong to a subaltern social group in Western societies, in spite of the fact that the variables mentioned above introduce other factors that are crucial to understanding gender subalternity and therefore to transform it. Each feminist woman has a different conception of women's rights, however there cannot exist social action unless there is a common ground from which collective activities emerge. Griselda Pollock said it this way:

To avoid the embrace of the feminine stereotype which homogenizes women's work as determined by natural gender, we must stress the heterogeneity of women's work, the specificity of individual producers and products. Yet we have to recognize what women share – as a result of nurture not nature, i.e. the historically variable social systems which produce sexual differentiation. [...] Difference is not essential but understood as a social structure which positions male and female people asymmetrically in relation to language, to social and economic power and to meaning.[11]

Although I do not think there is an essential identity or femaleness, I do believe there are some cultural elements that integrate something called gender identity which changes with time, geographical space and historical contexts.

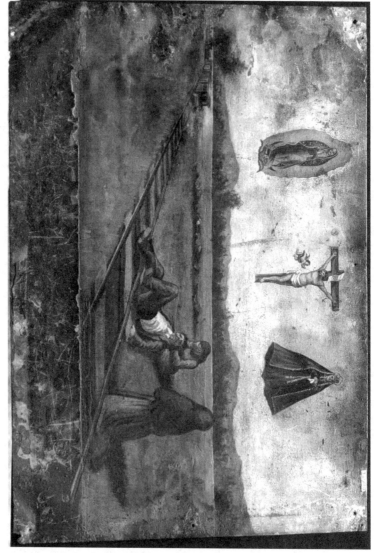

Ex-voto. Oil on metal. Museum of the Basílica of Guadalupe. No text.

Chapter Two

Women and Votive Paintings

In some museums and many private collections in Mexico and abroad, and also still in some churches, one may find what remains today of an extraordinary folk art known as votive painting or ex-votos. In Mexico they are also known popularly as *retablos* (a word which in official use means altarpieces) or *milagros* or *milagritos* (miracles). In Castile and León in Spain, they have been called *ofrendas* (offerings) and in Catalonia *retaulons* (little *retablos*).

Ever since human beings invented gods (or the other way round, if you prefer), they have shown in various ways their gratitude for favours received in view of the miracles observed. Ex-votos are, then, perhaps as ancient as the gods and their creators. There has always been a relationship of reciprocity between human beings and their gods, and ex-votos are a clear manifestation of this relationship.

As a customary form of devotion within a region spreading across much of Catholic Europe – southern Germany (Bavaria), the south of France (Provence, Languedoc, Roussillon), Italy and Portugal, ex-votos were painted to give thanks to God, to the saints or to the Virgin in her various advocations, for a miracle or some favour received, and were placed in churches or sanctuaries. They were almost always painted in oils, on a variety of materials. In Mexico they were painted at first on canvas, but in later times almost all of them were executed on sheet metal (occasionally on boards or even card or cardboard). In Spain they were first painted on wood or cloth. In Italy there are also some on cloth, a few have been preserved on glass and ceramic and the great majority are on wood. It was mainly in the eighteenth century that cloth was used. In all geographical areas they were generally small: the great majority measure around 30 centimetres by 20

The Mexican painted ex-votos almost always consist of three elements. In the lower part they contain a handwritten text with the description, at times highly detailed, of the miraculous event, with

the date and place it occurred, the name of the affected person, and that of the person making the offering if the two are not the same. Then, painted in the centre, is the image of the story, the miraculous event, with greater or lesser detail and with greater or lesser skill. And, thirdly, in the upper part (generally to the right, but it may also be in the centre or even on the left), we have the image of the saint invoked.

There is no way of knowing exactly how many were painted, but to judge by those which survive, there must have been many thousands. It can be said that now their creation has practically disappeared from all the countries where the tradition was once present. In Mexico they are still produced in a few very specific places, in the states of Tlaxcala and Jalisco for instance. There are also some contemporary examples that are pictures made by children with crayons, in general of very little interest.

It is a fact that a considerable number of painted ex-votos have been destroyed throughout the centuries. Nowadays those still preserved in churches are few, because mostly they are to be found in public or private collections and even in antique shops.

It is a commonly held opinion that since all folk art has a specific social function apart from the aesthetic aspect, it will continue to be created as long as it is needed for that function, and that although it may undergo changes, this does not in itself account for its falling into decadence or degeneration.[1]

In the case of the painted ex-votos, production has now reduced drastically: at the same time the religious function continues very much alive, and the need to give thanks to God for favours granted is still felt by the faithful. Nevertheless, it seems obvious that we have reached the 'degeneration' of the ex-voto as a work of art when we see in many churches *retablos* that consist of nothing more than a little handwritten or typed letter and the photograph of the child who recovered from an illness, or of one who finished his studies with a secondary school diploma, a shoe with a text, or a photograph of a mother with her newborn baby. These ex-votos fulfil the same religious function, but not the same aesthetic function. Of course, the question of the aesthetics of *retablos* is something about which there is no consensus at all: many people think and say that they are just badly done, ugly, worthless daubs. Carlos Espejel for example, a specialist in folk art, is of the opinion that ex-votos 'attain no artistic value and are regarded only as curious forms of devotion'.[2]

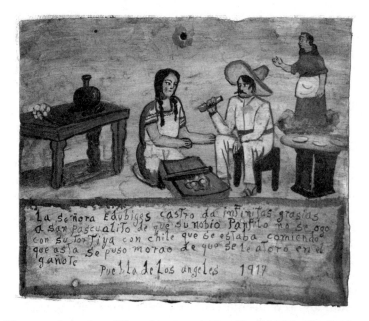

La señora Edubiges castro da infinitas grasias
a San Pascualito de que su nobio Panfilo no se ogo
con su Tortiya con chile que se estaba comiendo
que asia se puso morao de que se le atoro en el
ganote Puebla de Los angeles 1917

Home-made ex-voto. Oil on sheet metal. Text: Sra Edubiges Castro gives
infinite thanks to St Pascualito that her betrothed Panfilo did not choke on
the tortilla with chilli he was eating and which stuck in his gullet until he
turned purple. Puebla, 1917.

Another present-day phenomenon is the production of false ex-
votos, forgeries in the sense that they are painted now with invented
stories and dated a century or fifty years ago, and are made for the
express purpose of being sold in antique shops.

In the Abbey of Montserrat in Catalonia, there is a little room next
to the church in which modern ex-votos are kept (the old painted
ones are to be found in a special room which can only be visited with
the permission of the monks) and this little room is full of objects
such as shoes for a wedding, babies' bootees, a wide variety of other
garments, photographs, handwritten sheets of paper and heaps of
trinkets. Sometimes they are arranged to form *sui generis* ensembles
that can only be described as kitsch. Apparently, such is the quantity
of objects which are left there that every so often the monks burn
everything.

Ex-votos began to be painted in Mexico soon after the conquest and
were first made, it seems, in the schools for Indians set up by the mis-
sionaries. Similarly, it is said that they made their appearance as soon

as churches were built: their origin is therefore obviously Spanish. Nonetheless, according to Angelo Turchini the ultimate origin of the tradition can be traced to Italy between the thirteenth and sixteenth centuries, whence the practice spread across Catholic Europe and then to the Americas. According to the same author the painted Italian ex-voto tradition was consolidated in the sixteenth century and reached its peak of development from the eighteenth century.[3] The antiquity of the tradition in Spain is shown by the fact that the oldest known example dates from the fourteenth century.

While the painted ex-voto is a very strong manifestation of Catholic devotion, it is not exclusive to Catholicism, since in many Japanese shrines, particularly Shinto ones, ex-votos painted on wood – known as *emas* – also exist. Although these are always extremely simple, the modern examples are reduced to a mere written text, almost always without any painted image and mass produced.

It is curious to note that a feature in the evolution of European painted ex-votos is also to be observed in that of Mexican ones. For example, the French, German and Italian ex-votos of the fifteenth, sixteenth and seventeenth centuries are painted with greater skill, show signs of formal apprenticeship and use perspective in a more 'realist' way than those of the eighteenth and nineteenth centuries. In the 1800s, styles become more naïve – a tendency that persists to the present day. The history of European ex-votos seems like a metaphor of the history of European plastic arts of the last six hundred years. During the fifteenth to eighteenth centuries the dominant plastic expression was figurative, with technical perfection and the greatest possible closeness to nature, or to the human figure in the case of religious art. In the nineteenth and twentieth centuries, one sees an increasing tendency towards so-called primitivism and naïve art, and towards the alteration, in countless ways, of what is conceived as reality, whether impressionism, cubism, surrealism or abstract expressionism. This also happens in the personal evolution of painters: it is often noted for example that at the beginning of their careers artists tend to be very figurative (academic, perhaps) and later, as they seek a style of their own, they pass through a metamorphosis that distances them from so-called realism, even when they remain close to the figurative. Today it would seem that the kind of painting known as realistic and figurative has given up its place to photography, as if it lost its historical *raison d'être*. Photography can know and recreate reality with such precision that painting has preferred to seek other approaches to reality which perhaps allow it to obtain an ever deeper knowledge.

Meanwhile, there is also the somewhat special form known as hyper-realism, which is not nineteenth-century figurative painting augmented or increased in some way: rather, it is something completely different, although not of course a move from the more figurative to the less.

The ex-votos undergo a similar process of transformation, and this can also be observed in Mexico: this does not mean the earliest *retablos* are more primitive, but rather the contrary. Eighteenth-century

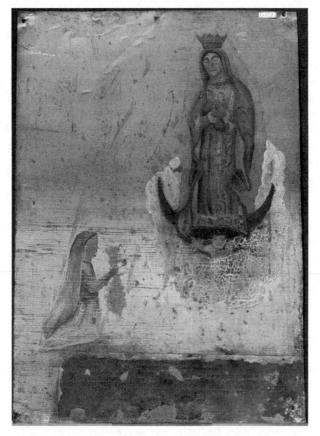

Ex-voto. Oil on metal. Museum of the Basílica of Guadalupe.
Text (type-written): To the Holy Virgin of Guadalupe. Having been seriously ill from an illness that not even the doctors could know what it was, I invoked with all my heart the Holy Virgin of Guadalupe. Immediately I found relief and in gratitude I dedicate the present *retablo* for all those who may behold it with faith. Eligia P. Widow of Saldaña.

Mexican ex-votos are generally characterized by being painted with greater skill, most of them evidently created by people who were masters of the craft. Here again one can see photography eventually coming to replace painted ex-votos: however, instead of being artistic photography, it is unfortunately that of the passport photographer. It is likely that the earlier ex-votos were painted with greater skill because they were the work of specialized artists who also had considerable experience. There is also direct evidence of *retablo* artists also painting works of the kinds recognized by conventional art history. However it seems likely that the explanation for the gradual impoverishment of the art of the ex-voto lies in their increasingly being made by the very individuals who give them as offerings, or by local amateurs with little training or experience.

As for Western plastic arts in general, while the evolution I have mentioned was no doubt due partly to increased access to printing presses and the invention of photography and thus new forms of mechanical reproduction, it was also partly a consequence of sociopolitical and religious changes that reduced the dependence of artists on a particular patron or field (without forgetting, of course, the Soviet period of socialist realism, again imposed from above, which is like a backward step within the process outlined).

It is extremely rare to find a signed ex-voto from the eighteenth or nineteenth century, although we do have knowledge of certain artists who executed them, for example the recognized nineteenth-century painter Hermenegildo Bustos. However from the third decade of the twentieth century there are several signed ex-votos. Is this fact connected to the development of capitalism, the ultra-commercialization of art, individualism and competition? Is it something promoted by intermediaries and art buyers? Or is it instead a sign of a higher valuation of personal work, greater pride in creative work? It would seem that as much as anything the signature begins to appear for the outside world, because within the communities where they were made, the painter was not anonymous: everybody knew – or was able to find out – who the local painters of ex-votos were.

There are many sides to the question of anonymity. On one hand, there is the concern for the name of the creator, and for the originality and uniqueness of works of art, all linked in capitalist societies to the culture of individualism, progress and innovation, this taking precedence over the traditional, and more egalitarian, collective approach to work. It also has to do with the law of profit as signed paintings are more valuable, so it may become useful to elevate certain works of folk

art to this category, generally those to be consumed outside the community and for aesthetic purposes. Anonymity, on the other hand, hides the differences between creators. It also of course prevents us from distinguishing the men from the women. Awareness of the gender differences is important because it can help us to see whether there are also differences of hierarchy and oppression involved in the process of production of art and at the same time enable us to appreciate the possibly differing visions of the world expressed by men and women.

In the case of ex-votos, there is always the possibility that, since they were not conceived of as art, the need to sign them was simply not recognized. Alternatively the fact that previously they were never signed and more recently signatures occasionally appear may perhaps be related to differences in the work process. There have been periods when there was more mass production in workshops, many of them family workshops, where the work was done collectively, and that when they were the result of a more individual labour carried out by a new figure in society, the folk artist, some signed their work.

In order to gain a better idea of the characteristics of all the different social groups involved and avoid simply bundling them all together as 'the people', it is necessary to know what these people think, what they feel, and what they actually do. Anonymity can indicate a collective task, or the reverse. Female creative work often lies concealed behind it, but because of their situation in a patriarchal society the assumption is simply that the work was done by men. It is thus as well to recognize the importance of knowing – that everyone knows – what is done by each person involved in the process. If there is a division of labour, it is important to see which part is done by whom, and to recognize the contribution of each in his or her own work. The invisibility of domestic labour is a good example: it has been necessary to claim it as a form of work, and also as feminine, in order to be able to understand the situation of women for what it is and then attempt to transform it.

Recognizing one's own work is part of having an identity, and the construction of individual identity is as important as that of the collective. Identity is one of the axes of existence.

Thus, returning to ex-votos, it is unfortunate that many of the existing signatures do not permit us to identify the artists' gender, forenames often represented only by initials. Where the first names are clearly indicated, in every case seen by the author all belong to men. So there is no way for anyone to know whether any ex-votos were

painted by women. All the information uncovered, both in Mexico and in Spain, refers to male painters. The specialist in Catalan folk art Joan Amades, for instance, refers to known painters of ex-votos in late nineteenth-century Barcelona, but does not mention a single woman.[4]

On the other side of the Atlantic, however, the specialist in ex-votos and altarpieces Gloria Fraser Giffords has ventured the hypothesis that women might also have been responsible for the creation of religious items; and that often it was most probably a production process involving whole families. Her speculation is based on a comparison between production of ex-votos in the past and today's processes of folk art production. She asserts that if it is now very common for a whole family to take part in the production of folk art then it is highly likely this also happened in the past.[5] However, in her book *Mexican Folk 'Retablos': Masterpieces on Tin*, she makes no mention of gender differentiation.[6]

Very little has been written about ex-votos, and in particular Mexican *retablos*. In general, the books that exist in France, Spain, Italy, Germany, even in Mexico, are large format books with more illustrations than text: one finds barely a line which mentions the gender of the creators, or the consumers, even in the iconographic analysis. Everything is always presented in this desexualized, neutral way.[7]

It is most unlikely that when *retablos* were first painted they were done by women, as it is known that they did not attend the schools of painting and during the colonial period this kind of work was very rarely carried out by women. I have in fact realized that it will be utterly impossible to arrive at full identification of the artists. So far, I have not discovered any evidence whatsoever that supports the idea of women painting ex-votos on a professional basis. However it does seem quite possible that in cases where the person making the offering also painted the ex-voto some were women, and also that there were women involved when creation took place in a family workshop.

It appears quite clear that before Mexican independence and up until the mid nineteenth century, ex-votos were offered mainly by the rich (landowners, traders, aristocrats, governors, hierarchs of the Church) and that afterwards the practice was gradually taken up by the poor. The ex-voto came to be art of the poor.

The wealthy status of those making the older votive offerings seems clear simply through observation of the clothes and jewellery worn by the figures and the luxurious carriages and mansions with their brocaded decorations and sumptuous furniture that appear in the

earliest examples, as well as the reasons for offerings, almost always on account of recovery from illness: there are practically no cases mentioning accidents at work or the loss of a cow or pig. Some even specify the rank of the person offering the ex-voto – the *alcalde mayor* for example. In the mid nineteenth century accidents at work appear ever more frequently as reasons for offerings and we find more and more examples dedicated to a sacred image revered in Guanajuato, known as Our Lord of the Works (*el Señor de los Trabajos*).

One of the many ways of classifying the arts, particularly the folk arts, has involved the criterion of whether they were produced for the community's internal consumption or for consumption outside the group that created them. In the case of ex-votos, the question of distribution and consumption is rather complex: it can be said that their creation (by those who paint and those who offer them) takes place within a particular community, but in general they are not 'distributed' – in churches – exclusively within the same community. It often happens that they are placed in some far away sanctuary, because the particular image of Christ, Virgin or saint exhibited at that sanctuary is the object of devotion of the person offering the ex-voto. Some Virgins are more miraculous than others: this is well understood and recognized everywhere. In Mexico the most important images have been the Virgin of Guadalupe, national patron saint; Our Lord of Chalma (these are both dark-skinned figures); the Virgin of San Juan de los Lagos; Our Lady of the Rosary of Talpa; Our Lady of Solitude; the Holy Christ-child of Atocha (*Santo Niño de Atocha*); Our Lord of the Willow Tree at San Luis Potosí; Our Lord of the Lamp at Charo; Our Lord of the Column, and a host of other sacred personages are rewarded with ex-votos. Thus, in this context, the fact of the *retablos* being 'consumed' at a distance does not affect their fundamental status as folk art. Nevertheless, the regions where most ex-votos are painted are those where the main sanctuaries are to be found: in the Central Highlands, where the Villa de Guadalupe is situated, in what are now the outer suburbs of Mexico City, and in the states of Jalisco, San Luis Potosí, Guanajuato and Michoacán.

As has already been said, folk art represents tradition more than innovation and artistic vanguards. The structure of the ex-voto is very much the same throughout the centuries. Those of Mexico consist of the three elements mentioned above (a written text, a painted story and a religious image). In other places, for example Germany, France and even Spain, only the term ex-voto appears and no written text, or sometimes the text is written on the back of the painting.

The ex-votos reflect partly the world as it is and partly the world as seen through the eyes of the person who painted it: in the age of horses and carts, we find horses and carts; in the era of the combustion engine, cars appear. People are dressed as in the eighteenth century, or the twentieth century. One can see whether hats were worn or not, whether people drank bottled refreshments, travelled by train or bus, or whether the bedroom and bed were luxurious or simple. In general it is quite easy to detect the social class to which the offerer belonged. Although formally ex-votos have varied little, the contents have changed as the world itself has been transformed.

Ex-voto. Oil on metal. Museum of the Basílica of Guadalupe. No text.

In theory, ex-votos – as Anita Brenner, writing in 1929, observed – should be able to provide us with information of a political, economic, social and ideological nature regarding the producing group:

> A collection of ex-votos from all over the country would give the lives, the thought, the happenings and concerns of each place and of the people, and would give it more honestly than any narrative, more accurately than the most careful statistical survey.
>
> From place to place and period to period, significantly, occupations, situations, official clothings, progress in caravan against a changeless,

endless background, vibrant of human trouble and of racial agonies throughout. Plagues, droughts, conflicts, are dated and described [...]. It is a moving record of a nation, the stethoscopic measure of its heart.[8]

This was my idea when I began to be interested in ex-votos. Unfortunately, due to the vicissitudes of the history of the genre and the often incomplete nature of the information contained in the *reta-blos* themselves, it is frequently impossible to use them as documents with which to achieve a better understanding of a specific region or particular social group. It would be different if the churches had not been pillaged and the ex-votos stolen, carried far away from their places of origin, distributed around the world and kept in museums and in small or large private collections, if the production of the immense majority were not completely anonymous for the people of today, external to the communities where they were created, if we could know more exactly whose artistic and religious expression they are, if all of them carried the date and place of origin. If it were not for this host of difficulties, the ex-votos would represent a most valuable source of information. Nonetheless, in spite of this long list of problems, we can extract many useful questions, above all at the level of nation, country, and (though not as much as we might wish) gender. I should like to quote here another expert in Catalan folk art, Ramón Violant y Simorra, because his opinion on ex-votos seems to me interesting, although to a certain extent contradictory:

> Our *exvots*, for all their having been painted by professional *pinta-sants*, are mostly, artistically, an aberration in all senses. But... how delightful they all are! Because, aside from their documental interest concerning buildings, interiors of dwellings, furniture, dress, working equipment, etc., and their garish and multicoloured decorative beauty – sometimes akin to ultramodern painting – , their naïve texts, expressed spontaneously and with all the sincerity of the soul, they are like a magnificent treatise on the psychology of our people. For no other document could reflect better than these legends and the painted scenes of miracles the way of thinking and acting – inasmuch as the beliefs and religious, and even human, feelings are concerned – of our rural and even our town people, the ingenuousness that emanates from this manifestation of folk art, so childlike and devoid of artistic tricks, of malice and unhealthy feelings.[9]

We must not forget, then, that besides showing us how the world actually was, the ex-votos also enable us to see how their creators perceived the world and how they conceived its existence. While these works are certainly an excellent source of information regarding the

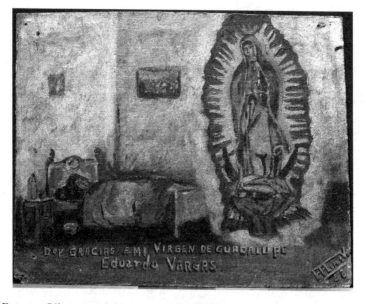

Ex-voto. Oil on metal. Museum of the Basílica of Guadalupe. Text: I give thanks to the Virgin of Guadalupe. Eduardo Vargas. Signed: F. Flores 58.

occurrence of epidemics, the incidence of particular diseases, the frequency of road accidents, and offer fascinating and differing points of view on the 1910 Mexican revolution and other armed struggles, the most important thing is the awareness afforded of how their makers envisioned their world.

When one has the opportunity to examine carefully a large number of ex-votos at the same time, one can clearly identify the hand of a single person behind many offerings to a particular Virgin or saint. For example, in the Frida Kahlo Museum in Mexico City some four hundred ex-votos are on exhibition (a similar number is stored in the depositary) and they can be sorted into various groups, such as those offered to Our Lady of the Rosary of Talpa between 1886 and 1938 or those offered to Our Lord of the Oak (Señor del Encino) between 1985 and 1987, and in each case it is obvious that they were painted by a single person. This fact enables us to see that we are dealing with individuals who in one way or another spent their time painting ex-votos, in other words that it was their trade. There is also photographic evidence (for example an image by the Mayo Brothers of a notice on a wall which reads '*Retablos* painted'). The same conclusion can be drawn from the collection of ex-votos dedicated to the

Virgin of Montserrat in Catalonia. In the room in the abbey where the painted ex-votos are to be found, one can clearly see that the majority were done by hands that knew the trade: it is also quite obvious that many of them were painted by the same hands.

The Mexican ex-votos express imposed beliefs. The Christian faith was installed ready-made on top of the different pre-Hispanic religious beliefs. The new religion was imported and with it the tradition of producing painted ex-votos. Some have wished to believe – since we are dealing with folk art – that the ex-votos represent the most genuine aspect of the indigenous soul regarded as 'the Mexican': for instance the painter Gerardo Murillo ('Dr. Atl') deplored the fact that 'International industrialism has replaced the naïve and interesting works of the indigenous sensibility with cheap coloured prints, with medals minted by the million and with polychrome plaster figurines manufactured in Barcelona'. A more dispassionate gaze, however, would find it hard to detect these supposedly indigenous characteristics of ex-votos.[10]

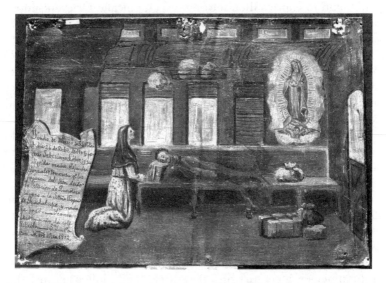

Ex-voto. Oil on metal. Museum of the Basílica of Guadalupe. Text: Ex-voto of Alejandra González. Travelling from Mexico City to San Luis Potosí on 26 December 1909, Saberiano López passed away and his afflicted mother Alejandra González, fearing that they would be made to leave the train at Querétaro, prayed to the Most Holy Virgin of Guadalupe and nothing happened to her. And as a testimony she gives this *retablo*. S. Luis Potosí, Nov., 1912.

Remaining for a moment on this Catalan note, it is of course also worth mentioning that in Catalonia and its capital Barcelona ex-votos were produced by the thousands, and a series of interesting parallels can be traced. For example, this feature so characteristic of *retablos*, their naïve or primitive style – assumed to result from their being a product of the indigenous people of Mexico – is exactly the same in the Old World and also, naturally, in Catalan ex-votos. A Catalan author even refers to them as examples of 'graphic barbarism'.[11]

In Catalonia, wood and cloth are used more than metal, and in Mexico the converse is true. It is a question of economics: in Mexico, sheet metal is much cheaper than wooden board. It is very curious to note, as has been mentioned, that Catalan ex-votos carry fewer inscriptions than Mexican ones. Also, when they do have something written the immense majority are in Spanish rather than Catalan despite the fact that the people involved were Catalan speakers. I say curious because in Mexico a much greater proportion of the population was – and still is – illiterate, and it is normally assumed that illiterate people would tend to express themselves more graphically. Or even supposing that the degree of illiteracy were equal in different places at the same period, why is the descriptive text (situated at the bottom of the ex-voto) more common in Mexico? It is rare to find a Mexican *retablo* without a single written word, although a few do exist. Both in Mexico and Catalonia ex-votos are for giving thanks for some favour received or, for a miracle that has taken place. In Germany, on the other hand, ex-votos are also used to request a favour.

I have been able to observe that the general attitude of the educated classes to ex-votos, both in Mexico and in Catalonia, is a complete lack of interest: they are not taken at all seriously and often, in fact, give rise to laughter.

As for colourings, while at first sight there is much similarity among all ex-votos, I think that if one looks carefully it might be said that the colours of Mexican *retablos* are more brilliant, the combinations more daring. The Catalan ex-votos have a more sober appearance.

It is likely that Catalan, and European ex-votos in general, painted in the nineteenth century on wood or cloth are duller because they need cleaning and restoration or possibly because on metal the colours tend to darken less than on wood. Whichever is the case, it seems to me that more brilliant colouring is a particular characteristic of the Mexican ex-votos.

Comparing contents, we find that on both sides of the Atlantic thanks are given for a return to health, one of the most common

motivations everywhere: there are also many ex-votos offered by persons of both sexes referring to men in war situations and many more that refer to men suffering accidents at work. Neither in Catalonia nor Mexico have I found evidence of ex-votos offered by women suffering violence towards them, less still of violence at the hands of men (except for the cases from Chalma referred to below). In Catalonia, there is an enormous number of *exvots mariners* (offered by or on behalf of fishermen or sailors) while in Mexico it can be said that these do not exist. Nevertheless, I have found some from the nineteenth century in Mexico that refer to storms suffered on the high seas by people – obviously monied people – who were travelling to Europe. The reason for this difference is no doubt the fact that Catalan culture is largely sea-based, as Catalonia lives facing – and drawing much from – the sea: meanwhile in Mexico, despite thousands of miles of coast, most ex-votos are produced far inland.

In Mexico there are very many ex-votos about migration to the United States and all kinds of accident and difficulty related to (often illegal) emigration, caused by hunger, to faraway places. By this I mean to illustrate that the production of ex-votos is very closely linked to the economic, socio-cultural and geographical conditions of the society that produces them.

I tend to think that what is considered indigenous in Mexican ex-votos is due on one hand to their formal aspects: given their lack of technical refinement they are considered a kind of primitive or naïve art. At the same time, since the indigenous people are also regarded as primitive and naïve the association is easy and immediate. The 'people', the poor of Mexico, are in their immense majority *mestizos* and Indians, and they are the creators of ex-votos. Thus we find that the ex-votos are folk art because they are poor and also primitive in execution.

As for their function, ex-votos do not fulfil one which could be called immediate and material, nor strictly do they have an aesthetic function like the art of the elites. They do fulfil a function, but it is of a religious nature: they have a religious usefulness. Each work is created on receipt of the mercy of divine forces, after having obtained a utility: divine intervention for a solution to a problem, generally one to do with the body, with life, with survival.

Nonetheless, the function of ex-votos has undergone modifications. When they were first made their purpose had that religious priority. Nowadays, however, for many people they are aesthetic and sociological: their religious function is lost. This process is shared by

much folk art, as already mentioned: it emerged to serve a specific practical function and now later, acquired by people from outside the community and from other social classes, it loses all meaning apart from the purely aesthetic.

In principle, elite art is supposed to respond to the producer's need to create and communicate: it is said that it does not have an external reason for being, as in a specific usefulness like popular votive painting. In fact there is much elite art that is indeed like this, but there are also countless exceptions such as religious art or that directly linked to a political interest, for example socialist realism or feminist art.

If we study ex-votos looking at the gender difference of the persons who wish to give thanks – either on their own behalf or for someone close to them – resulting from some temporary misfortune in life suffered and survived thanks to miraculous divine intervention, we find more or less the same proportion of men and women. This proportion can vary, however, when one concentrates on examples from a specific region and/or time, or to a particular sacred image of Christ, Virgin or saint. According to Fina Parés, for instance, in Catalonia there are more female than male offerers.[12]

In general terms, what is very striking in gender differentiation is that men suffer many more acts of violence than women, whether it be cases of human violence (attacks, brawls, wars), accidents involving animals (falls from horses or being gored by bulls) and they also suffer more accidents at work, with illness being the motivation for a minority of ex-votos. With women, on the other hand, in first place are always health problems associated with pregnancy and childbirth, followed by accidents (mainly in the home, the equivalent of men's accidents at work), and only lastly acts of violence. Irrespective of sex, offerers give thanks for the health and good fortune of their children.

This observable difference may indicate that men and women inhabit two separate spaces: we are given the image of the world of work and a violent exterior filled with multiple and assorted dangers for men, and the world of women in the home, where only illness and the occasional domestic mishap threaten. Is this the social reality or does it also reflect the symbolic space of each gender? Is it really the case that women do not live in day-to-day contact with violence, in particular male violence? Perhaps cases of systematic rape and beatings by the husband are not considered sufficiently serious. Or is it that they are regarded as something normal, as natural? It could possibly be that violence carried out by men on women is a social taboo which cannot be referred to in any form, or perhaps is something

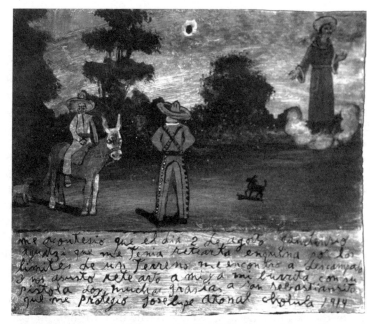

Home-made ex-voto. Oil on metal. Text: It happened to me that, on
2 August, Gandensio Aguatzi, who has a right awful grudge against me
over the boundaries of a piece of land, found me in the open country and
gave us a terrible fright, my donkey and me, with his pistol. I give thanks
to dear St Sebastian (*sansebastiansito*) who protected me. José Lupe Atonal,
Cholula 1914.

seen as a strictly personal matter, and therefore one is not permitted
to give thanks to Heaven on finding oneself more or less free of such
violence: in other words, alive.

Nevertheless, there are a pair of ex-votos in the sanctuary at Chalma
that refer to this kind of violence suffered by women. One concerns
the beating received by a woman at the hands of the father of her child
and his cousin (1939) during an attempt to take the child away from
her. Another describes the beating administered to a man and his
sister by the brothers-in-law (they call it a 'family accident') because
they refused to go drinking with them (1969). Also at Chalma there
is one that refers to a woman who is in prison (1913), but everywhere
there are many showing men in prison. It would appear that women
do not go to prison. Or is it rather that their families do not ask mercy
for them when they are in this situation, or that they themselves do
not see the need for divine intervention when in jail?

An interesting group is provided by thirty-five ex-votos offered to the Virgin of San Juan de los Lagos between 1908 and 1981 (with several undated) by workers who emigrated to the United States; rather unusual ex-votos which formed an exhibition in the Diego Rivera Studio Museum in 1991 entitled 'Miracles on the Border'. A statistical analysis reveals that of this mixed group of 'wetbacks' there were more men (twenty) who received divine favours than women (thirteen), although it is mainly women who asked for favours on behalf of their men; the most common mishap affecting the female migrants was illness (eight) followed by accidents (four), and there is one case of abduction (or attempted abduction). With the men we find that firstly they are victims of violence, accidents or other dangers (eight), secondly of problems crossing the border, finding work or obtaining papers (seven), and then illness (four), some being occupational; finally, there is one that simply mentions the receipt of an unspecified favour. A couple had an accident and a child fell ill. This sample shows, with all its peculiarities, that the same constants, already seen for more typical cases, are presented.

It is interesting to compare the daily lives of women with the image given by the ex-votos. Because while it is true that through their anonymity they give us no clues as to gender differentiation in the process of production, they do provide information to reconstruct the life conditions and identity of women; likewise their image.

Considering the distribution and consumption of ex-votos, we find that these links in the process are rather special. These paintings have been created as offerings given to some divinity for a favour received, and to be placed in a church or sanctuary. They thus become public art, objects liable to be looked at by anyone. It is of course well known that women attend church more than men: thus it is an art consumed mainly by women.

It is often asserted that current-day folk artists no longer use what they produce.[13] This is a generalization that turns out to be false since there are numerous examples that prove the contrary. I have referred above to the different patterns that exist in the consumption of folk art, and to the fact that sometimes, though not always, artists do consume what they produce. In the case of ex-votos, when painted by the offerer, the artist does indeed use them: when the work is commissioned to another it is often someone from the same community who carries it out.

Since this production is mainly anonymous for us nowadays, it represents an important contribution to our knowledge of the collective

imaginary. And once again we come up against the gender neutrality of the process as this collective is in fact made up of a female and a male part. The imaginary is not neuter: it too has genders.

If we consider that women live socially in what are often different spaces and times, if their condition in the world is one of subordination, their bodies and their work also different, and their outlook thus also different, there must be a female collective imaginary of which we are still not entirely aware. Hence the importance of introducing gender analysis throughout the artistic process; also the great significance of whether or not there were female ex-voto painters. But, as Joan Amades says, 'to follow the footprints of the painters of miracles is more than difficult: it is impossible'.[14]

Judas, Amorgos, Greece, 1999.

Chapter Three

Judas was not a Woman, but...

Studying the cardboard figures known as 'Judases' from a non-androcentric perspective and aiming to seek out the presence of women might seem at first glance a perfectly absurd task. Even so, I shall embark on this adventure.

The traditional figure of the Judas is masculine: the traitor – the devil – has gender and is male. Judas was not a woman, and yet I hope to show where and in what manner women appear in the process of creation and utilization of this expression of folk art.

The Judases made in Mexico are figures of cardboard and paste, painted using natural earth pigments, aniline dyes or brightly coloured acrylic paint and their sizes vary between as little as fifteen centimetres and as much as three metres tall. The small ones are sometimes made with a mould and the larger ones are made by hand with a framework of canes or wire. They are supposed to represent Judas Iscariot, the betrayer of Christ, and are created to be burned on Easter Saturday at ten o'clock in the morning. In previous times, Lent was deemed to end on Saturday and now it is on Sunday, but in the few parts of the country where the custom is still practised, the Judases are blown up on Saturday, at varying hours of the day.

Much has been written about this almost extinct tradition of burning cardboard Judases filled with fireworks in Holy Week,[1] even regarding the process of their production and sale but, as is to be expected, there is almost nothing concerning gender differentiation.[2] What has emerged most is the work of the now famous Linares family of Mexico City. Don Pedro Linares, maker of Judases, learned the craft from his father, a cobbler who also made cardboard horses, masks and *piñatas*. In turn, Don Pedro taught the craft to his three children – who have passed it on to their own children – and died in 1991 aged over eighty, after having received a well-deserved prize from the Mexican government[3]. Don Pedro Linares was perhaps the Mexican Judas-maker par

excellence. A long life dedicated to work in the cardboard crafts and an exceptional talent led to Mexicans and above all foreigners paying special attention to this man and his family: his extraordinarily prolific work has thus been recorded through texts, photographs and videos, as well as being the subject of exhibitions. His children and grandchildren continue the hard work but now devote themselves, basically, to the production of *alebrijes*, discussed later, and also skulls.[4] When Don Pedro was alive the Linares family would make as many as three or four hundred Judases for Easter week, and even went out to sell them on the streets of the city. Nowadays, however, they make barely a dozen and one firework vendor or another will order a few Judases from them; they also make about twenty to be burned in front of their own house in the Merced–Balbuena district of Mexico City.

The custom of burning Judases in Mexico is of Spanish origin (like the ex-votos) and, according to the sources I have consulted, the practice was once common in almost all parts of Latin America. Now Judases can acquire a startling variety of forms, though in most places the Judas figure which is burned, shot full of holes or stoned, is a rag doll badly improvised by the people of the neighbourhood or village.

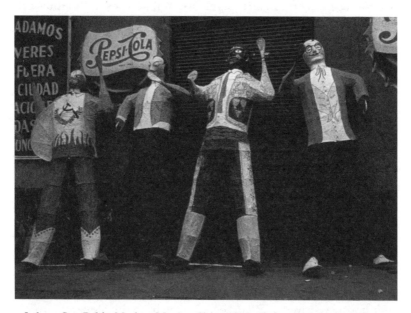

Judases, San Pablo Market, Mexico City, *c.*1953. Photograph by Raúl Flores Guerrero; Fototeca del Instituto de Investigaciones Estéticas, UNAM.

Some authors consider the Judas industry to be one of the most typically Mexican,[5] and I believe they are right: although the custom of Judas-burning exists in many other places, in very few does it involve such a well-structured form of folk art production. The historical point of origin in Europe is uncertain, as is the precise moment the tradition was taken up in the New World. It has been suggested that its primitive roots are pre-Christian and that it is inspired in some way by rites of immolation: it is related, perhaps very obviously, to the ancient rites that have existed all over the world of purification by fire.

In the Iberian peninsula there are the so-called *fallas* of Valencia. It seems that their origin goes back to the sixteenth century: the custom takes the form of the burning of the *parot* (or *peròt*), a wooden device which used to serve as a support for the lamps that lit the carpenter's shops during the long winter nights. For the feast of St Joseph (19 March) and with the advent of springtime, the members of the carpenters' guilds used to burn the *parots* in big bonfires together with other old junk. With the passing of time it became customary to add effigies as a way of expressing social or political criticism. These might represent, for example, the caricature of someone who was the laughing stock of the neighbourhood. Nowadays monumental, sometimes even grotesque, cardboard figures are burned and it is a genuinely ephemeral art of the most elaborate nature. According to Joan Amades, in Valencia Judases also existed in the form of rag dolls inside which fireworks were placed and then shot at, or otherwise torn to pieces after being beaten by the children as if they were *piñatas* and finally burned.[6]

Ramírez de Lucas, writing in 1976, said that the Judases were, properly speaking, 'an ancient Spanish custom of the villages of Extremadura, where nowadays the custom is practically extinct, while in Mexico it is still very much alive and totally incorporated as an integral part of the country's folklore'.[7] That the tradition was still as alive in 1976 as Ramírez suggests is doubtful: it was however certainly more so then than it is today at the beginning of the twenty-first century.

Joan Amades wrote in 1950:

> In Barcelona years ago the children of the orphanage used to congregate on this day in the morning [i.e. Easter Saturday] in the courtyard and play for hours with a doll that they would make believe was Judas. They would treat the doll to countless indignities and finally burn it in the middle of the courtyard.[8]

I also found in the same book what seems to me a pearl of information in terms of both the gender question and the origins of the Mexican Judases:

> In the city of Majorca it was the tradition to burn the Judas which they hung over the middle of the street with a rope suspended between two balconies. Today [Easter Saturday] they would burn him with a tremendous uproar and noise of gunfire and fireworks. Then they would spread the ashes around. Before burning they used to shout at the figures for a good while. It is worth noting that they were referred to in the feminine, i.e. as *las Judas*. The figures were made of rags – the odder and more repulsive the better; it was de rigueur a redhead, and red had to be the dominant colour among the clothes it was dressed in. It used to hold in its hand a bag full of pieces of glass arranged so as to tinkle when it was shaken, as if they were the thirty pieces of silver received for betraying Jesus. They hanged the figure by the neck in memory of Judas committing suicide.
>
> Also in the island of Majorca, in the town of Sóller, they used to hang from a tree a figure in the form of a man carrying a basket which was supposed to represent Judas stealing the figs from the trees: they would shoot at it and afterwards burn it or otherwise destroy it.

The kinship of the Judases of Majorca with those of Mexico seems quite obvious. The obligatory red colour and ugliness were also requirements everywhere. As for the process of burning, the Judases were hung between two balconies in Mexico City as well, while in the countryside they were hung from a tree: the use of squibs and other fireworks is the same, and also if we observe those still made in Mexico today, we find that many have a rope around their necks. Now as far as the use of the feminine – *las Judas* – is concerned, it does not surprise me in the slightest; what does surprise me is that this has not been recorded in Mexico. It is a manifestation totally congruent with the role which women have always played within the Catholic tradition. It is simply a transposition onto the image of Judas of the sinful Eve, the woman treacherous 'by nature'. So after all we find that Judas was not a woman, but he may become one when convenient.

While I have not heard of any other region, apart from Mexico, where Judases are made of cardboard, we do find that in Spain figures called *peponas* are made of this material: in Barcelona and Valencia the popular *pepa* was made until well into the last century and they are very similar to those still made in Mexico, particularly in Celaya in the state of Guanajuato and in Zacatecas where they call them *Lolas*

or *Manuelas*. Perhaps the people who began to make Judases out of cardboard were inspired by the *peponas*. During the nineteenth century Judases were manufactured and burned in Mexico by the thousands. There are eye-witness accounts by Mexicans and visiting foreigners recorded in various writings: 'the Judases that were burning in almost all the streets of the city'.[9] Nowadays, the burning of Judases has to all intents and purposes disappeared: it only very occasionally takes place in particular neighbourhoods of Mexico City, and not in public streets but in interior spaces, for example the patios of old buildings belonging to a university (*casas de cultura*). But above all it is in individual towns and villages of the Guanajuato, Hidalgo, Morelos and Mexico states where burnings are still sometimes celebrated and stalls selling Judases are found on the streets. They continue to be manufactured, despite having become nothing more than 'a traditional Easter Saturday toy',[10] or as decorative objects. Curiosities that find their way into folk art collections inside the country or abroad, they have almost completely lost their original function of being 'burned alive', and have become folk art objects produced fundamentally for the market in this art form.

When Easter week arrives, we no longer see the Judas vendors with their long poles and heaps of multi-coloured Judases all around. Nor do the market squares fill with Judases. But one still finds the occasional stall on the corners of big avenues: every year there are fewer, but they have not disappeared completely. A few can still be found in some markets or handicraft shops, half hidden away and covered in dust among many other curiosities.

The parts of the country where most Judases have been produced are Mexico City and the state of Guanajuato, although they are still made on a lesser scale in some other states such as Puebla, Morelos and Zacatecas.

As with the ex-votos, opinions are totally divided as to their artistic value. For Francisco Javier Hernández, these toys have an 'undeniable artistic quality'.[11] Apparently, for most people, they are merely grotesque figures. The comment made by the Marchioness Calderón de la Barca is interesting:

> Hundreds of these hideous figures were held above the crowd by men who carried them tied together on long poles. An ugly misshapen monster they represent the betrayer to have been. When he sold his master for thirty pieces of silver, did he dream that in the lapse of ages his effigies should be held up in the execration of a Mexican mob, of an unknown people in undiscovered countries beyond the seas?[12]

It is difficult to know whether what seemed so ugly to the Marchioness was the image of Judas itself, or the crude and coarse manner in which the figures were executed.

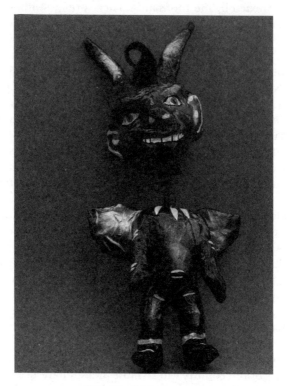

Judas Devil, paper, 2000.

In Mexico the traditional representation of the Judas par excellence is in the form of a devil, very often with wings. Following these we have images which also continually appear of horsemen, gentlemen with bowler hats, *catrines* (foppish rich men) in many forms, clowns, *muertes* (i.e. skeleton figures), and soldiers. But there are also images of a circumstantial nature. During the revolution, for example, Judases appeared representing Pancho Villa and Emiliano Zapata. Nowadays the *catrín* (the rich man) appears in the form of Uncle Sam with a bulging moneybag. Modern Judases also include flesh and blood personalities such as the comedians Cantinflas or Palillo, and figures from the imaginary world of fairy tales, films, especially television or comics, among which Walt Disney characters had

pride of place at one time. Now in the twilight of the tradition, the red devil with his thousand faces reigns once more.

Female Judases are practically non-existent in Mexico. I have never seen a representation of a woman among Judases for burning. But of course the only evidence available is in the form of photographs, engravings and such written records as remain. Now, we find exhibited in museums little female figures such as circus performers and dancers which are not really Judases, but during Holy Week they were sold as Judases, for example those made at San Miguel de Allende.[13]

In an exhibition of Judases, I have also seen a woman entwined with a serpent: obviously it represents Eve. It is a very strange, quite exceptional Judas. I am intrigued by the fact that there are so few female Judases, especially considering that this could have been a splendid way of expressing and manifesting machismo. They could have been used to ridicule women or the female personages most rejected by men. One could have the equivalent of the wicked and treacherous woman who inhabits popular verse and song in such abundance. One could have prostitutes or La Malinche. Judas could have been invoked in the feminine, as in Majorca. But it has not been so. There are references to the female Judases that existed in the nineteenth century, linked to the inversion of social roles of which Beezley speaks, citing in turn Frederick Starr and mentioning the existence of 'male and female Judases'.[14] I found one very interesting piece of information, though unfortunately extremely brief: 'Venezuela is the only country where we have been able to document the burning of female Judases. Any woman whatever may be burned under the name of Judas; or as his imagined wife'.[15] In Mexico they say that among the indigenous Cora:

> ...they make straw dolls dressed with traditional clothing, that represent a male Christ and a female Christ; after they engage in a simulated sex act they are burned on Easter Saturday.[16]

Some female Walt Disney figures appear and also from time to time one comes across a woman in a bikini. I have also seen some Judases made recently by the Linares family that they call Judas-Juana, consisting of a figure with long pigtails and typical regional dress. However she comes not alone but accompanied by her *charro*, the traditionally dressed horseman. Frequently seen in places such as Temixco, Morelos, or on the streets of Mexico City, are the *Judas-catrinas*: female figures in fur coats who are the partners of the famous traditional fop (the *catrín*). The *catrina* can be seen among the few Judases that

are still sold in the plaza (*zócalo*) at Coyoacán in Mexico City amid the infernal din of dozens of wooden rattles, the traditional objects inseparable from Judases.

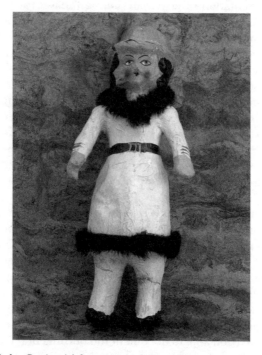

Judas Catrina (rich woman), Celaya, Guanajuato, 1996.

Perhaps the explanation for the scarce representation of women lies in the fact that the protagonists of Judas burning are men. Men used to organize it – traditionally the shopkeepers and especially bakers, who were in charge of the burning itself – and the figures represented were also men. The burning was attended by everyone: men, women, children of both sexes, but men had the active, leading role and the women were mere onlookers or at least that was their public role. Within the family, one can be sure that it was the women who prepared the feast, as generally they prepare all fiestas, doing the invisible work behind the scenes. Today, however, we have an exception: one of Don Pedro's granddaughters, Elsa Linares (born in 1978), who early this century – at the age of twenty-six – organized from beginning to end the burning of some twenty Judases created by Miguel Linares's family in the annual celebration in front of the family home.

She relates that it was a difficult situation because it gave rise to much envy. Also, during the burning she held a lit cigarette the whole time in order to ignite the tapers and this was also severely criticized.[17]

The burning was a public popular fiesta of transgression with much rowdy behaviour and not without violence, typical of male popular fiestas. Above all, this manifested itself in the catching of all the buns, sausages and sweets stuffed into the bellies of the Judases and scattered onto the ground when the figures exploded.[18]

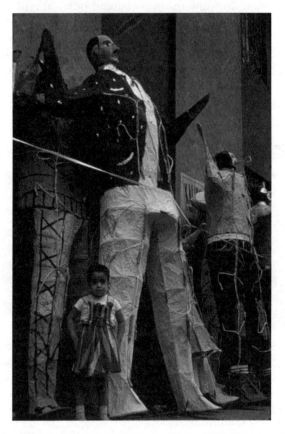

Judases with girl, San Pablo Market, Mexico City, *c.*1953. Photograph by Raúl Flores Guerrero; Fototeca del Instituto de Investigaciones Estéticas, UNAM.

This typical male ritual has a number of parallels: one, similar to some degree, is the world of masquerades and masked dances in Mexico and another is Carnival. The manufacture of masks is an

almost totally male art, though exceptions occur when the widow of an artist, for example, carries on the work of the deceased husband. The masked dancers are all men, even when the figures they represent are female. Also in the case of the Judases the principal creators were men, although women came in to help, and there are many women who today take part in the making of figures or even find themselves doing it on their own.

In the nineteenth century (and even today, although ever less so) the Judases were instruments of social and political criticism. Public personages one wanted to ridicule were represented: generally some politician of the moment. There was no possibility of the representation of a woman, as women were totally absent from activities in the field of public politics.[19] Women had no place in power structures that warranted their being the butt of popular criticism. This is another reason why traditionally female Judases did not exist.

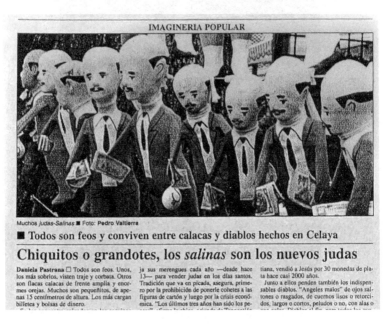

Muchos *judas-Salinas* ■ Foto: Pedro Valtierra

■ **Todos son feos y conviven entre calacas y diablos hechos en Celaya**

Chiquitos o grandotes, los *salinas* son los nuevos judas

Daniela Pastrana □ Todos son feos. Unos, los más sobrios, visten traje y corbata. Otros son flacas calacas de frente amplia y enormes orejas. Muchos son pequeñitos, de apenas 15 centímetros de altura. Los más cargan billetes y bolsas de dinero.

ja sus merengues cada año —desde hace 13— para vender judas en los días santos. Tradición que va en picada, asegura, primero por la prohibición de ponerle cohetes a las figuras de cartón y luego por la crisis económica. "Los últimos tres años han sido los pe-

tiana, vendió a Jesús por 30 monedas de plata hace casi 2000 años.

Junto a ellos penden también los indispensables diablos. "Ángeles malos" de ojos saltones o rasgados, de cuernos lisos o retorcidos, largos o cortos, peludos o no, con alas o

Judas of Carlos Salinas de Gortari, newspaper *La Jornada*, Mexico,
10 April 1998.

Judases were objects of ephemeral folk art par excellence, unlike masks which last and are used over a long period of time. This is a problem when one wishes to make a study of the iconography of the

Judases. As has been said, one has to use photographs and the few examples that remain preserved in collections.

It is because of this same ephemeral nature of their existence in this world that the figures are so crudely made. This is also why they are grotesque and ugly, however they also have to be like this because they represent evil and ugliness of spirit. The devils often have horrible long fangs, although sometimes they are painted with a sweet smile. Almost all the Judases are amusing, even friendly, not perhaps a characteristic that fits very well with the obligatory depiction of Judas as betrayer and villain. They are amusing because they are, more than anything else, the expression of the irony and humour of the people.

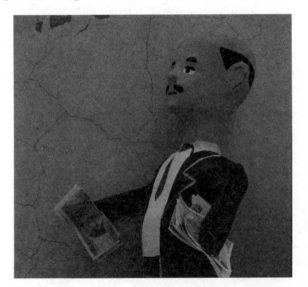

Judas of Carlos Salinas de Gortari, paper, *c.*2002.

Meanwhile, when Judases represent characters from real life, it is not only contemptible but also admired people who appear. Powerful and important personages in the political and social life of the country are represented (but only men, as we have already said). Likewise, admired figures from the worlds of sport, theatre or cinema are recreated and once again the best known of these have been men. One day in 1992 I saw a Judas-Devil with the name of the Spanish singer Miguel Bosé written on its belly. The *charro* is one of the most recurrent figures among Judases, even today, and is said to represent the rich and powerful landowners of the past, thus being the object of hatred.

The figure of the *charro*, some authors tell us, reminds country people of landowners or bosses who have exploited them.[20]

I think this is too facile an interpretation. The *charro* in Mexico can be a rich landowner, but it is also one of the figures most loved and admired by the people. The mariachis, who have become the national musicians par excellence, dress as *charros*. The singing *charros* have been great popular idols of the screen since the golden age of Mexican cinema. The *charro* is also a national symbol: perhaps it is because of this, rather than as a representation of the detested boss, that he appears so often in the figure of Judas. Similarly Cantinflas appears, not because the people despise him, but quite the opposite.

Death – so loved and so feared – is of course another form frequently adopted by the Judases. The *calacas* (skeleton figures) were burned with great pleasure: the greatest, the ultimate traitor. This death always close at hand and present in the life of Mexico, so feared and respected yet amiable as the faithful deceased, has been a very important figure among the Judases.

Judas Charro, paper, Celaya, Guanajuato.

As we have seen, although female Judases are very rare and women have played only minor roles, they are nonetheless present throughout the process of creation and distribution. It is interesting to see that although women create Judases, they do not make them the same as men do. According to a female Judas maker from Mexico City, Guadalupe Ventura Olivares (Doña Lupe), when women make Judases they work differently from men 'because they have their ideas and we have our ideas, in line with how we are'.[21] There is also an important division of labour: in general women do not make big Judases but concentrate mainly on small ones. In 2005, Doña Lupe, owing to her age and health problems, no longer made Judases: she only helped her husband Don Enrique García from time to time, who despite his advanced years continued to make occasional objects out of cardboard.

Doña Guadalupe Ventura Olivares, *Judas* maker, Mexico City, 1993.
Photograph by Eli Bartra.

As for their distribution, men and women without differentiation can be seen selling this fragile folk art presented as cheap merchandise.

Why then has the custom of burning Judases almost completely disappeared, if the figures are still being created? The reasons perhaps

are various. There is reference to the fact that since the mid nineteenth century there have been sporadic government prohibitions on the burning of Judases. In 1853, under Santa Anna's government, the governor of Mexico City ordered that Judases should not be burned if through their dress or some other aspect they could be deemed to ridicule some social class or a particular person.[22] In 1856, during the empire of Maximilian of Habsburg, the people wanted to carry out a general burning of effigies of imperialists and both Judases and fireworks were prohibited.[23]

If originally the burning of Judases was supposed to express the people's hatred of evil or betrayal, in practice what it really represented was satire and mockery. And as there is not always agreement between different social groups and classes over what is and what is not a legitimate target for mockery, the safest measure was to make this 'barbarous' custom disappear. In 1986, a Judas of an enormous effigy of Ronald Reagan with the legend 'I am a Contra' was burned in Mexico City.[24] This has the ring of a political demonstration rather than a folk religious festival, one might conceivably think.

Gabriela Rosas, *Catrina* Skeleton and *Alebrije*, paper, Tacoaleche, Zacatecas, 2009. Photograph by Eli Bartra.

In addition to the above, the fiesta itself used to give rise to all sorts of riotous behaviour that was not well regarded in terms of maintaining social order and the fireworks could also be dangerous. Numerous disasters have taken place as a result of explosions caused by the gunpowder used for the rockets and squibs. Some commentators believe that changes to the Christian calendar were another reason for the disappearance of the tradition of burning. Daniel Rubín de la Borbolla remarked some decades ago: 'municipal and religious prohibitions are finishing off the "Judas" industry'.[25] While the production of Judases has fallen off considerably, it is interesting to note the emergence in the cardboard figure-making craft of a new character to take the place abandoned by the Judases, namely the *alebrije*. At the same time we also find some Judases which could be seen to mark the transition: these are the monster-Judases, beings with cockerel heads and bodies of winged devils, or donkey heads with human bodies.

Gabriela Rosas, *Judas*, paper, Tacoaleche, Zacatecas, 2009.
Photograph by Martín Letechipía.

Tacoaleche is a small village thirty minutes from the city of Zacatecas. There, in the San José del Río neighbourhood, live Gabriela Rosas (born in 1969) and her partner of twenty years, Martín Letechipía, both of whom call themselves 'cultural workers'. They are the parents of three male offspring, aged nineteen, fifteen and thirteen, also artisans. She grew up in Chietla in the *Mixteca Poblana* but moved to Zacatecas twelve years ago. She says that her mother (a Nahuatl Indian) dressed her as a boy and she only played with boy's toys until she was around twelve years old. As a teenager she finally accepted reluctantly that she was a girl. Her father was a peasant who also made wooden masks. Gabi is an extremely versatile person: she makes figures with cardboard and clay and also creates marionettes, as well as participating in puppet plays. Moreover she is a nurse, and today she also likes to give therapeutic massages.

Some eighteen years ago she saw the video made by Judith Bronowski, 'Pedro Linares: Papier Maché Artist', and says that he is her master teacher. Watching him make *alebrijes* made her decide to make Judas dolls and later create *alebrijes* as well. The majority of her Judas dolls are male, the traditional devil with horns, but she has also made some which are female. She distinguishes gender by putting a hat on the

Judas burning, Tacoaleche, Zacatecas, April 2009.
Photograph by Martín Letechipía.

males and a skirt on the females. She does not sign her pieces because she wishes to remain in the 'anonymity that makes all artisans part of one culture'.[26] However, she does feel that a signature can be important in letting people know where a piece was made rather than who made it: 'What I do is *from* Tacoaleche, not *by* Gabriela Rosas'.

To make Judas dolls, she uses newspaper which she buys by the kilo or is given to her free: for details she employs cardboard boxes or heavy paper. She makes a structure with reeds for big Judas dolls and wire for small ones and has to buy the paint. Sometimes she forms the figure and the other members of the family decorate it but never the other way around. When Martín forms a figure he paints it. She never uses a mould, and that is also why she says she makes folk art and not handicrafts.

She takes care not to represent women of the *pueblo* or indigenous peoples in her female Judas dolls, although other artisans usually do. Four years ago she started competing in the contest organized each year by the Instituto de Desarrollo Artesanal of Zacatecas and she has won several prizes. She also organizes the feast of Judas doll burnings every year in her neighbourhood, for which she makes a Judas doll two metres high. She and Martín are truly committed to preserving and reviving popular traditions. The entire family has a project, 'Hilos de la invención' (Threads of Invention), centred around the popular family and children's puppet plays they perform, and for which she makes puppets in wood and cardboard and also wooden marionettes. Fourteen years ago, Gabi created another project, 'Árbol en movimiento. Taller artesanal multidisciplinario' (Tree in Movement: Multidisciplinary Artisanal Workshop), the beginning of her activities in coordinating folk art workshops. Gabi offered the first workshops on *alebrijes* in Zacatecas for the Instituto de Desarrollo Artesanal. In August 2009, another woman gave her first workshop on *alebrijes* for the same institute, Sanjuana España, who is thirty-three years old and from Juventino Rosas in Guanajuato state: she used to make toys with her father.

Gabi makes little Judas dolls fifteen centimetres high, and with a clay head, a traditional form from the past:

> In the town of Nochistlán and in the city of Zacatecas, they used to make little Judas dolls that were children's toys. The head was made of clay, and the body of approximately fifteen centimetres was a small paper cylinder in which they put the firecrackers. The little Judas dolls were dressed with brightly-coloured China paper, and burned by the dozen together with the enormous Judas figures that were exploded

at the church entrance or in Nochitlán's neighbourhoods. The elders of the town say that those popular toys cost ten cents during the 1950s, and today these Judas dolls are being made again in Tacoaleche, Guadalupe.[27]

Gabi Rosas makes Judas dolls of all sizes, from little ones such as they used to make in Nochistlán, to figures more than two metres tall. However, she prefers to make the big figures because 'then I have the time so that they can become what they want to be, and sometimes the characters themselves win'. She thinks that there is a difference in the way men and women create art: each gender has its own style, ideas, colours and designs.

Gabriela Rosas, *Judas, Ando que me lleva el diablo* ('I am having a devil of a time'), paper, Tacoaleche, Zacatecas, 2009. Photograph by Jazmín Márquez.

The main issue for her is being with the people, and belonging to them (an abstraction referred to earlier). She feels that she is part of 'the other culture, the people's, not to the one on top'. After having been a member of different groups and associations, she now belongs to the Frente Popular de Trabajadores (Popular Front of Workers). They have been invited to present their plays for the state governor but she refused, saying 'We are not going to be the buffoons of the powerful'.

She says that she has been engaged in a long struggle over housework, and has expressed to Martín that 'he is not helping me'. However all the family members participate equally now, and she no longer has the burden of doing everything.

Among their many activities is an itinerant museum, 'Museo Siete Lagarto' (Seven Lizard Museum), where they have put their collection of puppets, masks, toys, and dancers from all over Mexico. She would also like to organize a group of women artisans and has just finished a book about the popular toys of Zacatecas. Moreover, she finds time to read extensively.

Gabi Rosas is a fascinating person: energetic, creative, and passionate about the different facets of her life as well as politics and religion. I have the impression that she incarnates the postmodern popular artist of the twenty-first century. She talks about class struggle, the hierarchical differences of gender, sexism, poverty and racism, yet none of these words appear in her vocabulary. She is very much against the Catholic church hierarchy and, though she has no religious affiliation herself, she talks often about spiritual values. She has a very elegant way of addressing all these issues and, in the end, she always returns to the importance of 'the people' and the lore that provides identity to a community.

Gabriela Rosas in her workshop, Tacoaleche, Zacatecas, 2009.
Photograph by Maiala Meza.

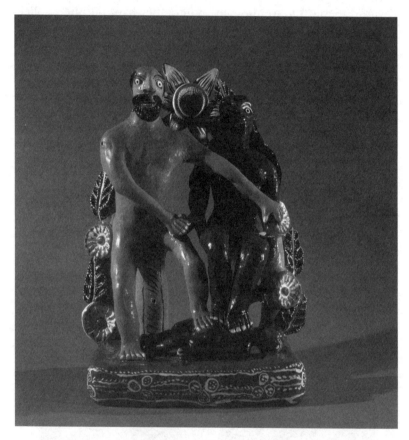

Antonia Martínez, *Hernán Cortés and the Malinche*, polychromed clay,
Ocumicho, Michoacán, 1992; inspired by a mural by José Clemente Orozco.
Photograph by Lourdes Grobet.

Chapter Four

Fantastic Art: *Alebrijes* and *Ocumichos*

Monsters of a thousand colours

What really marks the boundary between fantastic and surrealist art? These two concepts are applied almost exclusively to the art of the elites. Folk art is hardly ever described as either surrealist or fantastic. Are these terms perhaps too sophisticated to be applied to an art regarded as eminently 'primitive'?

Very often it is difficult to apply labels: it can also be uncomfortable and totally inadequate and yet sometimes it is perhaps necessary. The surrealistic and the fantastic elements in art are two of the most difficult to define. For example Frida Kahlo's work was described, early on, as surrealist. Furthermore it was André Breton, the patron saint of surrealism himself, who was the first to do so. However, as is well known, she rejected the label and never identified her work with the surrealism of the day.

In folk art we find clear manifestations of what can be called fantastic art and even, perhaps, surrealist art. Both make use of considerable amounts of imagination. Fantasy is almost pure invention, pure deliberate and conscious imagination: surrealism relates rather to unconscious processes and the world of dreams, and for this reason is often far removed from any logic other than its own. Surrealism may be a personal search for the real. By allowing ideas to flow or come to the surface without the interference of reason, it is supposed that one obtains genuine thought. Both fantastic and surrealist art appear at times quite absurd, because indeed it seems absurd to remove something from its place of origin and put it elsewhere: logic and common sense tell us that urinals do not belong in glass showcases and that teacups are not furry.

Although generally one does not talk of surrealist folk art, plentiful examples of it do in fact exist. In Mexico *alebrijes* and *ocumichos* can be considered principally fantastic art but at times they are also surrealist. Ex-votos also can often appear surrealist.

The *alebrijes* of the Linares family of Mexico City are figures in cardboard, sometimes with a wire reinforcement: they are made in various sizes (from fifteen centimetres to one metre tall) and represent the strangest of monsters, quite extraordinary, fantastic, multicoloured beings. All sorts of paper are used in their creation: brown paper, kraft, manila, newspaper, thin China paper, and cardboard for the details. They are painted with acrylic colours and finally an acrylic gloss lacquer is applied.

In Arrazola, a village in the state of Oaxaca, *alebrijes* are also made, except these are made of wood, painted with less brightness and variety of colour and also without the glossy varnish. Most of them are simpler in terms of the level of imagination invested to create a monstrous creature. Here, it is usually the men who do the work of carving the figures out of copal wood and the women who carry out the painting.

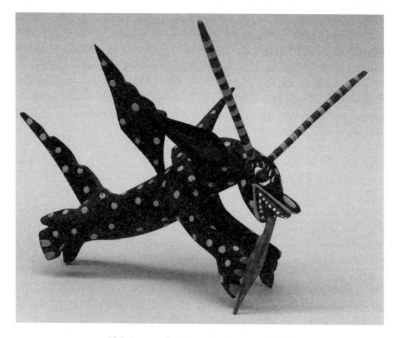

Alebrije, wood, Arrazola, Oaxaca, 1998.

Don Pedro Linares used to insist that *alebrijes* were his own invention,[1] and not only the objects but also the underlying concept. Of course, strange and monstrous zoomorphic figures have existed in very different cultures throughout history, all of them representations of evil. The Minotaur of Greek mythology is probably the first that comes to mind; Scylla is another. The scores of gargoyles that sprout all around Gothic churches represent monstrous beings. The *dracs* of Catalan folk festivals, gigantic monstrous dragons made of painted cardboard, remind us of outsized *alebrijes*, as do the dragons of Chinese festivities. An art history review of the planet, picking out the many thousands of monster figures that have inhabited it, would result in an immensely long list.

The *alebrijes* of Mexico correspond to the type of folk art that has no immediate practical function. Magical though they may appear (and there are people who attribute to them a magical value), the purpose behind their existence is purely and simply ornamental: this characteristic, of course, makes them comparable to the art of the elites, and differentiates them from ex-votos, whose main function is religious, and the Judases, created to be burned as traitors. As we have seen, most folk art is made to fulfil some function beyond that of merely being contemplated. Not *alebrijes*, however: they are made only to be purchased and admired.

Their cradle was humble. They entered the world – as had so many Judases – from the prodigious hands of Pedro Linares. It is fair to suppose that in view of the prohibitions on the burning of Judases and the rapid decline in their consumption, Don Pedro was looking for something new to which he could apply his skills, and – assisted by chance and the breadth of his unbridled imagination – he created the *alebrije*. On the website designed by his granddaughter Elsa Linares, one reads that when Pedro Linares fell ill at the age of thirty and became delirious, he dreamed that he was in a strange place and 'saw a donkey with butterfly's wings, a cockerel with bull's horns, a lion with an eagle's head, and all these animals were shrieking at him just one word "*Alebrijes!*" Each animal screamed louder and louder, "*Alebrijes! Alebrijes! Alebrijes!*"'[2]

Nowadays these fantastic creatures are being manufactured by both men and women. Don Pedro's wife only helped, but his three sons Enrique, Felipe and Miguel learned the art from their father. Now, in Miguel Linares's family, it is different: his wife Paula García makes *alebrijes* and many other items such as *calaveras* or *piñatas* and has herself been creating figures, generally on her own, for more

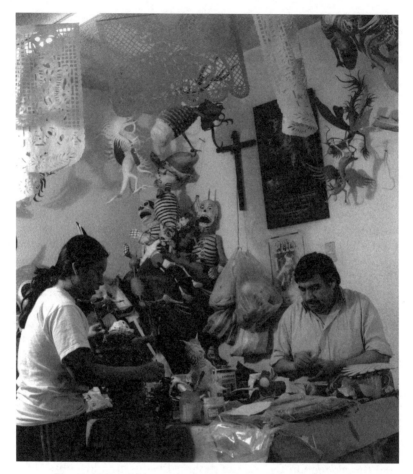

Elsa and Miguel Linares in their workshop, Mexico City, 2004.

than fifteen years. Her two daughters, Elsa and Blanca Estela, and her son Ricardo, have also learned the art of making cardboard figures. Blanca got married and abandoned the art for a time, but a few years later she separated and went back to her parents' home and the craft. As we have already seen, in some families the work is divided so that the women make smaller Judases and the men work on the larger ones and the *alebrijes*: this is more common in families with limited resources.

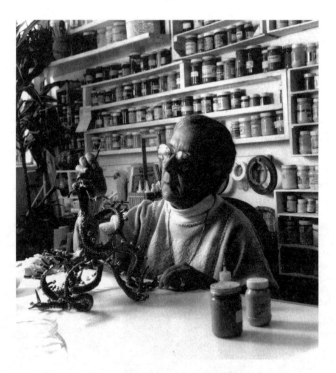

Susana Buyo, Mexico City, 2004.

In the case of the Linares family, the women participate in the work of cardboard modelling in four different ways:

1. in a minor helping role (Don Pedro's wife, or Don Miguel's wife at the beginning).
2. in a major helping role, participating in the whole process except for the final decoration (when there is an urgent order for an *alebrije*, Miguel and his daughter Elsa set to work together on the painting).
3. in a situation of equality with the men, whether fathers, husbands or brothers. (Nowadays, in Miguel Linares' family, although Don Miguel is the acknowledged master craftsman, he and Ricardo, and the women – Paula, Blanca and Elsa – work together on an equal footing throughout the whole process.)
4. where it is the women who take their own decisions about their work, take orders, organize public relations, design websites and keep accounts (this is the case with Paula and Elsa).

According to Susan Masuoka, at first the tendency within the family was for the men to devote themselves to creating art, while the women produced folk art.[3] I believe, however, that it is certainly different today and creativity is expressed in a quite equal way by all family members.[4]

There is also the case of a middle-class woman of Argentine origin living in Mexico City named Susana Buyo, who devotes herself to making *alebrijes*, teaching classes in cardboard work and running demonstrations of how the figures are made. This is very interesting because here we see the phenomenon of a folk art being adopted by people who belong in some way to the educated elite, thus converting it into an art made by and for elites.

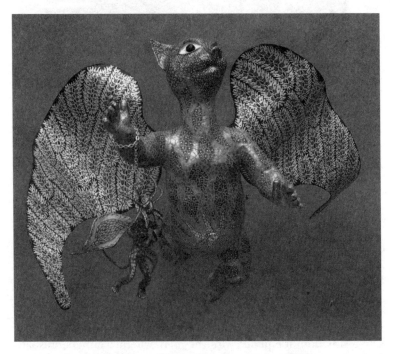

Susana Buyo, *Alebrije with wings*, paper, *c.*2004.

The *alebrijes* made by the Linares are, it seems, improvisations. There are no preliminary sketches and perhaps not even a clear image exists in the artist's mind; the figures emerge gradually as the hands go to work. Elsa and Miguel Linares comment on the fact that there are no rules for making an *alebrije*, only the basic rules of working with

cardboard. In the case of Susana Buyo, the process is the same, as she explains: 'they [the *alebrijes*] always have their own way and while I'm constructing them, they change their forms and their colours'.[5]

On the face of it, the *alebrijes* made by the Linares are sexless monsters, there being no external markers to help us determine their sex but nevertheless my own impression is that these fantastic beings are really very macho. Personally I don't see them as being creatures without sex: they seem decidedly male monsters, in part perhaps because many of the elements they bring together seem characteristic of male animals, or perhaps just because of their poses and attitudes, although it is quite possible that they are created without any conscious intention regarding sex. It is necessary at this juncture, however, to point out there are differences between the *alebrijes* created by women and those made by men. One might say that the former are less ferocious, their attitudes less aggressive or terrifying.

On this very question of whether *alebrijes* have a sex and if they are male monsters, Elsa told me 'I am really quite feminist and I don't believe they are all male; if I did, I wouldn't make them'. As for Susana

Elsa Linares, Mexico City, 2004.

Buyo's *alebrijes*, as the artist herself remarks 'Mine are sexed: they have penises, breasts, their expressions come out as feminine or masculine as my feelings about them dictate'.[6]

Elsa Linares thinks there are clear gender differences in approaches to working. Of course she can only speak of her own family: she says 'My mother is maternal, she sits on a stool almost level with the ground and sort of curled up in a ball'. Her father, on the other hand, sits on a very high stool. In addition, her mother spends considerable time on each piece, much more than her father does, perhaps out of perfectionism or perhaps because she feels less sure of herself, more hesitant.[7] She states, however, that there is practically no difference between her brother and herself in what they do and the way they do it. The only point she notes is that he likes to finish off his pieces with very ferocious teeth, for example.

Indeed, from my observation in the Linares studio, the difference in the degree of ferocity in the *alebrijes* they make is quite noticeable. For the last fifteen years or so, Elsa has been making *alebrijes* entirely on her own. Meanwhile she was also studying systems engineering and she wrote to me the following:

> We women are the ones who decide to do handicrafts or work on handicrafts, and to achieve what we set out to do, but we are also the ones who impose limits on our imaginations and dreams [...]. I would like other craftswomen (and women in general) to know that there is nothing we can't do, and also that we can break the vicious circle of repression, maltreatment and mediocrity.[8]

Elsa thinks that, for women, one of the great advantages of working in craft like this is you can do it at home: it is more comfortable, there are no fixed working hours and you can keep an eye on the children while you do it. In other words, the women of Elsa's household take for granted that they are responsible for both domestic and artistic work: thus the day's double day takes place in one and the same space. Regarding the double day, Elsa says:

> Here everyone washes their own clothes, cooks, makes beds and other things like that, but as for keeping the house clean, I'm afraid, we do it between Mom, my sister Blanca and myself; not because we like doing it, of course, nor under some kind of order or obligation, but just because if nobody else does it, if no one else washes the dishes or cleans the bathrooms.... Well someone has to do it, just for the sake of mental health or out of common sense, and that's the way it is.... It's unfair, just like in many other homes around the world.[9]

All the *alebrijes* made by the Linares family carry their maker's signature. Don Pedro used not to sign them to begin with but later started to do so and at first Paula García was also reticent about signing her work, but she was told the work was hers and so she ought to sign it. Now everybody signs his or her work.

It is no surprise that this process of adaptation happens to have occurred with *alebrijes*, given that these are the most sophisticated of creations. As sophisticated, one might add, as the devils of Ocumicho which have become the favourite of favourites perhaps for this very reason.

Alebrijes can be purchased in the handicraft shops of Mexico City and in some outlets abroad and, regarded as folk art, they are relatively expensive: production is limited, the time invested is considerable and, as always, intermediaries' profits increase prices. Very large *alebrijes* are difficult to have in the home unless the house is very big, and so they are mainly bought by museums and other institutions: very often their final destination is in Europe (the UK, France and Germany) or the United States.

Ocumicho, Michoacán, 2004.

Laughing little devils

Ocumicho, a village of dust and mud: winters of dust, summers of mud. And it is this dust, this earth which women have exploited, turning it into marvellous polychrome clay sculptures.

The Purépecha village of Ocumicho, with its approximately five hundred families, lies about a hundred miles to the north-west of Morelia in the state of Michoacán. The origin of the name is as much a mystery as that of the village itself or indeed of its productive and artistic activities. Each of the authors I have consulted gives a different account. Some say that the word *ocumicho* means 'place of tanners': so originally it was a village of tanners.[10]

Nowadays no animal skins of any kind are tanned: there are no animals in the area whose skins might be worth tanning. Nor do they fell many trees, as there are barely any trees left. Today the principal activity is that of women. A few little fields are cultivated and what wood can still be found is used.[11] Those men who can go north: if luck turns out to be on their side, they can build a house of bricks and mortar on their return.

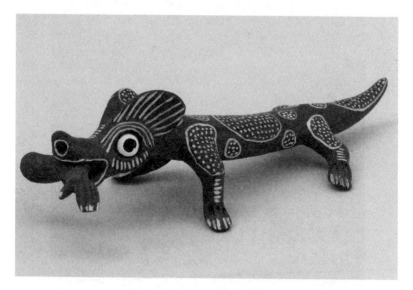

Lizard with arm, clay, Ocumicho, Michoacán , 2003.

Apparently the men of the village ceased to tan hides during or immediately after the 1910 revolution and reportedly it was in the late

1920s that the pottery business began, mainly involving women.[12] It is very likely that the activity already existed before this period but that following the decline of tannery it developed as an important economic and artistic occupation. One person interviewed from the village said that pottery already existed 'before baptism' (a phrase that can be taken to mean 'as old as the hills'). In past ages they mainly made whistles and piggy banks for the community's internal consumption and for that of nearby towns and villages. They still make them today, but production has increased enormously in quantity and variety of figures.

Legend has it that one Marcelino Vicente (who was born around 1940 and died in the late 1960s) provided a creative driving force in pottery and 'taught' the women of the village much through his example. They say he was 'a very odd sort of man', living alone, making his own tortillas and doing women's work: pottery. It is said he was the first to make devils and today they are the speciality of the village's women. The local people themselves confirm that he taught them to make the devils. However other people interviewed, both in Michoacán and elsewhere, insist that the women of Ocumicho have always made devils and that it is not true they were taught by Vicente.

In the Regional Folk Arts Museum in Pátzcuaro there are some devils from Ocumicho, unfortunately without signatures or dates, but which could easily be as old as the museum itself, some sixty years or more. If this is true it bears out the assertion that devils were already being made before Vicente's era. But whatever the real origin of the devils of Ocumicho, the fact is that they are now famous in Mexico and abroad.

I am convinced that *ocumichos* are the most fantastic and often surrealist art works existing in Mexico. They are a genuine fountain of imagination. Hence, perhaps, the fact that so much effort has been made to prove by all possible means that the women of the village did not invent them and that not even those produced today can be considered in any sense the product of women's imagination. Time and time again one hears about external influences and there are also attempts to show that the idea behind the devils originated elsewhere and that the basis of the erotic pieces they make – these will be discussed later – was copied from foreign magazines. This attitude is very common where folk art is concerned, and in this case – it being an art of women – certain people find it of utmost importance to portray the few men involved as the masters and not recognize the imaginative capacity of the scores of women involved.

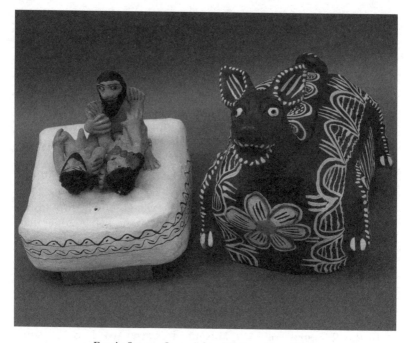

Erotic figure, Ocumicho, Michoacán, *c.*1998.

In Ocumicho, a wide variety of pieces are made: from whistles and piggy banks in a multitude of forms to Virgins, *huares* (women dressed in traditional costume), scenes from daily life, carousels, suns, moons, animals, mermaids, last suppers, nativity scenes and of course devils. The pieces range in size from a few centimetres to one metre. Very often the subjects are mixed together. There are last suppers attended entirely by devils and last suppers with mermaids: thirteen mermaids neatly seated around Jesus. Some little devils are money boxes and others are not. There are also clay devil masks, Black masks and little old man masks.

When they recreate scenes from everyday life – such as weddings, births, operations, peasants in the countryside – they make pieces that might appear surrealist but in fact are realist. There is, for instance, one that shows a peasant sitting in his corn field next to a dead don-key with its entrails hanging out and in the foreground a pumpkin with holes, both full of enormous maggots. It is not supposed to be a dream or a deliberate act of surrealism such as Buñuel might have created: it is a recreation of day-to-day life, of the life and death that

surround the artists. In this sense, some of these pieces would be closer to the crude realism of Frida Kahlo, for example, than to the surrealist visions of Remedios Varo or Leonora Carrington. Other pieces however could, I believe, enter into the category of what has been called surrealism, in particular those that involve little devils.

For me the most interesting items of all this production are the devils. They, too, represent scenes from imaginary or religious daily life. Anything is possible. The devils ride bicycles, sing, dance, play instruments, board buses or aircraft, eat, drink, drive trucks loaded with Coca-Cola, catch the donkey, carry out a caesarean in an operating theatre, eat corncobs or fish sitting next to a dark sun or make love: and at the same time, all of them are laughing. It is fabulous. These little devils who devote themselves to playing pranks around the world, dying of laughter, are it seems inspired by the flesh and blood dancers made up as devils, hermits, and Blacks who appear during Christmas shepherd plays, constantly laughing and fooling around in the dusty streets of the village.

> One of the most important syncretic experiences in our cultural memory is the presence of the devil at fiestas and carnivals. The devil is a character who appears in almost the whole of our festive universe embodied in the vitality, joy, craftiness, sarcasm, irreverence, rudeness, eroticism, sensuality, caprice, sin. As a prototype of the festive condition, this character wanders about dancing, seducing, telling stories, singing to a guitar, drunk, delighting the spirits of the fiesta.[13]

The devils of Ocumicho are also highly erotic. A large majority of them have phallic objects in their mouths: they are often seen eating bananas, corncobs or fish, playing the flute or trumpet, and they are always falling about with laughter. They may often be found in positions of amorous embrace or mounted upon some other figure, which could be a tortoise, mermaid or almost anything.

At the same time there is extensive production of erotic pieces that represent zoomorphic or fantastic figures, or devils, which, on removing a lid, reveal a couple, of human beings or devils, making love. Often not just a couple but a threesome. Generally they are pink-skinned people, although there are also brown-skinned figures: the observable tendency is that they are white, bearded men and white-skinned women and they appear in every position imaginable. These are referred to as 'covered' or erotic pieces. This kind of production is often carried out to order and at night, the artists hiding the work under their beds.

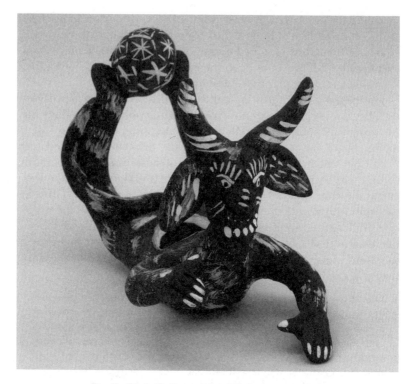

Devil with ball, Ocumicho, Michoacán, *c.*1992.

The origin of this production of erotic pieces is another mystery: everything which has been said about the matter is pure speculation. What is undeniable is that, for all their fame, in a certain sense of the word they are prohibited. The makers are told by the nun of the *yurishio*[14] it is bad and they shouldn't make these things: some pay heed to what she says and others do not. It is difficult to believe that out of the poverty-stricken lives of the women of Ocumicho, their hard struggle not so much to make a living as simply to survive, in moments stolen from the endless morning, noon and night tortilla-making, surrounded by the hosts of children that have emerged from their bellies, can spring such a dynamic, colourful, amusing and erotic art, and that from these houses dark as caves should emerge hundreds of jovial multicoloured little devils, destined to lighten the hearts of people so far away from that world.

The devils, like all the pieces – except the piggy-banks and whistles which are made with moulds – are modelled by hand: previously only

moulded pieces were made, but 'now we make them out of pure feeling', as one of the potters said, and they are fired in the wood-fuelled ovens that each has in their home. At one time the village had a communal oven, but not today.

Some figures are made with greater skill than others. This is only to be expected, some artists being more skillful and imaginative than others. The clay is fired at a relatively low temperature and thus the figures are extremely fragile. They are taken out and painted, and finally varnished. The women generally prefer not to varnish the pieces, but the people who buy them would rather have such a finish, and so the women usually comply. The paints they use are aniline dyes mixed with lime, or emulsion or oil paints. They use pure unmixed colours, strident as the clothes worn by the women themselves.

Siurell, Dog, clay, Sa Cabaneta, Majorca, Spain, 1993.

It is curious when one compares art products (whether folk art or not) of different epochs, countries or ethnic groups, and finds astounding similarities. Or perhaps not so astounding, since at times it is simply a matter of common origin.

We return now to Majorca in the Balearic Islands, where hand-moulded clay figures are produced, shaped by the dictate of fingers. After firing they are coated with lime, then painted in stripes which are almost always green and red. They are actually whistles and called *siurells*, a dialectal form of the Catalan word for whistle (*xiulet*). 'They are manufactured throughout the year (in the villages of Sa Cabaneta, Pòrtol and Inca) especially by women and children'.[15] Just as in Ocumicho, the figures represent peasants with hens, or peasants in hats riding a horse or bull. They also make peasant women, a variety of animals such as owls and occasionally typical Majorcan cottages with a windmill. Other subjects include births, loving couples and market vendors. They are rather crude figures, like *ocumichos*, and the similarity is really quite considerable. Sometimes daring modernities such as motorcycle riders or baseball players are also made. The most significant similarity is that the Majorcans also make little devils:

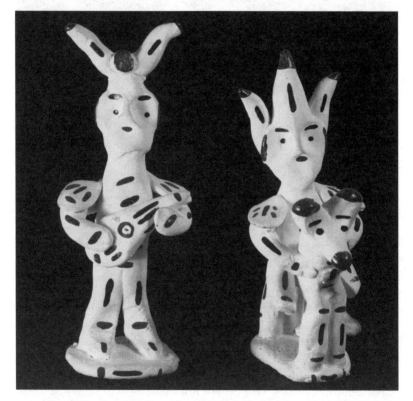

Siurell, Devil and Indian, clay, Sa Cabaneta, Majorca, Spain, 1993.

they make very many. There they are with a gallows in their hands, or a guitar or trumpet, on foot or on horseback. And they do not varnish the pieces except when they want to 'enrich' them, or perhaps when they are specifically asked to. Above all it is interesting to observe that many of the devils of Ocumicho have stripes over their whole bodies, and there are those who say this is because in pre-Hispanic Mexico the Purépecha Indians painted stripes over their bodies in a particular way so as to distinguish themselves in battle from other ethnic groups who painted themselves differently. The stripes on the *siurells* are much simpler than those of the *ocumichos* which are curved and more complicated. But still the resemblances are undeniable. We see, for example, the figure of a little dog standing on its hind legs with a gallows between its paws. It has more the face of a devil than a dog and appears very much like the devils of Ocumicho (although this one is not laughing): it even has the phallic-looking object in its paw.

In the villages of Sa Cabaneta and Pòrtol, in the heart of Majorca, there are still a few women who make *siurells*. At one time, the village children used to consume them to use as whistles: now they are only made as ornaments and sold around the houses of the villages where they are made or in the tourist shops selling 'curiosities' and handicraft objects in the towns of Majorca and the peninsula. Are these resemblances merely a matter of chance?

There are two possible explanations. The first is that it is mere coincidence, since world art history is full of repetitions of styles, forms and subjects, or contents, which appear at different historical moments and at very distant points of the globe – even in the same place and at the same time, but with different creators unaware of what others are doing. The second considers the possibility of production established in one place being taken to another where it serves as inspiration or model, and can thus be regarded as the origin of a particular production in the second location. Sometimes it is very easy to find the most probable explanation and at other times not so easy.

In a similar context, the resemblance between the *siurells* of the Balearic Islands and the votive statues of the Iberian sanctuaries of Andalusia has been noted (and a primitive magic has been attributed to the *siurells*).[16] Thus we find that if the origin of the *siurells* is possibly to be found in Iberian ex-votos and if the origin of the *ocumichos* is to be found in the *siurells*, then the Catholic painted ex-votos already discussed and the figures of Ocumicho share a votive relationship which at first sight was not appreciable. I have the impression, however, that we are going round in circles.

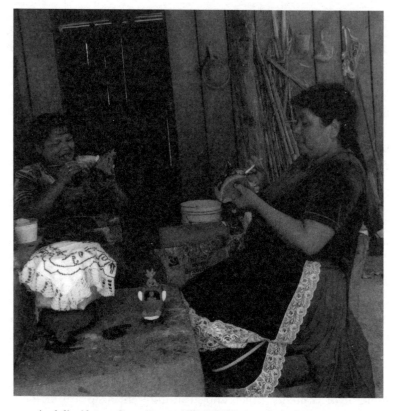

Audelia Alonso González and Eudelia Quiroz Rafael, Ocumicho,
Michoacán, 2004.

In Ocumicho, there is a clear division of labour. The women are
the artists and occasionally, when they are at home, the men (sons,
partners) 'help'. They help by hauling the clay to be found a few miles
from the village; they help paint the figures known as *monos* (a dispar-
aging word generally applied to any crudely-made figure, doll or the
like), and help sell them. Nonetheless – maintaining the lineage of
the mythical Marcelino Vicente – there are a few male clay sculptors.
These are precisely the artists who enjoy most fame and whose names,
lives and miracles are best known: on the basis of these names a some-
what distorted image of the real situation is created. The impression is
that they are the authentic masters, not only of their own wives but of
a whole village of female sculptors. What is undeniable at the moment
is that the men are becoming involved little by little in the process of

creating the pieces: but they are learning as adults because the technical training does not form part of the socialization of male children, whereas it does in the case of girls.

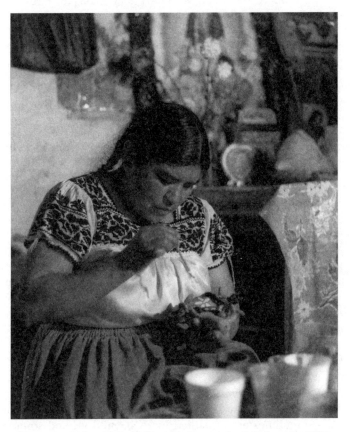

Genoveva Quiroz Rafael painting, Ocumicho, Michoacán, 2004.

There are visions so androcentric that when referring to Ocumicho they are simply unable to name the creators of this feminine art: for example, in one book the *craftsmen* or potters of Ocumicho are always referred to in the masculine form.[17] Another example is the article in *México Indígena* previously cited, where special attention is paid to the male artists who achieved particular renown, such as Teodoro Martínez Benito and Marcelino Vicente himself. Nonetheless, there are other writers who are aware of the truth: Eduardo Galeano, for example, who also puts it beautifully:

Like the Chilean *arpilleras*, the little clay devils of the Mexican village of Ocumicho are born from the hands of women. The devils make love, in pairs or by the multitude, and go to school, ride motorbikes and pilot airplanes, worm their way into Noah's Ark, hide among the rays of the sun who is the moon's lover, and even – disguising themselves as new-born babies – slip into the Nativity mangers. The devils lurk under the table of the Last Supper, while Jesus Christ, nailed to the cross, eats fish from the lake of Patzcuaro together with his Indian disciples.

As he eats, Jesus grins from ear to ear, as if he had discovered that it is pleasure rather than pain that will redeem this world.

In dark houses without windows, the female potters of Ocumicho model these luminous figures. These women, tied to their incessant children, prisoners of men who get drunk and beat them, make a free art. Condemned to submission, fated to sadness, they create every day a new rebellion, a new joy.[18]

Nowadays some of these women sign their pieces: speaking to them one realizes that they are fully aware of the importance given to their signatures in the art market and so they write their names, and not without pride. Generally, however, they only sign their work if specifically asked to, and most of them continue to leave their figures unsigned. In any event, if pieces lack a signature when they arrive at the handicrafts centre (*Casa de las Artesanías*) in Morelia, for example, one notes that a sheet of paper is placed over the item with the name of the artist (or artists): sometimes a single piece carries the names of a woman and a man, showing the work involved to be of a collective nature.

Ocumichos can be bought very inexpensively in the village itself, or in fairs at nearby towns: also, of course, in the folk-art shops in cities such as Morelia, Monterrey, or Mexico City rather less inexpensively. Often the women who make them take their boxes of devils and other figures – sometimes accompanied by their children and sometimes not – and get on the bus and travel long distances to sell off at a non-remunerative price those remaining pieces not broken, as many are, on the journey.

They also make them to order. Someone arrives for example, sees the Virgins and likes them, then asks for a hundred and fifty. In general these are intermediaries who will resell the pieces to shops specializing in folk art.

A considerable proportion of the clay sculptors are affiliated to the National Union of Peasant Craftsmen (*Unión Nacional de Artesanos Campesinos*), which is a branch of the National Peasant Confederation

(*Confederación Nacional Campesina:* CNC): they are real card-carrying members. Many also belong to the National Fund for Handicrafts (*Fondo Nacional para las Artesanías:* FONART). Belonging to the union facilitates access to the channels of distribution (the union basically exists to market products). In the village itself people say that some union members do not carry out all of the work themselves, buying from others already fired figures which they just paint and sell. This is not well regarded: many insist that one ought to carry out the whole process oneself, not just a part.

On no account must one imagine that all is peace and harmony in this simple indigenous community far from the ferocity of capitalism. Competition, be it capitalist or not, is rife in the very heart of the community. There are great rivalries of many different kinds among the potters, for example between those who belong to the union and those who do not; those who engage in the whole process of production and those who do not; those who are famous and those who are not.

The CNC was traditionally controlled by the Partido Revolucionario Institucional (PRI), the party that ruled Mexico for over sixty years, but the potters, although they belong to the union, vote for the Partido de la Revolución Democrática (PRD), the party founded by the state's former governor Cuauhtémoc Cárdenas: they insist that everyone in Michoacán votes for the PRD and every man and woman in Michoacán is *Cardenista.*

'High' art in Ocumicho

In 1989 the Casa de México in Paris, then directed by Mercedes Iturbe, commissioned a series of figures on the French revolution in commemoration of its 200th anniversary. The women were shown pictures of the revolution and so the new imagery travelled from Ocumicho to Paris. In 1992 the same person repeated the experiment by showing the Purépecha sculptors works of 'high' art. On the occasion of the fifth centenary of the Spanish arrival in America, the women of the village were shown old European engravings about the conquest, photographs of fragments of twentieth-century Mexican murals, photographs of codices made after the conquest, and were commissioned to 'copy' or use them as inspiration for figures. They executed a whole collection of pieces on the subject of Hernán Cortés's conquest of Mexico.

A few pieces remained on exhibition in the village *yurishio* and the rest departed for Spain. In March 1993, Barcelona's Ethnological Museum mounted an exhibition consisting of around thirty of these pieces under the sophisticated and even misleading title of 'Arrebato del Encuentro' (which might be translated roughly as 'the Captivation of the Encounter').[19] Had the little devils of Ocumicho with their big smiles conquered old Europe?

On the card accompanying each piece was the name of the woman who had made it: in this case, therefore, we are definitely not dealing with anonymous folk art.

These figures, which I shall examine in some detail, are a clear expression of the cultural syncretism referred to above. The artists of Ocumicho looked at the models they were shown and then translated the information into their own language, the one with which they normally express themselves in their clay sculptures. An identical process takes place in the reproduction of Frida Kahlo's paintings in Ocotlán, and the carpets made from famous painters' designs in Teotitlán del Valle, as we shall later see.

One of the curious questions arising from the clay figures of Ocumicho concerns the interpretation the artists make of history. The French revolution or the conquest of Mexico must be for them equally abstract and devoid of meaning. They were also shown a number of reproductions of paintings and engravings (European or Mexican) from other periods. European engravings of the sixteenth, seventeenth and eighteenth centuries, fragments of murals by José Clemente Orozco and Diego Rivera, as well as reproductions from the Florentine, Yauhuitlan, and Diego Durán codices, served as models for their rendering of a historical event in clay. In other words a *multiple* process of reinterpretation took place. The images in all these models are already subjective reinterpretations of other interpretations of a historical event; one where our knowledge lacks absolute exactitude. Therefore it is important to take account of the temporal and cognitive gap separating the figures of Ocumicho from the events they commemorate, since their models already represent a whole series of interpretations, their own being the culmination. Thus, on the basis of these sources of information the important task is to see how the women of Ocumicho interpreted the historical event of the conquest of Mexico and how they integrated it into their characteristic imagery.

It is interesting to take note of the scale of values – with respect to skin colour, for instance – that several of the artists display in certain pieces. María Luisa Basilio, in 'Our Lady of Guadalupe with

personifications of America and Europe' (based on an allegorical oil painting of probably colonial origin), gives the indigenous Virgin white skin. Then America at her side – in the original seemingly neither dark-skinned nor even very Indian, as far as one can tell – is shown with very dark skin, almost black, and dressed in Indian attire: in other words, the artist is aware that America is Indian, but the *Virgencita* cannot possibly be Indian and must be a white lady. Perhaps making her dark-skinned would be felt to degrade her or make her less sacred.

There is another white Virgin of Guadalupe by Carmela Martínez, who also adds the invention of a Mexican flag. The combination of *Guadalupanismo* and nationalism is well expressed in this work of folk

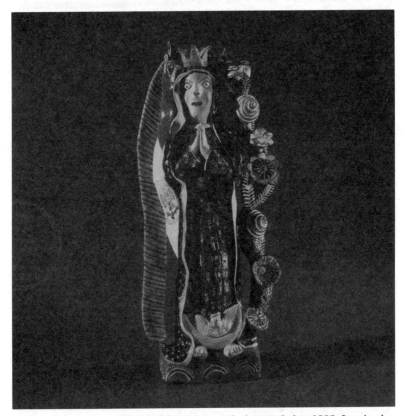

Carmela Martínez, *Virgin of Guadalupe,* polychromed clay, 1992. Inspired by a painting of the Virgin of Guadalupe of 1531, Metropolitan Cathedral, Mexico City. Photograph by Lourdes Grobet.

fantasy. The same Carmela reproduces Huitzilopochtli but with a devil's head. This is incredible as one supposes she does not know who this god was: perhaps someone told her it was some kind of devilish heathen idol and this is why she represents it as a devil. There is another Virgin of Guadalupe made by Magdalena Martínez which is indeed brown-skinned, but she makes the Indian Juan Diego very white.

In the massacres of Indians depicted by Guadalupe Álvarez and Bárbara Jiménez, the Indians are completely white. Of course we also find classical models in which the Indians appear perfectly white and rosy-cheeked, such as the painting by Antonio Solís.

Florentine Codex, *Slaughter of Indians in the party.*

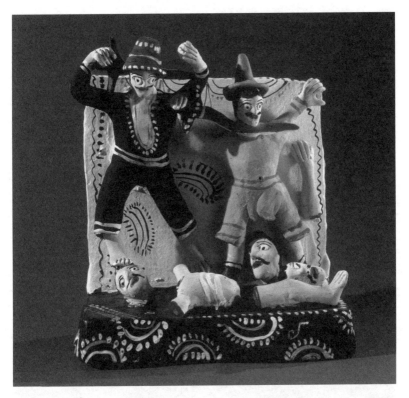

Guadalupe Álvarez, *Slaughter of Indians in the party,* polychromed clay, 1992. Inspired by the Florentine Codex. Photograph by Lourdes Grobet.

There are artists like Virginia Pascual who depart freely from their originals: while it is true that she makes the Indian couple dark, she introduces animals such as a donkey and cockerels that are not in her model 'First Encounter of Cortés with the Emissaries of Moctezuma'.

A woman signing herself 'Sabina' made a copy of a seventeenth-century ivory figure of the Virgin of Guadalupe in which, obviously, the original is white, but took the liberty not only of making her brown but also adding two flower vases with calla lilies and, in addition, the little angel bearing the Virgin in the original becomes an Indian figure (it could be either a man or a woman, or as it represents an angel perhaps it is intended to be sexless). Even in the remote village of Ocumicho the fashion for calla lilies, now found all over, has arrived.

A 'Baptism' by Rutilia Martínez shows the priest as a smiling devil. The original is a painting by Miguel González in which four persons

appear: the priest, a man and two other individuals of indeterminate sex. For Rutilia they are three little devils and a kneeling woman who is about to be baptized. The degree of liberty enjoyed by the artist is astounding. One imagines no priest being amused in the least to appear as a smiling devil about to do mischief. Another of her figures represents one of Cortés's caravels to which she adds what looks like a Mexican flag (red, white, and green) and shows the Spaniards as swarthy and bearded, wearing what closely resemble Mexican hats.

Baptism.

Paulina Nicolás copies from the Florentine codex a scene in which Moctezuma seems to have a beard. She gives the Indian a beard and in contrast makes the Spaniard clean-shaven. In the original, Malinche wears the ends of her plaits on top of her head and it looks as if she has little horns. The artists of Ocumicho have no trouble at all in making horns and so here Cortés's indigenous mistress is represented with devil's horns.

There are two versions of a fragment of a mural by José Clemente Orozco where Cortés appears with Malinche and an Indian lies at

Rutilia Martínez, *Baptism,* polychromed clay, 1992.
Photograph by Lourdes Grobet.

their feet. One is by María de Jesús Basilio, showing the Indian as white: in the other version, by Antonia Martínez, the Indian is brown.

In the Florentine codex the Indians look like Europeans and are as white as Cortés. From this model Paulina Nicolás makes the Indian women brown and to the female nude with its back to the viewer in the original she adds a pair of knickers. She must have disagreed with the nudity.

María Luisa Basilio, also working from the Florentine codex, saw the illustration where Cortés receives presents at Tepozotlán and created an absolutely surrealist figure. Behind Cortés stands another Spaniard wearing a helmet, but the character depicted by María Luisa is an outlandish creature with a green head, white scarf and red blouse, wearing a kind of little skirt and something no doubt meant to be a feather in the helmet, but which looks like anything but a feather. One cannot know whether the appearance of a figure like this was intentional or if it happened by accident. I tend to think that it was intentional, since all the other figures, Cortés and a group of Indians, are perfectly identifiable.

It is particularly interesting that one of the pieces shows the rape of an Indian woman by a Spaniard. It is not in the model: the artist incorporated it. The woman is tied to a tree and gagged: she has of course long black hair but her skin is white. The rapist has a beard and a large penis. On the other side of the piece, an Indian woman, also white-skinned, is lying down, half-naked, a stick in her hand. The representation of the rape of women in scenes of the conquest is very unusual, and even more so in such a crude, unsublimated way. I suppose it has something to do with the women's own sensitivity with regard to sexual violence.

Irrespective of the fact that the artists of Ocumicho were given graphic information about the conquest – and on the previous occasion the French revolution – the resulting pieces are, all the same, expressing their own commonly held concepts: likewise, the colours are those they use for the rest of their creations. The famous little devils here travel by caravel, eating, playing music and wearing the same cheerful grins as ever.

Florentine Codex, *Moctezuma sends presents to Cortés*.

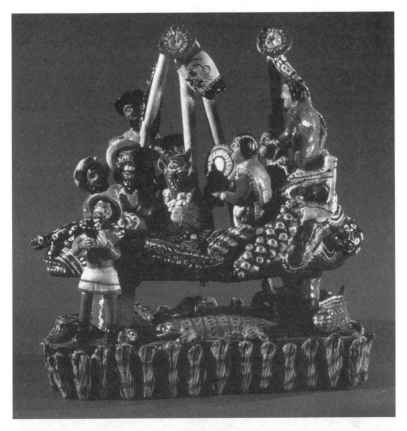

Rutilia Martínez, *Moctezuma sends presents to Cortés,* polychromed clay, 1992.
Inspired by the Florentine Codex. Photograph by Lourdes Grobet.

Syncretism between 'high' and folk art in these figures from
Ocumicho takes place in such a way that the subject matter of the
models is amalgamated with the habitual way they have of creating
their pieces. Instead of making a sun with devils eating fish, they make
a caravel with a bearded gentleman, supposed to be Cortés, and a
host of devils eating bananas. Also in this case, like the *Friditas* and
some serapes, the result seems to me extremely funny. Looking at
these pieces, one of the first things that one notes in viewers is the
broad smile, like that on the faces of the little devils now spread across
the four corners of the earth, disseminating their good humour while
their authors find scant relief from the dust and poverty of their tiny
Purépecha village.

Josefina Aguilar, *Self portrait with Thorn Necklace Dedicated to Dr Eloesser* and
Thinking about Death, polychromed clay, 1996.

Chapter Five

Frida Kahlo on a Visit to Ocotlán: 'The Painting's One Thing, the Clay's Another'

A further example of hybrid art that blends elements of elite and folk art is the reproduction in clay of the paintings of Frida Kahlo.

Ocotlán de Morelos is a sunlit and sparkling bustling market town of around 14,000 inhabitants in the state of Oaxaca, thirty-one kilometres from the city of Oaxaca on the road to the coast. Its beautifully kept church with six domes painted blue, yellow and white has a sober interior, and the adjacent sixteenth-century former monastery, Santo Domingo de Guzmán, has been restored to house a cultural centre. All this has been thanks to the efforts of one of the town's most illustrious citizens, the painter Rodolfo Morales, who lavished infinite love and devotion on his birthplace, and his state of origin, investing his time, energy and economic resources to create spaces for art, reforestation and beautifying the region as a whole. One day, for instance, he had several miles of the road linking Ocotlán with the city of Oaxaca planted with jacarandas.[1]

In the same town live the Aguilar sisters, folk artists by family tradition. All of them work in clay, making a great variety of polychrome figures which have become famous over the years. Not many towns in Mexico are home to a renowned 'high' artist and famous folk artists as well. Nevertheless, the two kinds have never really mixed: in Morales' lifetime they were not even acquainted, except by name, and tended to ignore each other.

Entering the town, on the right hand side of the main road are the houses, next to each other, of the Aguilar sisters, all with their respective signboards. One of the signboards, very well executed, professionally painted, reads 'Irene Aguilar A.'. Her studio-shop is quite big

and well constructed: one can see that she has more resources than the others. The doors are always open to visitors and potential buyers, as are those of her sisters. There are very many pieces, all magnificently executed, but not entirely to my taste, lacking a certain 'spirit'. Perhaps they could be described as rather 'industrial'.

The signboard on the house next door, rather poorly done, says 'Guillermina Aguilar A.'. The few pieces I saw inside this studio-house were interesting, although they did not strike me as particularly special. At the entrance is a clay dish with a painted *Frida* and another with the plants known in Mexico as *alcatraces* (calla lilies), immediately evoking two major fashionable subjects: Frida Kahlo and Diego Rivera.

A third sign, reasonably well painted, shows on the next door the name of Josefina Aguilar. This house is like many other provincial town houses in Oaxaca, and indeed other parts of the country. It has a large earth and cement patio in the centre with the rooms built to the left and right. On entering, one finds the oven for firing the clay on the left, and a little further on, in the open air, is the studio presided over by Josefina. It is here, as far as my taste is concerned, that the best and most interesting pieces are to be found.

A fourth sister, who seems to be the poorest of them all, lives nearby. Her family is smaller and her production on a smaller scale. Nonetheless, the *Fridas* signed 'Consepsion [*sic*] Aguilar' are also commissioned by both Mexican and foreign customers and are sold in the handicraft shops in Oaxaca. The US Latin American specialist Lois Wasserspring, who has carried out research into women making clay figures in Oaxaca, thinks that Concepción was the first to make *Friditas*: it appears she found them in a book. It is possible that someone gave her the book as a present and asked her to copy in clay a Frida Kahlo painting. Nevertheless, Josefina insists that she was the first to begin making *Friditas*. Wasserspring admits that this may have been how it was, and that perhaps she got the wrong impression when she went there. According to the research Wasserspring carried out in the late 1980s, Concepción Aguilar was then making pieces with *alcatraces*, but not yet *Friditas*. In other words, perhaps the *alcatraces* of Diego Rivera arrived first in the Ocotlán followed by the paintings of Frida Kahlo.[2]

Although the work of all four sisters is important, I decided to focus on Josefina and her *Friditas*: perhaps the decision was somewhat arbitrary, but it is her work I like most and her figures seem to me the most attractive.

Josefina Aguilar Alcántara began making clay pieces reproducing the paintings of Frida Kahlo around 1990. Josefina says she saw two reproductions of paintings by the artist in a coffee house in Oaxaca, and it occurred to her to make copies of them: people then started asking for more and more of them. She also says that she made them because she was struck by the physical resemblance, including the coil of plaited hair on the head, between herself and Frida. The only major difference was in the eyebrows: 'With the plaits, on the other hand, I imagined her as just like me', she says.[3]

Josefina Aguilar was over forty at the time; she is quite a serious person, though illiterate (she only signs her name), and is married to another craftsman, a potter who has given up his own work to devote himself to helping her with hers. She has no objection to granting interviews, but answers questions – which have probably been put to her hundreds of times already – carefully but mechanically, with statements that may or may not have much to do with reality. By a tone of voice indicating repetition and her attitude to questions that almost

Josefina Aguilar, Ocotlán de Morelos, Oaxaca.

never betrays surprise, one senses they have been well practised: she prefers not to enter into spontaneous or unrehearsed dialogues. As soon as one enters the house for a previously arranged interview, she automatically sits on the ground in her work place, begins speaking and gives a clay modelling demonstration. She gives the impression that she has carried out this *mise en scène* scores of times before.

She belongs to a Spanish-speaking *mestizo* community: she speaks no indigenous language. She has eight sons and a daughter, as well as several grandchildren. Unlike herself, her children have all been to school.

This artist will recreate any of the paintings of Frida Kahlo, whichever you wish, to the dimensions you require, from three centimetres to one metre. She also makes other figures such as mermaids: her mother and grandmother made these before her, but she makes them in many different postures whereas her mother always made them in the same pose. She makes devils too, a little like those of Ocumicho as they are rather playful and also include phallic elements: there is one seated on the toilet with a bottle in one hand and his tail in the other. Other pieces she makes frequently are market sellers, births, weddings, baptisms, market women and women of pleasure or ladies of the night.

Josefina started work at the age of six, taught by her mother and grandmother. Working clay was traditionally women's work, but 'nowadays it is no longer only for women', as her sister Concepción told me in passing.[4] When Josefina got married she used to work alone, but with time her children and husband began to help her prepare the clay and paint. Today her son Demetrio makes many pieces, even *Friditas*, and signs them in his own right. He is trying to make a name for himself without competing with his mother.

Friditas can also be seen in several handicraft shops signed by Jesús Aguilar Alcántara. As far as I know, the Aguilar sisters have no brother engaged in this work, so it must be one of Josefina's nephews using his mother's two surnames. It is interesting to note that as the four sisters have become famous and their profession gained prestige, those stepping into their shoes are the male descendents and not the women. However, the fact that the men help the women in their work with clay is no novelty. Josefina says that her father (who worked the land) did so: he also made the traditional huaraches, apart from helping Josefina's mother to paint the figures.

There is considerable rivalry and jealousy between the four clay-working sisters: they seem not to get on at all well. Josefina says that

she has many ideas of her own, but then a potential buyer comes and likes a piece which is already sold, so takes a snapshot and gives it to one of the sisters to make a copy, and of this she does not approve. According to her, the other sisters copy everything she does. She repeats time and time again that all the ideas come out of her own head: she doesn't look at magazines and so on, and everything emerges from her own thoughts. She takes great pride in her work and wants it to be the best and most beautiful possible. She therefore scolds her children when the figures come out 'all mucky': she tells them 'the figures must have a soul – that's right, a spirit – in order for them to turn out nicely'. Even so, she doesn't consider herself to be an artist so much as a craftswoman.

She has travelled a little. Occasionally she goes to the city of Oaxaca, and has also been by invitation to the United States, to Chicago, San Diego, Austin and Dallas. Someone buys a certain number of pieces and invites her to go across the border to do a demonstration.

Her husband tells her that much of the work could be done on a wheel, but she doesn't want to. As she says, 'my mother taught me to do it all by hand and with the wheel it would be something else, because everywhere things are made on the wheel, but not everywhere by hand'. Neither does she use moulds.

This difference between her husband's and her own attitude to the work is very interesting. He would prefer to increase output by modernizing the process of production, while she prefers the traditional way of working: she thinks her figures are better and worth more that way. An unusual amalgamation of the 'modern' and the traditional occurs. Really, both factors are connected to the market. She prefers to keep up the traditional form because she thinks that it gives added value and makes the pieces sell better: he on the other hand believes they would earn more because they would work faster and increase output. I believe she is right because in other places (Ocumicho, for example) where there was an attempt to follow the line he proposes, the quality diminished enormously and sales followed suit. In any case, for the moment at least, she does as she thinks best. We shall see later that the same situation exists in places like Teotitlán del Valle, but that there it is not the women who maintain the traditional ways.

There can be little doubt that this new production of clay imitations of the paintings of Frida Kahlo began in response to the market and demand, and the *Friditas* sell well. But Josefina continues making her other figures and many European buyers, from Denmark and Switzerland, for instance, buy all types of figures and not only *Fridas*.

The painter Rodolfo Morales regarded the ceramics of Ocotlán as among the most primitive to be found in the Valle de Oaxaca:

> They make some braziers for All Saints that are completely pre-Hispanic, but authentic, for the copal, to be placed on the altars to the dead, and also for taking to the cemetery. The Aguilar sisters' mother began to make folkloric pieces, like weddings for example, in the late 1940s. In other words the old lady evolved. The things the sisters make have their charm, their creative something. They make interesting things and all that, but if you go inside their private rooms you find knick-knacks from Taiwan, plastic articles, and that disorients me a lot. I don't understand that way of being; they've got no taste in domestic articles, for example.
>
> Nonetheless, other craftswomen have less imagination because their means are limited, the backstrap-loom weavers from Santo Tomás Jalieza, for example. But in the way those indigenous families live, there you can really notice the culture; they make their kitchens out of flat-trowelled mud, and lo and behold, you have a modern painting. In the crafts of Ocotlán you can no longer see the indigenous culture.[5]

This is how this painter – who in some sense could be regarded as a folk artist himself, but ultimately falls into the category of 'high' art – expresses himself regarding the female folk artists of his home town who, according to him, although highly imaginative and creative, do not transcend the condition of craftswomen and cannot be regarded as artists in the strict sense. What seems interesting here is the fact that in the homes of many folk artists of either sex, the taste expressed in their works is conspicuous by its absence. They often buy horrendous ornaments, pieces of plastic, and do not set out their houses with the same taste so evident in what they create.

Josefina Aguilar creates versions of any Frida Kahlo paintings commissioned to her, but she doesn't make them exactly the same as the paintings, since, as she puts it, 'the painting's one thing, the clay's another'. Thus one day she gave Frida a baby and her son told her that Frida had never had a child. 'Well maybe she never had a baby while she was alive, but now she's dead she's going to have one in my work'. Her son told her that the piece would never sell, but it sold immediately. 'You see!', she told him.

Josefina explains that the first picture she reproduced was one of Frida kneeling with *alcatraces*. I have the impression that her memory is confused and that she is probably referring to one of the pictures by Diego Rivera of the woman selling lilies. However, the interesting thing is that in the same way that Frida's paintings came to form

part of folk art, so did Diego's callas. Josefina and her sisters all make countless *Fridas* with *alcatraces*. The folk art of Oaxaca and other areas abounds with lilies: demand for them has clearly been great as they appear everywhere.

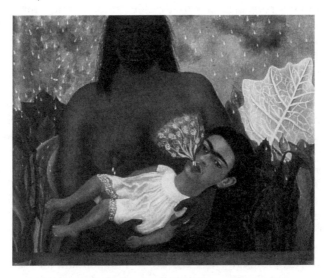

Frida Kahlo, *My Nanny and Me*, oil on canvas, 1937.
Collection: Dolores Olmedo Museum.

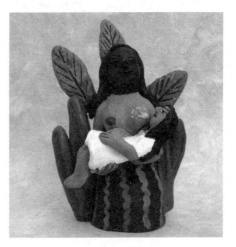

Josefina Aguilar, *My Nanny and Me*, polychromed clay, Ocotlán de Morelos, Oaxaca, 2004.

Josefina says that Frida Kahlo's paintings are very pretty and that she also tries to make beautiful things. She believes that though Frida is someone who has died, the dead are still among us. 'That's why I say you've got to give her life. In the clay she's born again, I bring Frida and her paintings back to life'. She thinks that a painting is different because you can only hang it on the wall: a piece of clay on the other hand can be moved around wherever you want it. When you are dusting, you just move it aside: you can put it anywhere. The idea she transmits is that clay figures are better than paintings because they are more versatile.

At first she didn't like doing Kahlo's saddest pictures, but now she does them all. This is because some years ago one of her sons was killed at the age of twenty-six and she is still mourning him. 'You feel a very deep sorrow', she murmurs. She thinks much about him. When she is working she is always thinking of him. 'The way I see myself with my sadness', she says, 'is how Frida must have felt'. She thinks that the painter was someone who suffered because she had no children, while she suffers on account of having given birth to many.

In Josefina Aguilar's family there is a clear division of labour. She is the 'master' of the art: the one who knows. The children are gradually learning, although Demetrio is now independent and seeking to acquire his own identity. Her husband and the children go and buy the clay about a mile away: they have to dig it out themselves at a depth of at least 16 feet. They used to bring it home in a cart. The husband helps her knead the clay, bake and paint the figures. The daughter is not sent to fetch clay because she is the family favourite, but she makes figures and likes doing so: she is considering taking up the same work herself. Only family members work the clay: there are no paid helpers, because they say if there were the tradition which they are keen to maintain would be lost. Demetrio says they want to avoid what has happened in the neighbouring village of San Bartolo, where the entire population purports to be artesans. That is what they do not want. In San Bartolo there is now considerable mass production coming out of small, medium and large craft workshops manned by hired labour.

While some of the pieces are entirely her own work, others are made by the children or are the result of a collective effort: most are signed by her. Generally she is asked to do so, and that is what she does. Often, when the children make figures, she gives them the final touches, painting in the eyes or some other detail.

She works from seven o'clock in the morning to nine at night, except Sundays. As far as domestic work is concerned, she sometimes

cooks and on Sundays washes clothes. She no longer makes the tortillas. Her daughter and daughters-in-law help with this and also assist with the clay figures. The husband only 'helps' with the housework when she is ill, but he is the one who imposes authority on the children. He also takes care of the accounts and the administration of the family business, although he takes her opinion into account. He asks, for example, 'How long did you take to make this piece?', so as to know what price to put on it. However it is she who decides what she does in regard to her work with clay.

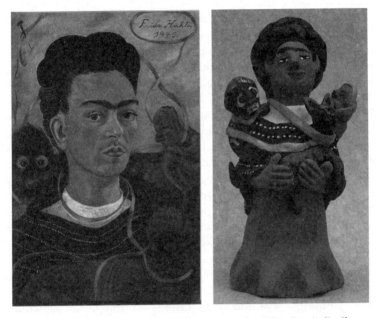

(left) Frida Kahlo, *Self portrait with Little Monkey and Dog Ixquintli,* oil on masonite, 1945. Collection: Dolores Olmedo Museum.
(right) Josefina Aguilar, *Self portrait with Little Monkey and Dog Ixquintli,* polychromed clay, Ocotlán de Morelos, Oaxaca, 2004.

Once the figures are modelled, they have to be fired in the oven for around nine hours. Then they are painted. 'While I am working on them they are dead: when they come out of the kiln and I start painting them I give them life'.

Josefina explains that access to emulsion paints facilitated the process enormously. Before they came into general use about thirty years ago, it was necessary to find natural pigments in the countryside.

A size, a kind of watered-down gum, was made by boiling, and it needed to be watched closely to avoid spoiling. Worst of all was that if the pieces came into contact with water some of the paint came off, leaving streaks. Neither did they look any better for the materials being natural: the paint was very opaque and there was only black, blue, red and white. Now that emulsion paints are available there are many colours and no deterioration occurs if pieces are left out in the sun, rain or night air. In the case of serapes, which are better when dyed with natural colours, the reverse is true. For *Friditas* only industrially produced paints are used.

Fridas are in great demand now: at the beginning they were ordered occasionally and individually but now are sought in large batches, and this is the main reason why Josefina continues to make them. Her mother used to make braziers and candlestick holders for Easter week and All Saints' Day, selling her articles to the local market, in the village and surrounding areas. The family was very poor. Nowadays, Josefina no longer sells anything within the community: all her production is for the tourist trade, either domestic or international. Some pieces go to the city of Oaxaca but her works are to be found, above all, in Europe and the United States, especially in private collections. This clearly demonstrates the significant change that has taken place between one generation and the next.

One of the most interesting points regarding the process of syncretism taking place is that, as already mentioned, it is nothing new. Frida Kahlo herself was originally an artist whose life and work were strongly marked by Mexican folk art and handicrafts. Frida's great political ambition was to make an art for the people, a 'revolutionary popular art'. Furthermore, objects of folk art were an ever-present element in her paintings. That is to say that this syncretism began to manifest itself in the work of Frida herself, in content and also form, seen for example in her adoption of the art of painting on sheet metal, as in painted ex-votos.

Nor should it be forgotten how close Frida Kahlo always was to Oaxaca: one thinks of the *Tehuana* dresses she used to wear, for example. Today a woman from a small town in Oaxaca readopts Frida's work in order to recreate and revive it. The paintings of Frida Kahlo occasionally had an appearance of deliberately naïve art, to the extent that it incorporated popular and folk elements. At the same time, the folk art reproduced in Frida's paintings becomes more sophisticated, bringing about the curious mixture of a rather crude execution with creation essentially belonging to another class and social milieu.

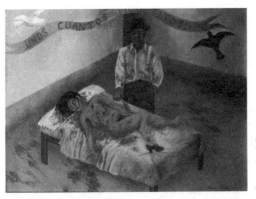

Frida Kahlo, *A Few Small Nips*, oil on metal sheet, 1935. Collection: Dolores Olmedo Museum.

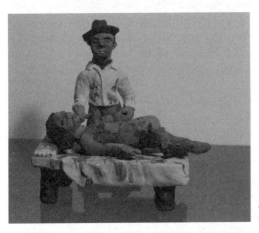

Demetrio García Aguilar, *A Few Small Nips*, polychromed clay, 1996.

The process of appropriation of the work of Frida Kahlo taking place at the hands of the 'folk' is, then, both interesting and pleasing. It is as if her people in some way were rendering tribute to her. It would seem that the process has come full circle: the close link between 'high' and folk art becomes circular.

That the person who introduced reproductions of Frida Kahlo in one of the Aguilar sisters' houses – supposing that to be what occurred – was clearly interested in both the Coyoacán artist and the work of small-town women may well be evidence of a certain feminist awareness. To this extent it can be said that while it was international feminism that rediscovered the figure of Frida Kahlo a few decades ago, it might also be the same connection that brought her back into Mexican folk art. Of course, this is no more than unsubstantiated speculation.

I think that Josefina Aguilar is fully aware of the fame she has gradually acquired, but to the question of how she feels about becoming famous, she answers 'Just the same as ever'.

If the tendency to repetitive work is one of the constants within folk art – at the same time distinguishing it from elite art as the latter is characterized by the creation of original and unique works – Josefina Aguilar follows in this tradition with her *Friditas*. She repeats the same painting as many times as she is asked to. Obviously no two examples are exactly the same, nor would she want them to be. At times she adds touches of her own, precisely in order to give greater variety to the pieces. But it is a fact that folk art is characterized by this repetition, almost ad infinitum, of a given type of object. Thus we find that Josefina allows herself certain detours on the path of imitating paintings, both in respect of the original and between different reproductions of the same picture. What is incredible is that we are looking at a painting by Frida Kahlo, in other words an imitation, but at the same time it is something completely different. More than a recreation, it is a new creation.

For example, with the 1931 painting 'Frida and Diego Rivera' Josefina enjoys sufficient liberty to have the figures seated instead of standing as in the original. The proportion is also different: Frida and Diego are for her almost the same size, although she makes Diego fat and paunchy as she had heard him to be. In the original, on the other hand, Frida is tiny and Diego big (although neither fat nor paunchy): the elephant and the dove. I am tempted to interpret this as Josefina aiming to set the two figures more in proportion because she feels that in Frida Kahlo's painting the difference is exaggerated. Diego is gigantic and it is he who holds the palette; Josefina, on the other hand, equalizes this disproportion of sizes. Could it be because she feels they ought to be more equal? Certainly this disproportion does not seem right to her, for whatever reason – perhaps merely because it doesn't work for her formally.

In 'Tree of Hope' (1946), Frida Kahlo places the dressed and seated Frida on the side of night. Josefina places her in the centre, between day and night, in three dimensions, and she places the other Frida, lying down with her back to the viewer, in the background. Where Frida Kahlo decided to paint herself probably did not have any particular meaning for Josefina: perhaps, again for formal reasons, not centring the figure left her unconvinced and so for the sake of better equilibrium she placed her in the centre. Sometimes she combines sculpture and painting, an interesting phenomenon in itself.

There is a self-portrait of the face only, 'Thinking of Death' (1943), in which Frida has a death's head painted on her forehead. Josefina makes it a full-body portrait and, as the skull would no longer be visible on the forehead since the whole figure only measures some ten centimetres, she gives the figure arms, the skull held in the left hand. This is a very interesting piece which personally I like very much. In fact all the Frida Kahlo self-portraits of only her face are made by Josefina into full-body portraits with arms, feet and clothing, which are then decorated and coloured as she wishes.

In 'The Broken Column' (1944), the nails she uses over Frida's entire naked body are real metal nails, meaning they are totally out of proportion with the figure as well as the original: she also gives her enormous uplifted breasts. She probably thought that if she made the nails in clay, it would be not only extremely laborious (and in any event she could not have made them in the same proportion as the original), but they would also be very fragile and easily broken if made the size of real nails. Thus she solved a technical problem, but the nails also take on a very significant symbolic dimension: they become a much more important element in Josefina's *Fridita* than in

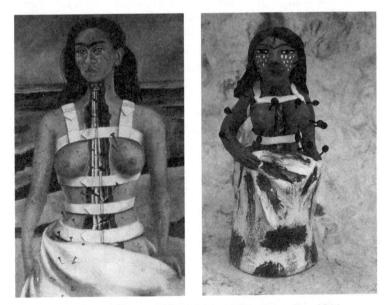

(left) Frida Kahlo, *The Broken Column*, oil on masonite, 1944.
Collection: Dolores Olmedo Museum.
(right) Josefina Aguilar, *The Broken Column,* polychromed clay, 2004.

the original. At the same time, if a certain image of femininity is high-lighted by Frida Kahlo through her beautiful firm breasts, Josefina takes up this message and emphasizes it even further.

'Memory' (1937) is a painting which has Frida and two of her dresses traversed by a stake, at whose point is a Cupid. Josefina makes the Cupid enormous: had she not done so, of course, the Cupid would hardly be visible. Also, the dress at the rear has Frida's left arm appearing out of the sleeve. In clay, Josefina sometimes makes it the right arm so it can be more easily seen: the figure of Frida would hide it otherwise.

One of Josefina's *Friditas* is completely invented. It is a full-body figure with a face supposed to be that of Frida Kahlo, hair coiled on her head and embracing six enormous *alcatraces*. There is no painting by Kahlo like this.

The question of colouring is extremely interesting. When copying a painting in clay, Josefina also reproduces the original's colours, but these are not the ones she generally employs on other figures as she normally uses livelier and brighter tones.

The faces of Josefina's *Fridas* (and similarly those made by her sisters) do not really look anything like Frida Kahlo: what provides the likeness are the other elements in the paintings and the colours, but above all the big joined eyebrows they are given. The eyebrows have become a major coded symbol in Josefina's work. She gives her figures a face which could be any, but when she paints on the eyebrows, *ipso facto* they become Frida Kahlo. Thus identity is given basically through eyebrows and dress.

Josefina Aguilar continues to perfect her own *Fridas* the more she makes them. For example, the artery joining 'The Two Fridas' (1939) was at first made of clay, but it broke too easily and now she uses wire.

The origin of these *Friditas* lies in the paintings of Frida Kahlo and nonetheless they present a certain autonomy that makes them some-thing beyond mere reproductions or copies of the paintings. This 'something beyond' is, to use Josefina's expression, their 'soul'. The *Friditas* have their own personality: a soul. In fact they are just as par-ticular to Josefina as are her ladies of the night, market women or mermaids. Of course we know that in this case we are looking at Frida Kahlo's works reproduced in clay, and that they are copies of an origi-nal: there is, naturally, a tendency to undervalue these *Friditas* pre-cisely because they are not 'originals'. But as I have just said, the high degree of liberty enjoyed by Josefina – also the fact that very different mediums are involved, clay figures as opposed to paintings – means

that we are looking at works of a very different nature, with in each case a very particular use of imagination.

If art is communication, then perhaps what occurs in this process of syncretism is that Josefina Aguilar communicates to us what Frida Kahlo said, but in another language. Josefina has to carry out a translation, and that is what men and women receive at the end of the process when looking at the *Friditas*. But apart from communicating this to us, they also have a peculiar and special effect on us. From my own point of view the *Friditas* are especially enjoyable: perhaps it is precisely the 'translation' process which is perceived as so delightful. It is a matter of seeing – scrutinizing even – what happens when we pass from one medium to another (painting to clay) and from one social group to another. The translation is in itself an important part of the enjoyment. Some of the pieces are quite crude and others are finely done, but each of them obliges us to perform a double reading so as to perceive both what Frida Kahlo said and also how Josefina interpreted it.

It is a fact that Frida Kahlo's creation of her extraordinary paintings came first. This means, perhaps, that the greater merits of imagination and originality in these works are attributable to her. On the other hand it is undeniable that Josefina's *Friditas*, even though dependent upon the paintings, are as good as any other figures she has made; to this they add the charm, and the interest, of being reproductions of 'high' art within folk art. Being works which emerge from the nation's cultural syncretism, they become a 'curiosity'. On the one hand, we have works born from the exquisite paintbrushes of Frida Kahlo, painter from Coyoacán in Mexico City, and on the other those brought to life by the muddy hands of Josefina Aguilar from Ocotlán de Morelos in the state of Oaxaca. One is called cultivated and the other folk art. And as Frida Kahlo is now internationally very fashionable, the clay *Friditas* contribute to the growth and development of 'Fridamania'. In other words the fact that there is a market for these *Friditas* is to a large extent due to the fame acquired by Frida Kahlo over recent decades. The difference is that while Josefina earns a living out of the Frida cult, some indeed grow rich on it.

Frida Kahlo is very famous, but Josefina Aguilar also enjoyed her own share of fame as a folk artist making clay figures before she even began to make *Friditas*. One should therefore point out that it was not Frida Kahlo who made Josefina famous when the latter decided to 'copy' her paintings; nevertheless, Josefina does now have a new product, which she knows is in demand, to offer to the market.

Folk art is never 'pure', free of influences from other cultural spheres. On the contrary, it receives constant influences of all kinds. The same is of course true of so-called high or cultivated art, where all sorts of copying and 'plagiarism' (with or without inverted commas) take place, both of folk art and elite art itself. One has seen recreations and versions of the same subjects to the point of satiety.

To recreate is to quote another precursor. Originality is understood to consist precisely of recreation. If Gironella copies Velázquez's 'Las Meninas' it is regarded as something original: if Picasso copied African art he was creating unique works, but when Josefina Aguilar copies Frida Kahlo, for many people it is no more than a vulgar imitation. In our society a dual morality always holds sway: what is approved of in some cases is frowned on in others. In general what is good for groups with power is bad for subordinate groups. These different valuation systems, or codes, are similar to the two codes applied to men and women. A public man, as is well known, is someone important and respected; 'public woman', on the other hand, is just a euphemism for prostitute, a person to be despised. Indeed, two different codes operate, one for 'cultivated' art and another for folk art.

For example, what Josefina Aguilar does with her *Friditas* is in fact the same as Frida Kahlo did with ex-votos. The process is very similar. Frida saw an ex-voto and then executed another painting which resembled it enormously, except that in her own work the woman lying on the ground after an accident bears her own face. Or, more precisely, the face has her eyebrows, because we are dealing with a very 'primitive' kind of painting, and the face is not well delineated; it is a figure with a non-specific face, but with enormous eyebrows that join in the middle. In other words Frida herself, when she was beginning to paint, did the same as Josefina does today in joining eyebrows to make any face into that of Frida Kahlo.

When elite artists take elements from folk art, they integrate them into their own and tend not to repeat them in the same way as folk artists. Of course Frida Kahlo repeated the subject of the self portrait. Nevertheless, no two self-portraits are quite alike; each is a unique work.

Josefina Aguilar can repeat a painting by Frida as often as she is asked, and while no two are exactly identical, one can easily see that essentially it is the same each time. Or she can make mermaids and it is always the same mermaid, although really each piece is unique because she does not use a mould; nonetheless, the question of uniqueness in the two cases presents differences.

To what extent does the apparently same process become different

in the cases of 'high' and folk art? Frida Kahlo can paint her own face as often as she likes, or José Luis Cuevas can draw his self-portrait ad nauseam, yet this does not render them folk artists. On the other hand, repetition is one of the fundamental characteristics of folk art. In an attempt to understand this question and seek an explanation, we could perhaps say that the difference in this process of repetition lies in the existence of a creative talent which is expressed through the mastery of technique in masterly works. If, with these elements, the same subject is painted hundreds of times, it might be construed as high art; if they are not present, but the same subject is repeated constantly, perhaps it is folk art. Is folk art inferior art? I am inclined to think it is just *different* and should not be measured by the same yardsticks. We must not forget that I am referring to those folk arts which have no practical or utilitarian function but a strictly aesthetic primary function. It is the same as that of elite art. What we must then do is see certain differences and similarities: acknowledgement that folk art is not to be automatically considered inferior does not obviate the task of identifying its specific characteristics and the recognition that folk art and high art are two different fields.

A Frida Kahlo painting and its copy in clay command hugely different prices in dollars and cents; but what is it that substantively distinguishes elite art to the extent that the difference in value should be so great? I think that in part it is a question of creative talent, imagination, mastery, greater control of technique and greater originality, but at the same time their being creations of the elites of society: the creations of elite art may or may not be true masterpieces and the same holds for folk art. There are genuine masterpieces within the field of folk art; nevertheless, these never attain the same kinds of prices nor are valued in the same way as elite works of art. There are exceptional works, great creations in both fields: in the elite, however, we find subjects generally belonging to the middle and upper classes of society, often to the educated minority who create art by and for the same elites, people with purchasing power and similar tastes. Folk art is art of the folk, 'popular' art, and as such it is poor art, made by the poor of society, requiring talent, imagination and, of course, mastery of technique: however it tends in most cases to be repetitive, and does not rise to the same heights as the unique, original works of magnificent elaboration cultivated by elite art. In any event, we must remember that the creators of the classifications, distinctions and above all systems of evaluation within art are the dominant classes and groups, the elites, and it is they who ultimately decide what is great art and what is not.

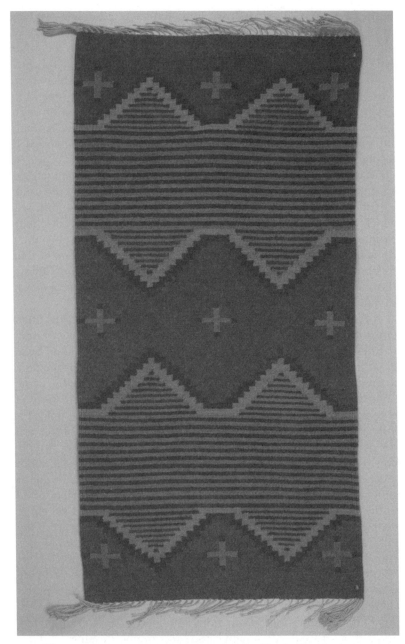

'Women who weave serapes', serape inspired in the Navajo designs,
Teotitlán del Valle, Oaxaca, 1996.

Chapter Six

The Paintings on the Serapes of Teotitlán

There are ugly towns and pretty towns. Teotitlán del Valle, Oaxaca, verges on the ugly. Its main interest is the very considerable production of serapes. The presence of a large number of houses of recent construction in concrete frame and brick infill is remarkable; many have the ends of their steel reinforcement rods pointing up to the sky, giving the horizon a spiky appearance and indicating that the second storeys await addition. It is a relatively prosperous town in rapid expansion.

Teotitlán is a Zapotec-speaking locality of some five thousand inhabitants about twenty-nine kilometres from the state capital. According to Lynn Stephen, in 1900 there were 565 male weavers and four female weavers. By 1930, the figures had fallen to 214 men and two women as weavers in small-scale industry but by 1940 there were 519 men and nineteen women doing this work. At the beginning of the twentieth century Teotitlán was basically a village of small farmers, but by the 1980s only eleven per cent of the economically active population was still devoted to agriculture, while sixty-nine per cent was either weaving or selling serapes. In 1986, between thirty-five and forty per cent of the weavers were women.[1]

Nowadays the principal source of income in the town is still the sale of serapes, rugs, tablecloths and similar items. Since the 1960s, approximately, women have been increasingly in evidence as weavers on the foot-pedal loom. Before 1980 they did not appear in the statistics as weavers and did not take part in the national folk art contests: this however was not because of their absence from the manufacturing process, but because their participation tended to be limited to the level of 'helping', in tasks such as washing the wool, carding, dying, spinning and tying the warp ends rather than as weavers. It is

important to point out that the making of wool serapes is a process
that consists of several stages; it would be wrong, therefore, only to
consider the actual weaving.

Teotitlán del Valle, 2004.

People involved in textiles fall into two groups: those who weave
and those who sell what others weave. According to Lynn Stephen, all
the weavers of Teotitlán, men or women, are quite clear about the fact
that the traders buy the work of others, the individuals who produce
it. The traders earn more money than those who weave, and moreo-
ver do so without sweat, not really working: the weaver lives solely as a
result of his or her own work.[2]

Women have been weaving in Mexico with the back-strap loom
since the pre-Hispanic era and in certain areas continue to do so.
Following the conquest the upright loom with foot pedal was intro-
duced and for centuries it was used only by men. Now women do all

the work involved in the making of serapes, the only exception being that they do not handle the very big looms. Of course, as well as weaving all day they also have to attend to domestic chores and look after the farm animals.

The traditional sexual division of labour in Teotitlán del Valle, as in other places, used to dictate that women did not engage in productive work but only in tasks of reproduction and 'support' to the male bread-winner. However the moment arrived when, assuming the bread-winning weaving man actually existed, the money he earned was not enough for the survival of a generally large family, and the women had to start weaving as well in order to make ends meet. Again, and for whatever reason, in many homes the men didn't exist or were elsewhere, and so the women had to provide for their families alone.

Although women's entry into weaving took place at approximately the same time as the introduction of designs from elite art into serapes, there is no connection between the two developments. In 1963, Rufino Tamayo and the weaver Isaac Vásquez García, who worked together for twenty-two years, began to make reproductions in the village. Their models came first from Oaxacan painters such as Tamayo himself, and later they took them from famous European artists. Francisco Toledo, then barely beginning as a student, apparently was also involved as he spent much time there, and Isaac Vásquez weaved rugs with his designs. By 1968 they were beginning to use designs by Picasso, Miró, Kandinsky, Vassarely, Escher and others.[3] As it happens, there were no women among the artists imitated.

The syncretism in the making of serapes is curious. There are some designs that seem to be taken from pre-Hispanic codices and they make much use of the ancient step-and-fret motif (called *grecas*) from Mitla, the eagle, flower of Oaxaca – designs they call 'Navajos', after the Indians of the United States – and alongside are rugs reproducing paintings by European artists such as those mentioned above. A few also represent one of Diego Rivera's paintings of lily-sellers.

There is a significant tendency to repeat a particular design: there is not much variety. Basically they do a Miró, a Picasso, one or two Matisses, and then a Kandinsky. The case of Escher is interesting as they have practically integrated him into their own fish and bird designs which considerably predate Escher. It is as if the birds and fish which form part of their most traditional designs simply underwent a slight transformation with no perceivable break such as any clear difference between a traditional bird design rug and one inspired by Escher.

There is a cooperative in the town formed exclusively by women called 'Dgunaa ruyin chee lahady' (women who weave serapes), set up in 1992 and the first of its kind. It began with twenty-eight women but some had problems with their husbands and withdrew. Fourteen years later it was made up of eighteen women – three married and fifteen single women and widows. All are bilingual but their mother tongue is Zapotec, which they speak among themselves. Some of them did not even finish primary school. They say the group consists of only women because that is their preference: working among women they think is easier, and leads to quicker understanding. The cooperative has had its difficulties and better moments: in 1996 it still had the support of the central government's National Solidarity Programme (*Programa Nacional de Solidaridad*: PRONASOL). It has also had much support from the Mexico City feminist NGO 'Semillas'.[4]

The cooperative has an executive committee and premises in the town. Josefina Jiménez, who was born in 1960 and now chairs the committee, says that at first it was very difficult because they were not used to going out alone; many of them didn't even know the city of Oaxaca, but they gradually began to learn. Her mother began weaving in 1965, approximately, but found it difficult learning the trade as an adult. The father was a weaver and peasant farmer. She says the women of the cooperative prefer weaving to going out to work in the fields, because that work is harder.[5] She has a twenty-five-year old son who is also a weaver as well as a good designer and he helps with their creations.

There is enormous competition because everybody in the village weaves: men, women, boys and girls. 'It should come as little surprise that weavers compete to gain advantage in an ever-changing market'.[6] At the same time 'they cooperate with each other, depend on unpaid child labour, and organize into more or less formal groups to improve their standing'.[7] Theirs is a hard life and they are always having to invent new products: for instance they also make leather and textile bags as these sell well. In 2006 there were three women's cooperatives.

The male weavers began making pieces with reproductions of paintings, but now everybody does them. Isaac says 'The problem of the craftsmen is precisely this; they copy everything'. Nevertheless, in the market there is very little variety of design because creating new ones implies much work. A new pattern has to be worked out on paper, and most people prefer to repeat existing ones unless someone comes and commissions something new: this of course is then delivered.

The women of the cooperative are familiar with other paintings by Picasso or Miró, but they do not reproduce them, mainly because of lack of time. The first occasion they weave a new design is the most difficult and they take a long time over it, so they prefer to continue repeating the same designs. 'Walking the Dog' by Miró was the first they did and as people still ask for it, they continue to make it. The step-and-fret designs are easier to execute than those with paintings because they work counting the threads and not from a pattern. A rug with a new design by an elite artist may require months of work and as these are women with scant resources they need to sell quickly in order to make a living, buy more material and continue weaving. It probably takes longer to make a rug with a picture than it took the artist to paint the original.

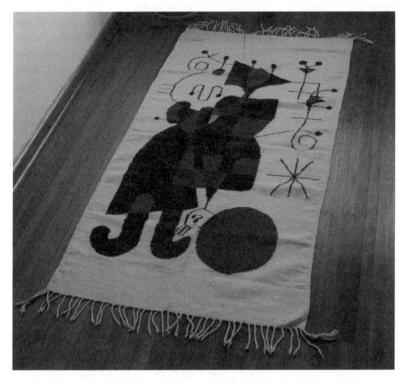

Serape inspired by Joan Miró, Teotitlán del Valle, Oaxaca, 1996.

The rugs with designs based on paintings are consumed basically by international rather than domestic tourism. This is also interesting

since the tendency is to believe that foreign tourists prefer the most traditionally 'Mexican' designs.

The reason they make calla lily designs is simply that one day someone started to do so, and as people still ask for them they continue to make them. It is quite clear that the choice of designs is more than anything in response to the market: they make what sells. The women prefer to sell rugs directly to the visitors; only if they are under pressure do they sell to middlemen as very low prices are offered. They also sell in Oaxaca City and Mexico City. In 2003, Josefina was invited to an exhibition in Segovia (Spain) and she made the journey on her own.

The women say they like to weave what there is most demand for from buyers. But they also enjoy making new, original designs. They have taken courses in the use of vegetable dyes (a traditional practice which was on its way to extinction), and at the moment they are using both types of dye, vegetable and chemical. The negative aspect of natural dyes is that they work out more expensive, which presents a problem. They are in fact lagging behind in the use of natural dyes. Other weavers, among them Isaac Vásquez García, make far more use of them.

Each weaver has her (or his) own way of weaving: some rugs come out thin, others thick; the work of some is slipshod while others produce genuine works of art, magnificent original and unique rugs which entrance all who look at them. But as far as differences between the work of men and women are concerned, the women say that 'men, being men', can work with broader looms: the widest looms used by women measure about one and a half metres, with an absolute maximum of two metres. They think this is the only difference arising from the weavers' sex, and that in other respects they can make exactly the same designs as men. The reality is that designs and colours depend more than anything on customer requests. When one of the cooperative women is asked for a particularly large carpet, if there is a husband or other man at home the work is done by him.

They are perfectly capable of carrying out the whole process, but as they need to work fast in order to keep selling they often buy manufactured yarn. In general they only spin their own yarn when they are commissioned to do so for a particular order that specifies that industrial thread is not to be used. Some might think that the use of factory thread lowers the quality and also only one thickness is available. The women work with a thicker yarn than that used by Isaac, for example: he uses a finer thread not produced in a factory.

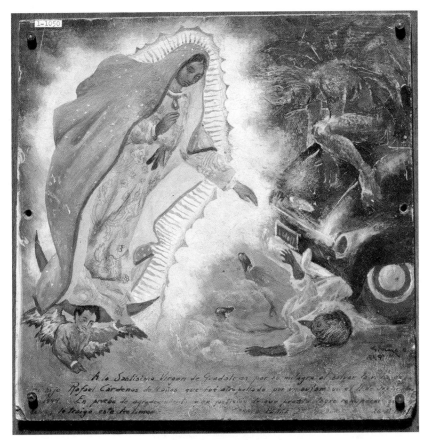

1. Ex-voto. Oil on sheet metal. Museum of the Basílica of Guadalupe.
Text: To the Most Holy Virgin of Guadalupe for the miracle of saving the life of my son, Rafael Cárdenas, who was knocked down by a car on 11 September 1949. In proof of gratitude and in supplication for his prompt recovery, I bring Her this testimony. Carmen Pérez de Cárdenas. 2-IX-1949.

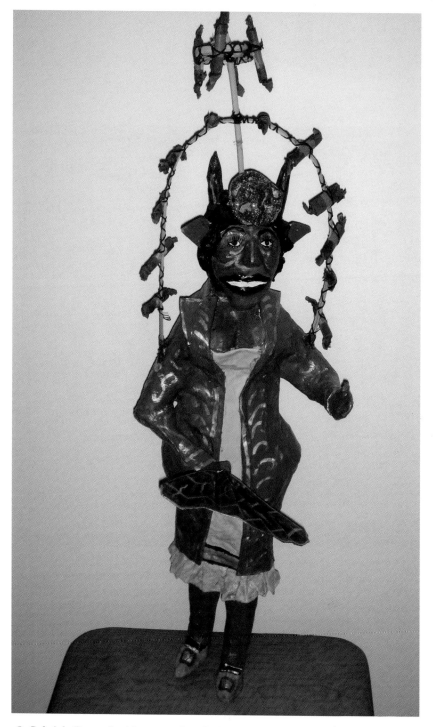

2. Gabriela Rosas, *La Mona-arca*, female *Judas* ('The Mon-arch', a representation
of evil), paper, Tacoaleche, Zacatecas, 2009.

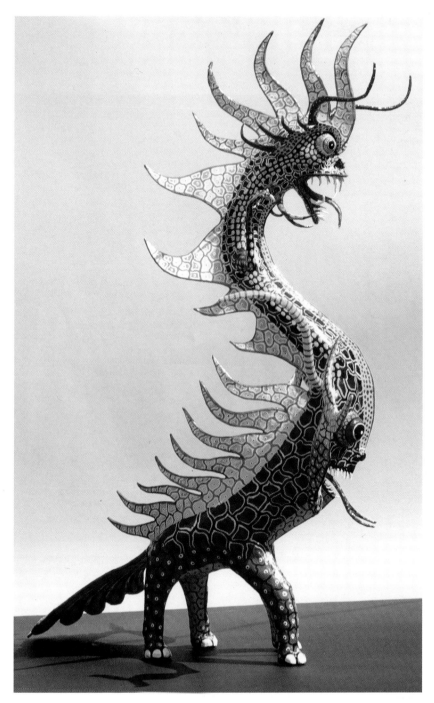

3. Miguel Linares, *Alebrije*, paper, Mexico City, 2004.

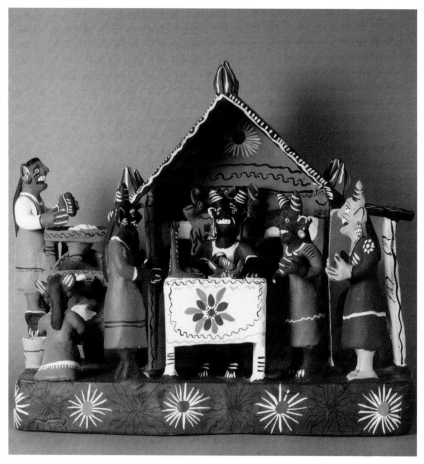

4. Eudelia Quiroz Rafael, 'Food Stand', polychromed clay, Ocumicho, Michoacán, *c.*2004.

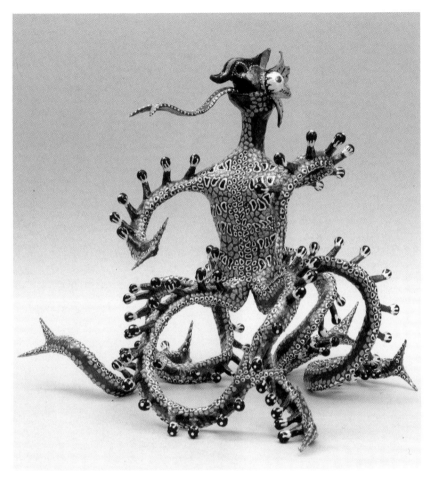

5. Susana Buyo, *Alebrije*, paper, Mexico City, *c*.2004.

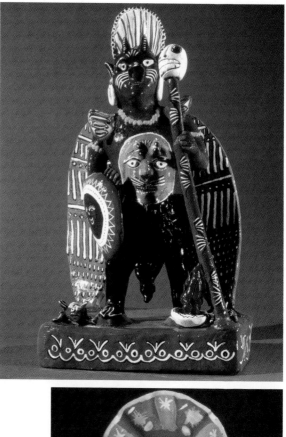

6. Carmela Martínez, *Huizilopochtli*, polychromed clay, 1992. Inspired by a European etching; photograph by Lourdes Grobet.

7. Josefina Aguilar, *Self-portrait as Tehuana*, polychromed clay, Ocotlán de Morelos, Oaxaca, 2004.

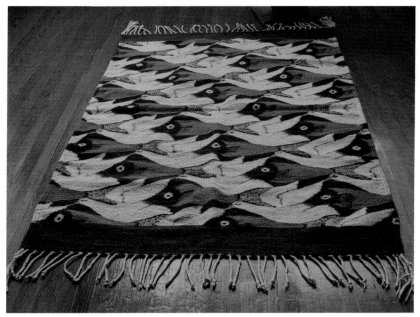

8. The 'Women that weave serapes' group, serape inspired by M. C. Escher, Teotitlán del Valle, Oaxaca, 1996.

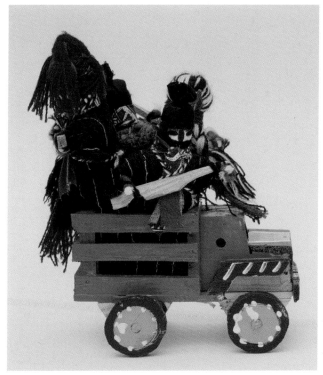

9. Truck with Zapatista dolls, cloth, Chiapas, c.2000.

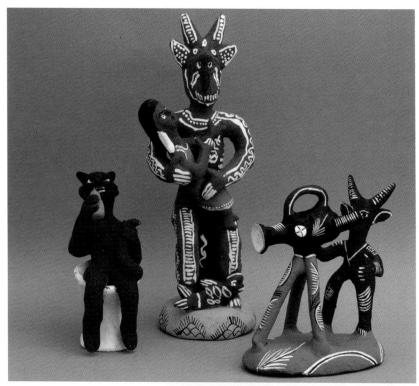

10. *Devil in the WC,*
Mother devil with baby,
Devil cinematographer,
polychromed
clay, Ocumicho,
Michoacán, *c.*2004.

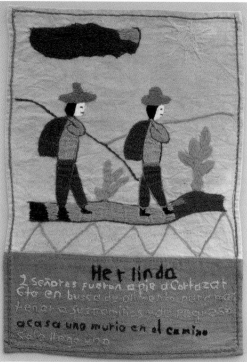

11. Embroidered ex-voto,
San Miguel de Allende, 2002.
Text: Herlinda.
Two gentlemen went on foot
to Cortázar, Guanajuato, in
search of food to maintain
their families; on the way back
home one of them died on
the road and only one arrived.

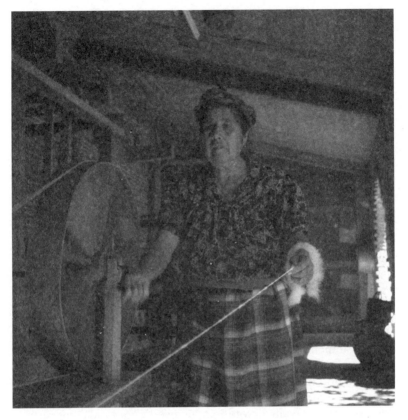

Adela Matías, Teotitlán del Valle, Oaxaca, 2004.

The 'Navajo' designs are much used because they are the easiest to execute. In fact, both Isaac and Josefina say that traditionally the people of Teotitlán made rugs with the pre-Hispanic Zapotec diamond and that those rugs were sold in Oaxaca. They were then taken to Saltillo and finally reached the Navajos;[8] the Navajo weavers copied those designs and now are said to have come back to their place of origin as 'Navajo' designs. This seems a difficult idea to substantiate. We know that there are coincidences and influences of all types in folk art all over the world: however it is only during the last two decades approximately that so-called Navajo designs have been made in Teotitlán. The same designs can be appreciated on serapes made by the Navajos as far back as the nineteenth century.[9] On this issue June Nash asserts:

Copyrights on designs and even trade names to avoid undercutting prices with debased products claiming to be part of the cultural tradition have become important means of advancing the rights of artisans to their patrimony. The current outsourcing of the production of 'Navajo rugs' in Zapotec workshops where weavers carry out the designs of Navajos is a cost-cutting 'solution' that injures producers in both cultures.[10]

I think this statement is debatable. Zapotec Navajo rugs do not appear as 'debased products claiming to be part of a tradition', which is exactly why they are called Navajo and not Zapotec. In the world of art creation, 'copying' another is intrinsic to the field. The copying of ideas takes place all the time, and it is also how we make changes in different fields and in the world.

Very few of the cooperative women know how to make the Picassos and Mirós. Each becomes accustomed to her particular design and, it might be said, specializes in the designs and colours they like most or know best, because if all did the same design there would be much competition between weavers. Josefina for example likes to make *grecas* and landscapes, 'because when I weave I start imagining… What I prefer is to weave a rug out of my inspiration'. In addition, she thinks their own designs sell best.

The women weave fewer hours than the men because they have their housework to do and the children to care for. When they go to an exhibition they have to leave the dinner prepared, so the husband only has to warm it up and then they return home to wash the dishes. The women generally devote four or five hours to making carpets; Josefina weaves six hours a day. The men on the other hand work eight or ten hours a day. According to Isaac, for this reason the rugs made by the women are of lower quality and, besides, they use the warp-to-weft ratio per centimetre 'count twelve and fourteen', and it is assumed that this gauge is easier to work with. The best rugs have a thread count of eighteen and twenty. The women in Isaac's workshop use a warp-to-weft of sixteen.

There are eight men and four women in the shop, and all participate in the complete process. It is the same for all. Isaac, nonetheless, decides which designs are to be worked. The special rugs woven by him, obviously with vegetable dyes, carry his signature. Not all are signed, floor rugs being an exception. 'When it's art I sign, when it's for the floor I don't. Anyone can make a rug for the floor, that's not art', says Isaac. 'Not everyone knows how to weave a Tamayo or a Toledo tapestry. Not just anyone makes a Miró or a Picasso.' He is an

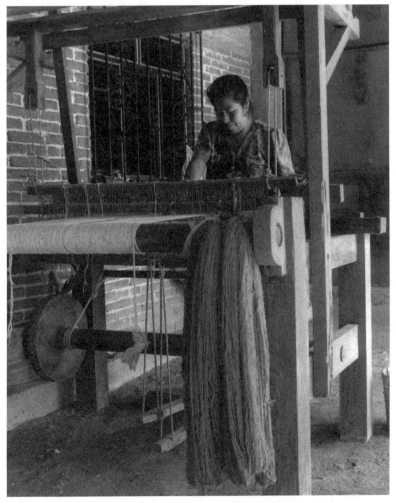

Josefina Jiménez Matías, Teotitlán del Valle, Oaxaca, 2004.

artist, knows he is, and demonstrates by signing his works. The women of the Teotitlán cooperative or Isaac's workshop do not add a signature. It is in fact quite exceptional for rugs to be signed. Although the women of the cooperative attach a small paper tag with the name of the weaver who did the work, all those to whom I spoke considered themselves craftswomen and not artists, just like Josefina Aguilar.

It is worth pointing out that it was not the introduction of designs from elite painters that brought about the significant movement back towards traditional pigments. For these designs, as for the more traditional ones, both natural and industrial dyes are used. However some twenty years ago, perhaps at the same time as the Navajo designs were introduced, a revolution took place that affected the colours of all their creations. They incorporated new tones which they had previously not used, such as very dark oranges, deep reds and blues. This resulted in a drastic transformation in the use of colour, although the use of pure and raw tones did not end.

When copying an artist's design, the weavers often do not restrict themselves to the same colours used by the painter. They tend rather to use whichever colours they see fit, thus altering the original message. Frequently, for example, they use a design taken from Escher but include a colour he never used and thus the difference between the original and the rug is enormous. In other words we find both copies true to the original, with identical colours and design (although differing in size and material) and we also find pieces that show considerable divergence from the model that inspired them.

In the first case, what is communicated is close to what the painter wished to express, but as the medium and size are different, the sensation it produces is also different. Comparing a Miró or a Diego Rivera in a small-scale paper reproduction with the effect given by a large-scale copy woven in wool one becomes aware of a new sensation, a greater warmth for instance. Again, the painting can often be better appreciated in this form than in a postcard-sized reproduction. Nevertheless, a sense of strangeness is unavoidable as the floor does not seem the 'natural' place to find a Matisse. Additionally, this is one of the few conditions under which one can sit or walk on a picture by a famous painter. In other words, when these pieces are not hung on a wall like a canvas or tapestry, they can acquire a practical-utilitarian function through use as a blanket, rug or something to lay across a sofa. To a certain extent they become demystified: as the reproductions on carpets are sold in markets to be placed on the floor, at an economical price, the aura of the elite painter's original work, which is to be found in a museum, becomes dissolved. Also, when the original has undergone this metamorphosis, it is as if we are faced with a new design that vaguely reminds us – again, like the *Friditas*, in a rather enjoyable way – of some distant elite art painting.

Thus, in this particular process of syncretism, we see that – even though the weavers can in principle execute any design – in

practice the dominant tendency is to make simple ones which are then repeated.

The process of repetition inherent in folk art finds, then, part of its explanation, in this case for reasons of both technical expertise and economics. It is always difficult to bring together the creation of art and the satisfaction of the need for survival. In general terms, it is still true that art can be more easily produced when one is sure of having a plate of beans on the table. If weavers of either sex are paid a salary to produce whatever they wish – or if, as in the case of Isaac Vásquez, they have resources and a workshop which guarantee them an income – they can devote themselves to making works of art. On the other hand, if they have to work hard to sell their serapes in order to earn a living and provide the money required to buy materials with which to carry on weaving, it will be much harder for them to produce outstanding works.

Serape stand, Teotitlán del Valle, Oaxaca, 2004.

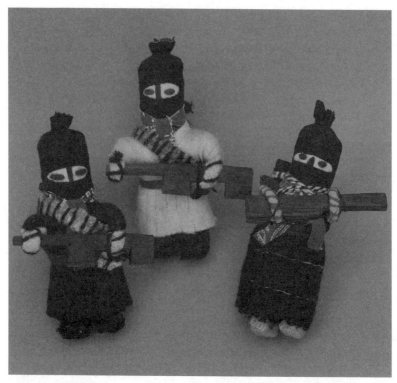

Marquitos, male Zapatista dolls, cloth, Chiapas, *c.*1998.

Chapter Seven

From Humble Rag Dolls to *Zapatistas*

With combinations of folk and elite art being possible, as we have seen, what I shall now describe appears to be a form of articulation between politics and folk art. While art in general and folk art in particular are never alien to politics and ideology, here we shall see the direct link between a popular armed uprising and artistic creativity.

There are some interesting 'characters' of fairly recent appearance among Mexican handicrafts. These are the rag dolls from Chiapas representing Subcomandante Marcos and Comandanta Ramona of the Zapatista National Liberation Army (Ejército Zapatista de Liberación Nacional: EZLN). We find that reborn Zapatism has brought with it a born-again range of local handicrafts.

Such items in general are described variously as folk art, primitive art or handicrafts, depending on the opinion of the person using these terms, probably without any clear differentiation between them. From my own point of view, some of these little dolls can be described as folk art, while the great majority would fall into the general classification of handicrafts. In other words, some present characteristics of art because they show a high degree of imagination, creativity and skill, while others, most of the production, are made in a repetitive manner and are somewhat crudely done.

Chiapas is one of the poorest regions of Mexico as far as its inhabitants are concerned, though rich in agricultural production (coffee, cocoa, cotton, fruit) and precious timbers. Together with the states of Oaxaca and Guerrero it is here that the greatest number of different ethnic groups are to be found. Thirteen clearly differentiated autochthonous languages are spoken besides Spanish.[1] The Tzotzil-speaking population (over five years of age) in Chiapas is 260,026, of whom 133,053 are men and 129,973 women. This is the mother tongue

of the women who make the woollen dolls. 47.5 per cent of Tzotzil women and 26.8 per cent of men are monolingual. The illiteracy rate among Tzotzil speakers aged over fifteen throughout the country is 39.6 per cent for men and 76.7 per cent for women. The rate for the total population of Chiapas is 26 per cent, but in respect of women it rises to 32.7 per cent.[2]

The indigenous armed uprising that began on 1 January 1994 represented a significant alteration to the rules of play in Mexican politics and also contributed to the transformation of the whole political culture. One can clearly perceive the gathering strength of what has been described as the search for:

> A politics closer to the needs and desires of all individuals, less exclusive, that does not merely subsume the needs and desires of some within those of others, that does not hierarchize priority needs, but above all, that particularizes in order to be truly universal. (Millán, 1998, p. 32)

Chiapas was no longer a totally ignored corner of the world and began to be front page news. Fifteen years later it is still news, but the living conditions of indigenous men and women have not improved in the slightest. Rather, they have been at the mercy of the army and paramilitary groups prepared to exterminate them if they can.

Subcomandante Marcos, Guadalupe Tepeyac, Chiapas, 1994.
Photograph by Frida Hartz.

The Tzotzil women, or Chamulas as they refer to themselves, used to make articles to sell to tourists, including embroidered blouses, belts, bracelets and rag dolls wearing the same traditional dress as they and their men folk do. They would dress the dolls, usually female, with the same woollen cloth they use to make their *cotones.*

Chamula female doll, cloth, Chiapas, *c.*2000.

Following the emergence of the neo-Zapatist movement, the crafts-women transformed these dolls into representations of Marcos and Ramona, so that now *Marquitos* and *Ramonas* are found everywhere. They also make *Zapatista* figures out of clay and wood and the charac-teristic balaclavas can be seen on a variety of objects.[3]

These woollen dolls are made by indigenous women from San Cristóbal de las Casas, San Juan Chamula and its environs, but the ori-gin of the *Zapatista* dolls is the result of a curious mix. On one hand, they emerge from the previously existing Chamula dolls that the women were already making, and on the other is a foreign element, since the demand for these dolls came from outside the community.

Two Chamula dolls, cloth, Chiapas, *c.*2000.

During the first weeks of the armed uprising of indigenous men
and women, San Cristóbal de las Casas was swarming with foreign
correspondents whose base was the Hotel Diego de Mazariegos.
Due to the armed struggle, tourism fell off drastically and the crafts-
women had serious problems selling the objects they were making.
Joaquim Ibarz,[4] a Catalan journalist on the Barcelona newspaper *La
Vanguardia*, recounts that the women selling rag dolls made him dizzy
with their attempts to sell him their merchandise and that, a few days
later in San Juan Chamula, he was so tired of saying he did not want
to buy any rag dolls that he told one of the women that if she were to
turn the dolls into *Zapatistas* he would buy them all. She was doubt-
ful and asked him how she was to go about it. She came up with the
answer herself: you just sew balaclava helmets on them and there you
have your *Zapatista*. She brought him fifteen or sixteen and they all
sold. The foreign journalists snapped them up. At first, says Joaquim
Ibarz, they were very basic and crude, but then they began to perfect
them. It was a highly successful strategy and they sold instantly. On
10 February 1994 a photograph of these *Zapatista* dolls was even pub-
lished on the front page of the national daily *Excélsior*. It was their first
public appearance in society, but in this photograph of three dolls,

only one appears with a balaclava and the other two without. In fact the only thing they had done was sew the balaclava onto the doll, all the rest of its outfit consisting of the same traditional costume that had appeared on dolls made up to then.

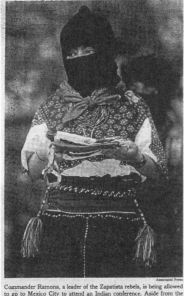

THE NEW YORK TIMES **INTERNATIONAL** *FRIDAY, OCTOBER 11,*

Dying Zapatista Leader Is Focus of Only Accord So Far

By JULIA PRESTON

SAN CRISTÓBAL DE LAS CASAS, Mexico, Oct. 10 — The Government and the Zapatista rebels have narrowly averted the collapse of peace negotiations by agreeing to allow a terminally ill leader of the guerrilla army to travel to Mexico City to take part in a national Indian meeting.

The journey of the ailing Commander Ramona, which began today, is the first time a Zapatista rebel has received official Government clearance to travel outside the southern state of Chiapas since the group's week-long uprising in January 1994 to demand fairer treatment for Mexico's 8.7 million Indians.

In an emotional news conference on Wednesday night in a Zapatista stronghold in the Lacandón jungle, Subcommander Marcos, the rebels' chief political strategist, said Ramona is dying and had expressed a last wish to meet with Indian leaders from other regions. Other rebels said Ramona, a diminutive Tzotzil Indian who had not been seen in public for two years and whose real name was not disclosed, has kidney cancer.

The guerrillas gave her a colorful sendoff from her jungle hamlet in a large sport utility vehicle accompanied by 40 armed and masked rebels on horseback. She is to travel by road to the Chiapas coast and then fly in a Government plane to Mexico City, arriving Friday.

After three days of mostly hostile talks between Zapatista leaders and a team of national legislators who serve as intermediaries with the Government, the safe conduct for Ramona was the only point of accord. The Government failed to persuade the Zapatistas to set a timetable for their disarmament and full return to civilian life, and the Zapatistas failed to get firm commitments from the Government to implement reforms called for in a pact

both sides signed in February.

The Zapatistas started the confrontation last week by insisting that high-level commanders would travel with or without official permission to the five-day conference involving 1,500 representatives from most of Mexico's 96 Indian tribes.

President Ernesto Zedillo said the trip would be a "provocation" and a violation of the law underpinning the peace talks, which suspends arrest warrants for terrorism and other charges against Zapatista leaders while the talks are under way.

Officials threatened to arrest any Zapatistas who tried to leave Chiapas without Government assent. The Government's approach to the Zapatistas has toughened since the emergence in June of the Popular Revolutionary Army, a separate guerrilla organization that is more radical than the Zapatistas and has shown no inclination to stop fighting.

While mediators were wrangling with the Zapatistas in a mud-filled jungle hamlet, President Zedillo toured several military barracks in Chiapas on Tuesday to emphasize his support for the army.

The outcome of the crisis could disappoint Zapatistas' followers. Their bold statements last week gave the impression that several of the highest commanders — perhaps even the enigmatic Marcos — would emerge from the rainforest, defying the Government if necessary.

Apparently anticipating his followers' reaction, Marcos insisted that the Zapatistas did not ask for permission to leave the jungle. "We're just leaving," he said.

Still, Ramona promises to make an impact in the capital, if only for her frailty. Dressed in a finely handembroidered shirt, indigo skirt and a black ski mask, she arrived at the news conference leaning on Subcommander Marcos's arm. Almost too weak to speak, she only introduced herself and left.

Associated Press

Commander Ramona, a leader of the Zapatista rebels, is being allowed to go to Mexico City to attend an Indian conference. Aside from the minor Mexican Government concession that allows her to travel, the latest negotiations with the rebels went nowhere.

Comandanta Ramona from the Ejército Zapatista de Liberación Nacional (EZLN), *The New York Times*, Friday 11 October 1996.

Marquitos and *Ramonas* are made in various sizes, from about six centimetres up to twenty centimetres tall. The male dolls wear a kind of short poncho made of thick undyed wool known generally as a *cotón* (or to the Chamulas as a *chuj*), with a red kerchief at the neck, a rucksack on the back, a wooden rifle in their hands and the chest crossed by cartridge belts; sometimes they also wear a woollen cap. Without exception, all the men have green or blue eyes. The women wear a wraparound woollen skirt, an embroidered blouse and sometimes they have their hair tied back in a pony tail. They carry a rifle,

woollen cartridge belts and sometimes even carry a baby in their arms as well. The *chujs* they wear are white or black, often with a white backstitch (they are, as already mentioned, the same woven cloths of natural-coloured, undyed wool they use to make their own *chujs*). The women who craft the dolls use a backstrap loom to weave the cloth for dressing the dolls: only cloth for the kerchief and the balaclava is bought. There are many more *Marquitos* than *Ramonas*: the male sex of the most visible or emblematic character is definitely the dominant one; *Ramonas* are not abundant. Sometimes the dolls come with feet, sometimes without.

It is worth noting that the myth that Subcomandante Marcos had light-coloured eyes (blue or green) began at the outset, though it seems that they were, at the very lightest, pale brown. They were said to be blue or green in order to underline the fact that he was not of indigenous extraction and even rumoured to be a foreigner. In the event the women who make the dolls simply decided always to give him, as an identifying mark, green or blue eyes. The balaclava and the eyes automatically convert the figures into Marcos. The *Ramonas* do not truly represent Comandanta Ramona (who died in 2006): they are merely the female partners of the *Marquitos* and have no personal identifying feature. This is so much so that in some cases they even make her eyes blue or green, although to judge by photographs Ramona had dark eyes.

We have already seen this strategy at work in the figures of the Aguilar sisters, where they reproduce in clay figures the self-portraits of Frida Kahlo. By emphasizing a particular feature of the person being portrayed it becomes a symbol of that person. Thus the eyebrows are the identifying mark which turns the figures into Frida Kahlo, and in the same way the balaclava and pale eyes enable us to identify Marcos.

It is almost exclusively adult women and girls who make the woollen dolls: the little girls make the smallest ones which are cruder than those made by the women. One of the women told me that some boys and one or two men also take part from time to time.[5] Often the women devote themselves to their art while the men work in the fields, in a trade or as employees of some kind.

The function of these dolls cannot be described as practical-utilitarian: their only purpose is as a souvenir of the struggle in Chiapas for visitors from within Mexico or abroad. They are a local curiosity, like the non-*Zapatista* dolls which were made before (and still are made). They are the equivalent of the regional dolls (in traditional

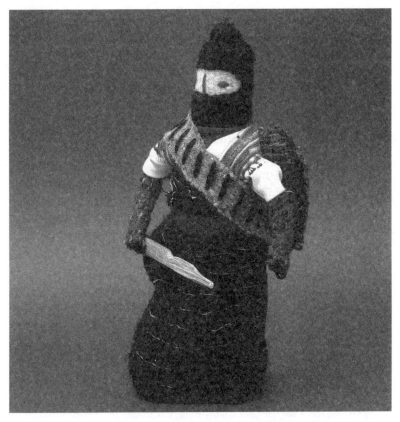

Ramona, female Zapatista doll, cloth, Chiapas, 1999.

local costume) that are made and sold in many parts of the world: they are basically for adornment. Nowhere are they really intended as toys for children: they do not fulfil the play function of dolls. In this case, the purchasers are mainly people who, to some degree or another, are sympathetic toward the EZLN or the struggle of indigenous people in Chiapas, and these objects are thus a symbol of justice and liberty.

A variant of these handicrafts are the wooden slat-sided trucks of various sizes, full of male and female *Zapatistas*, which bear a painted inscription reading 'Chiapas', just another curious example in a long tradition of Mexican curios.

They are almost always made and sold by women, passing directly from producer to consumer, though occasionally mothers make them in Chiapas while their sons and daughters sell them in Mexico City.

They are not readily found in handicraft shops nor are they exported commercially: nevertheless cases of resale do take place locally. If someone runs out of her own stock and sees the possibility of more sales, she may buy from others so as to continue selling.

I asked all the craftswomen/sellers why they make *Zapatista* dolls and they simply said 'Because they sell'. I also asked if they were in agreement with the EZLN. The answer was a laconic 'Don't know'. It seemed to me interesting to discover whether those who make or sell them are in agreement with the *Zapatista* movement even though they might not be actively involved with it. The most emphatic was a seller who told me proudly 'They're not a fashion; they're an ideology'. It is interesting to point out that according to data in 1982 the PRI won 94.8%: at the 1988 elections, 89.1% of the registered population voted for the party in power, the PRI, and in 1995, 50.5%. In 2000 the PRI received 46.9% of votes and a leftist alliance 46.9%; in 2006 the PRI had almost the same, 46.4%, but the alliance went down to 47% [6]. According to George A. Collier (1994) the population of San Juan Chamula was particularly sympathetic to the PRI, and the women who make the *Marquitos* are from precisely that village. It is, therefore, likely that many of the women who make the dolls are not in agreement with the EZLN although perhaps some are not against it, but what is most certain is that hunger does not inquire much into politics.

According to the women, everyone now has a *Marquito* at home and they no longer sell as before. All the EZLN sympathizers with any money in their pockets who ever came upon the possibility of buying one or several Marcos dolls have done so. This is why some women have returned to making the pre-1994 dolls, those without balaclavas. Alternatively they make key chains, earrings and necklaces of *Marquitos*. In fact these can indeed be bought in some handicraft shops, but apparently the *Zapatistas* still sell better than others.

The capacity of these Chamula women in particular – and of folk art in general – for change and adaptation to the demands of the market is incredible. Supposedly, this art is traditional by definition. Some people firmly believe that it does not change: but we see – as soon as the most minimal opportunity arises to make a little extra money on which to live – that male and female folk artists are willing to transform their works or create completely new ones. The economy of Mexican folk artists is so precarious, their products selling at such low prices, that it is hardly surprising they are more than alert to new sales possibilities which might help guarantee their daily subsistence.

The *Marquitos* and *Ramonas* are condemned very soon to disappear entirely for several reasons. The effervescence generated by the initial armed rising of the *Zapatista* movement has declined, along with the sympathy it aroused worldwide: thus also the interest in buying these dolls. The future of the EZLN and the Frente Zapatista de Liberación Nacional has become uncertain. The promulgation of a controversial law on indigenous rights and culture will, among other effects, inevitably bring about changes that may result in the movement's disintegration. The market is becoming saturated, and this will lead to the figures no longer being made: at the same time, the very material – the wool – used to make them has a fairly short life, being much less durable than stone, metals or even wood,. This, then, is just one more of the many expressions of ephemeral folk art that have existed and will continue to exist in Mexico.

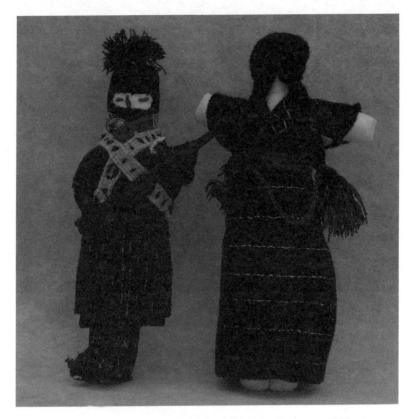

Marquitos and female Chamula doll, cloth, Chiapas, *c.*1999.

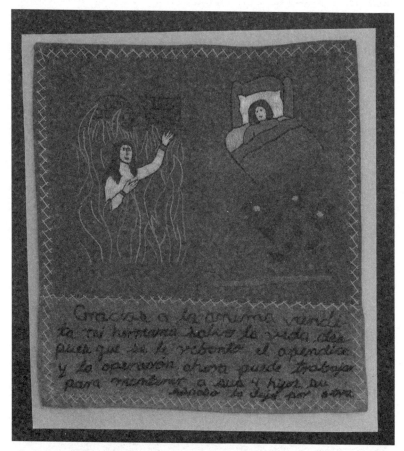

Embroidered ex-voto, San Miguel de Allende, *c.*2002.
Text: Thanks to the Blessed Soul, my sister came out alive after her appendix burst and they operated on her, now she can work to support her four children after her husband left her for another woman.

Chapter Eight

Embroiderers of Miracles

The daily miracle worked by the women of Guanajuato is insufficient to earn them a decent life and provides no escape from penury. Arid, semi-desert lands, where prickly shrubs and cacti such as the *cardón* and *huizache* grow, and the grass is very yellow throughout the dry season, the vista is broken from time to time by large cultivated estates, where the crops are green, always green. In the highest areas there are evergreen woodlands, but elsewhere is a landscape of spiny bushes, interrupted by *nopal* cactus plantations and irrigated pastures. There in the small villages surrounding San Miguel de Allende, there is no miracle that really works.

San Miguel is 274 kilometres from Mexico City. In 2000, the municipality as a whole had a total population of 139,297 inhabitants, of whom 47.6 per cent (65,487) were men and 52.4 per cent (73,810) women; 96 per cent of the population describe themselves as Catholic.[1]

About fifteen years ago some of the many embroiderers who live in this part of the state of Guanajuato began to make ex-votos. They also refer to them as *milagros* (miracles), *retablos* (as the painted ex-votos are also known), *cuadros* (pictures) or simply embroideries. They also call them 'the miracle of the day', since in the daily experience of these women, if someone fell sick then recovered and told their story in an embroidery it was a miracle, the miracle of the day. Of course these women were not the first to make embroidered ex-votos. Victoria Novelo, in a book compiled by her, *Artesanos, artesanías y arte popular de México*, reproduces one from her own collection.[2] It was made by Doña Carmen Díaz de León, of Coyoacán in Mexico City, and it was given to Victoria as a wedding present in 1965; she also made the frame. 'She was a consummate craftswoman, who embroidered and made decorated ceramics as well', says Novelo.[3]

In the state of Guanajuato there are several communities where embroidered ex-votos are made, all of them belonging to the *ejido* of San Martín de La Petaca.[4] Los Barrones, La Cuadrilla, La Petaca itself, El Bordo, Capilla Blanca and El Lindero are the hamlets close to the town of San Miguel de Allende in the direction of Dolores.

The village women have done embroideries for as long as anyone remembers. Before, they only used to make napkins and other simple things to sell if they found anyone who would buy them, but it was always difficult since there were many women making such things and few buyers.

Karen Gadbois is a woman from north of the border who has a handicraft shop in San Miguel and was one of the promoters of the idea of marketing the embroidered 'miracles' and similar objects produced by the villages' women.[5] In 1996 Karen teamed up with another North American, Susan White, to whom the idea of ex-votos had occurred, and together with Ángeles Agreda they set up the group 'Mujeres en Cambio' (Women in Change) in the hamlets of the La Petaca *ejido*. This newly invented folk art – the embroidered ex-voto – was likely to be a success since it would be attractive to tourists: these are small objects easy for people to transport as they travel.

Ángeles Agreda, San Miguel de Allende, Guanajuato, April 2002.
Photograph by Eli Bartra.

Karen explains that she taught the women to dye the cloth and make the ex-votos; she also provides them with the materials. She stresses, however, that the ideas given form in the embroideries come from the embroiderers. She motivates them, for example by suggesting that in their work they 'say something about the village' or 'tell a story about daily life in the community'.

The group began with about ten and grew to around eighty: numbers have since dwindled as a result of the problems they have experienced in marketing their products and because of internal rivalries.

Apparently the cost of each ex-voto to Karen is approximately twenty dollars (raw material, labour, commission to Ángeles as manager of the group and intermediary, infrastructure costs) and she sells them in her shop for about thirty dollars. Generally, what the embroiderers actually receive is around six or eight dollars a piece. In the FAI (*Fundación de Apoyo Infantil*) charity shop in San Miguel the ex-votos cost 10 dollars because they are of a lesser quality than those Karen buys. They can also be found in some more exclusive outlets in San Miguel, for example the bakery 'La buena tierra', where the prices rise astronomically. In 2002 they displayed a panel made of sixteen individual ex-voto *cuadros* for which they were asking about 900 dollars, and another consisting of twelve *cuadros* marked at 700 dollars: both were marvellous pieces of work.

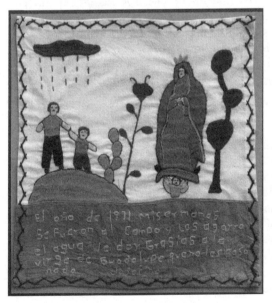

Embroidered ex-voto, San Miguel de Allende, 2002. Text: In the year 1971 my brothers went to the fields and got caught in the rain. I give thanks to the Virgin of Guadalupe that nothing happened to them. Josefina.

The money earned by the embroiderers is not enough even to guarantee their subsistence. The best years for marketing were 1998 and 1999, but by 2003 it was practically impossible to market ex-votos. In recent years an annual exhibition has been held abroad in Houston and San Antonio, Texas, in South Africa and also at home in Guanajuato and Mexico City.

From time to time women arrive from the United States – some from peace organizations – and commission work of them: in 2002, for example, they were asked to make seventy little flags in blue cloth with a dove embroidered in white and a flower, also white, in its beak, with the words 'peace' above and '*paz*' below.

In some of the hamlets, assistance has been provided by the government in the form of loans to buy material. There is a state agency in San Luis de la Paz that also supports them to go to fairs and exhibitions to sell their products. Usually one or two members of the group go.

The situation is that there is no market, no tourism: it declined considerably after 11 September 2001. In 2002 there was a foreign person supporting them, commissioning work, but she tells them what she wants them to do; for example they were asked for a dozen or so cloths embroidered with a fountain similar to one at San Miguel. Previously, the embroiderers did what they wished, whatever occurred to them to do, but this way they only do what is asked of them. The foreigner made up a sample book and took it to the United States to see if the embroideries could be marketed there. Cushion covers are one product selling a little better now.

To reach Los Barrones, one of the hamlets where embroiderers live, one has to pass through the village of Atotonilco, and from there continue a distance of some four miles on an unsurfaced road. There are around fifty families, living mainly in adobe houses with corrugated asbestos roofs.[6] Not one street is asphalted and the community lacks even a school; the children have to go to a nearby village, La Cuadrilla. I interviewed the women of this community with particular attention to their embroidered ex-votos. All of them laughed when talking about the stories told in their 'pictures'; these sometimes take the form of traditional ex-votos but are often merely stories about the community. All of them embroider in the 'spare moments' left by their infinite domestic chores. Francisca Bárcenas, 'Doña Pancha', functions as the leader of an untitled group made up of eleven embroiderers. In the *ejido* as a whole, several groups of embroiderers have been formed, mainly for the purpose of obtaining loans from

the government and from a number of NGOs. A few years ago Doña Pancha's group was awarded a loan from what was until recently the National Indigenes Institute (INI), principally for the purchase of material. Several of the women say that it was a mistake, since while some have already paid back the part corresponding to them, others have not and this affects all of them. Antonia Hernández is another of the group's more dynamic embroiderers; she lives with her husband who has a carpentry workshop next to the house. Antonia wears a machine-embroidered tee shirt of industrial fabrication. It is curious how almost none of the communities that produce folk art actually consume it themselves. As in this case, the idea that folk art is created by and for the 'people' is generally not borne out by the facts. At most the embroiderers make use of a few napkins they have embroidered.

Doña Josefina, Los Barrones, Guanajuato, December 2002.
Photograph by Eli Bartra.

Most of the embroiderers are young women of between eighteen and thirty, and they wear skirts much more than trousers. Almost all are married: there are few single women.[7] None of them speak Otomí, although a few remember their grandparents doing so: the language has now disappeared from this region. Some are able to read and write, others not, and their names do not even appear in the civil register.[8]

Some receive support from 'Progresa', grow vegetables and devote themselves to their children; others work as house employees in San Miguel. Some have a husband, others are widows and yet others are single mothers. There are few men in the communities since emigration to the United States is intense; girls, boys and women predominate.[9] No man does embroidery.

Ángeles Agreda is an extremely dynamic woman of middle age, enterprising and talkative. She lives in San Miguel de Allende, in a cobbled street, and in her house she has set up a miniscule grocery store which, as she says, is not going too well. In April 2002, I interviewed her for the first time. Often noisy buses went past drowning out our voices and then merged into the incessant barking of dogs; you could also hear the birds chattering and the cocks crowing endlessly. Ángeles told me that she used to do embroideries herself; she knows how to do them well enough to be able to teach the women, but now she devotes herself only to coordination, supervision and organization of the embroiderers' work. She says she learned to embroider at primary school because she had a very good teacher. At one time she was employed as a social worker for the national government agency DIF, which focuses attention on families in poorer districts, and there they trained her for many activities including embroidery, weaving, sewing, and growing vegetables. Then she worked full time at the municipal branch of the DIF. One day a foreign woman saw some of her embroideries in exhibitions and invited her to work with her for a period of about eight months, Ángeles continuing to work part time at the DIF. This woman recommended her to another foreigner to take part in the organization of a dress-making group, where she worked for four years: the group was successful.

Ángeles also does the finishing of the work and puts the pieces together when they are intended to form an ensemble: in other words, she sews the small squares (six, eight or more, depending on the size required) onto a finer cloth. The finishing can be done by machine, but generally it is carried out by hand. At the same time, she acts as intermediary in the marketing of the work, particularly that

of the women at La Petaca. It was she who received the order for the little peace flags mentioned above. When she has the opportunity to make a complete embroidery she finds it very satisfying, but she rarely has time for that now.

'The idea is that the women work at home in order to be able to look after their children', explains Ángeles. For her, a woman's place is – or ought to be – in the home, even though she herself is a woman who works away from home and also maintains her family. However, she recognizes that if women have children and have to look after them it is best to have paid work one can do at home. It is perhaps for this reason that so many women are engaged in the production of folk art, because in most cases they can do it at home and thus keep an eye on the children at the same time, even interspersing work with all the household chores.

In 2004 Ángeles was working principally with half a dozen women from La Petaca, as this is the village closest to the main road and thus the easiest to get to for people like her who have to travel by bus. They are from two families: each woman works in her own house but sometimes they get together in the evenings or when they are looking after the children and embroidering at the same time. Inés Trujillo is one of the best and most active embroiderers. She is thirty-five years old and married to an employee of a gas distribution company. She has several small children. They live in a brick-built house with a cement floor and a 'Catalan' brick vaulted roof. The rooms are separated by curtains in place of doors. She had previously worked as an assistant in a pastry shop, house employee and day-labourer in the fields. She says this last job was the least humiliating.[10] Inés and her two younger sisters, Alejandra and Liliana, obtained a loan to buy material from the INI. They were given the sum of 1,025 pesos (about one hundred dollars) each and in this project they have been involved with the women of Capilla Blanca, who invited them to take part.

As for exhibitions, they are not all able to attend freely, the reason often being the husbands' opposition. Inés told me, for example, that 'Cata's [Alejandra's] old man took a stick to her every time she went to an exhibition'. Besides there are malicious gossips who invent things about the women who go to exhibitions. Inés has become very sceptical about collective projects; she states that between the gossip-mongers and the jealous *machista* men the projects have little chance of prospering. She thinks there is a serious lack of solidarity, much envy and many other problems to solve. She also mentions a certain Don Camilo who is the former *ejido* commissioner: he used to take

their work to exhibitions in different parts of the country. He seems to have done very well since he now owns a tractor, a thresher and a machine for making tortillas. Ángeles Agreda says that Inés is a genuine artist who 'knows very well how to bring out the designs'.

Ángeles gave the impression that the women are no longer interested in making ex-votos except under commission. This seems a great shame, since these are the most interesting pieces of work they do. 'The problem is always the economic one because often one knows how to produce but not how to sell', says Ángeles. 'We need someone to support them in order to be able to move the work', she says. 'The hand embroidery thing was something exceptional, but it seems that the people of Mexico don't value this type of work; it's always been foreigners who value manual work, needle, thread and thimble. Not Mexicans', she concludes.

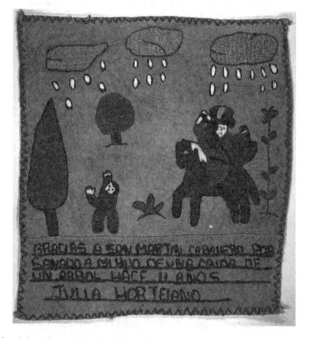

Embroidered ex-voto, San Miguel de Allende, 2002. Text: Thanks to San Martín Caballero [i.e. St Martin of Tours] for having cured my son after a fall from a tree 11 years ago. Julia Hortelano.

The working process is basically the following: Ángeles explains to them what is to be done, and writes it on a sheet of paper. Then she

makes a drawing of what is wanted on two pieces of calico previously dyed in different colours: the embroidery is then done on the calico, with the larger piece sewn onto a smaller piece below which carries the written legend. For the design, Ángeles brings them a photo, for example, and says 'This is what I want'. Those who work best get the orders and then, of course, jealousy arises. Ángeles keeps them apart on purpose to avoid problems because when she had the seventy or eighty women all together there was much destructive criticism. For instance there were rows about a lady called Cuca, who is in charge of a team at La Cuadrilla: she embroiders and also takes other women's pieces to sell, but forgets to pay for them.

Ángeles Agreda has started up a new enterprise to try and market the embroiderers' ex-votos. She has gone into association with a shop in San Miguel, 'La Victoriana', and made up a catalogue that bears the name 'Folk-Heart', with samples so that people can order an ex-voto like those that appear in it or can even ask to have one done to their own specification, to celebrate a wedding anniversary, immortalize a dog which died, or the canary who flew away. The cost of an ex-voto like these is 500 dollars. This new business is obviously orientated entirely to foreign, mainly US, tourism. There is also a gallery on the internet entitled Kalarte, which offers ex-votos at thirty dollars.

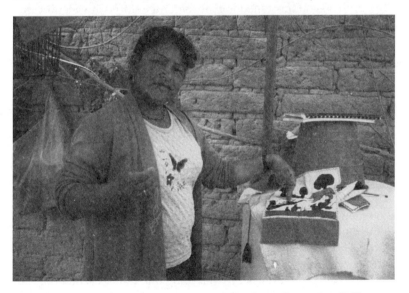

Antonia Hernández, Los Barrones, Guanajuato, December 2002.
Photograph by Eli Bartra.

At La Petaca there is another small group of embroiderers also connected with Ángeles Agreda. Among them is Carmen Velázquez (Carmela) and her daughter-in-law Beatriz. Carmela is quite discouraged at the lack of orders. She says that nowadays they are not doing anything, having little to keep them occupied. She lives in a well-built and nicely painted brick house with a tiled floor situated next to the main road; her husband is working in Texas. She is a good embroiderer who took dressmaking classes with a teacher paid by the INI, but now is making few pieces. It appears she is going to participate in a new project for embroideries of pet animals.

The FAI (*Fundación de Apoyo Infantil*) has been a member of the Save the Children international alliance since 1973. It has five offices in the country (Mexican headquarters plus four regional offices: Centre, Chiapas, Sonora and Guanajuato). This last has links with the embroiderers of the nearby communities, particularly those at Los Barrones. FAI Guanajuato has a shop in San Miguel de Allende, which is one of the few places where the embroidered ex-votos and other objects made by the region's embroiderers are marketed. In general the material is delivered to them, but in the case of ex-votos the embroiderers themselves buy it: they use a very thin calico of poor quality and cheaper than others and the finishes are not so well done. They are also commissioned to embroider tee shirts with a landscape: they embroider the words 'FAI save the children Mexico' and the logo, then underneath they write 'San Miguel de Allende, Gto.' and add their signature, 'Josefina', for example, or whoever it was who did the work. The FAI also sells little make-up bags decorated with birds, lambs, cottages, flowers, butterflies, clouds, the sun and *nopal* cacti with a few *chaquira* and *canutillo*. Both the tee shirts and the bags are made at Montecillo de la Milpa.

The different ex-votos vary in quality as far as the execution of the design is concerned, the type of calico used, the finishes, and the embroidery itself which can be more or less fine. Thus the prices vary considerably. There are some embroidered ex-votos that are quite extraordinary from the aesthetic point of view, both on account of the felicitous colour combinations of the cloths used, the perfection in the embroidery and the choice of coloured threads. In general the ex-votos are characterized by their bright colours and striking combinations of cloths and threads. When the embroideries tell stories of the family and community, the first thing one notices is that they are full of women and children. It is only to be expected as there are more women and children than men in the villages: the men migrate or are

out working in the fields. And unlike the painted ex-votos, these are made exclusively by women: it is through their eyes that we see the 'miracles' that have taken place. Men, however, do appear in them: men who suffered illness or some accident. Many of the accidents are minor ones: cuts on the hand, the foot, or a blow to the head. There is a parallel between these ex-votos and the painted ones to the extent that in both cases it is almost exclusively women who express their gratitude for having been cured of an illness, or for the recovery or good fortune of some other family member, especially children. They also give thanks for the husband's having found work, for instance, or for the recovery of a lost animal. The women give thanks too for their regained well-being after minor domestic accidents. We find that the constants regarding the problems affecting men and women which give rise to the search for divine intervention are the same for both embroidered and painted ex-votos. One suspects, however, that often the stories told are pure fictions: no saint or Virgin is thanked for having interceded in view of an adversity, since the adversities mentioned are actually just made-up stories. They imitate the 'true' painted ex-votos that do indeed have the religious function of giving thanks for the granting of a miracle.

The 'classic' ex-votos also have a 'classical' composition: an image which is an object of devotion and a catastrophic story which, thanks to divine intervention, turns out not to be fatal. The story is told in images and also in text: the event represented by the image is explained in words at the bottom, embroidered on a separate piece of cloth of another colour which is stitched to the upper piece.

The women create what are really nothing more than embroidered samplers, with inscriptions that say for instance: 'Thanks to Don Jose Luis who gave us plants. This year my children ate apples, lemons and grapes. O.L.E.'. Then there are others that express an ecological or social conscience, with messages like: 'With the rain the fields grow green and the animals do not go hungry. Oliva.' Or 'We pray to God that our dads may spend more time with the children and play with them more...' (unsigned). Or 'Remember not to leave your rubbish lying around'.

It is very interesting how time and time again the idea of the providing father is reproduced, when actually it is often the women who are the main, if not the only, providers. There is one in which, as if in the place of God, a man appears surrounded by chicks, a flower and a plant. The legend reads 'Thank God that my husband has had good luck in finding work and so my children will not be short of

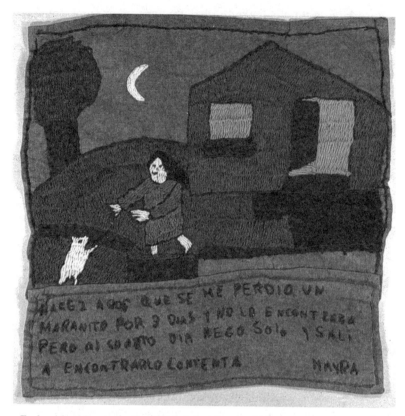

Embroidered ex-voto, San Miguel de Allende, 2002. Text: It's 2 years since
I lost a piglet for 3 days and couldn't find it, but on the fourth day it came
back by itself and I went out to meet it with joy. Mayra.

food. Oliva'. Often thanks are given to a superior being, although no
embroidered image is included; for instance gratitude to the 'Lord of
Mercy', but the divine being is not shown.

In addition, it is fascinating to see once again that the Virgin of
Guadalupe (a recurrent motif in Mexican art) is shown as white
skinned with blue eyes and light chestnut hair. The angel is depicted
similarly, but this is even more common. On being questioned
about this, Josefina, who embroidered the piece, just laughs. It has
already been pointed out that it seems they hold in higher honour
and respect a white Virgin than a dark-skinned one. If they represent
her with brown skin she is their equal, equal to the common mortals

surrounding them. So to make her divine, to make her more sacred, it is necessary to change the colour of her skin, eyes and hair so that she becomes a more suitable object of veneration. Nonetheless, in the case of the ex-voto this hypothesis is immediately questioned by the fact that the people shown next to the Virgin are also represented with rosy skin and blue eyes. On the question of the skin one might imagine that they simply use what is called flesh colour, which is pinkish. But this does not explain the eyes.

Most dates on the ex-votos (where they exist) seem completely invented along with the story. Nonetheless, the embroiderers insist that the events referred to are genuine and either happened to them or they heard happened to other people. Many of the miracles they tell of are more or less amusing, and the same applies to the events they describe about their communities.

Within the field of folk art the idea that anonymity is a basic characteristic is becoming less and less true. For different reasons, the visual folk arts, and in this case the embroidered ex-votos, are signed. The embroiderers of Los Barrones told me that the women who ordered them from north of the border asked for them to be signed, so that 'they wouldn't get lost', and also they would know who was responsible for each one. Until recent times both male and female folk artists were almost always anonymous for consumers outside the producing community, although normally known to other members of that community. Practically all these ex-votos are signed and it seems to be a growing practice. Some just write the forename, others write forename and surname, some even including both surnames. Others just put their initials.

Many of these embroiderers show imagination, creativity and mastery of their technique, yet it appears that all this is not enough to obtain recognition in the field of art. For art of any kind to thrive it needs social capital in the form of market, patronage or individual resources. In the absence of such resources, these women are forced to create art in a hand-to-mouth situation that must inevitably limit their creative capacity. The creation of each 'miracle' is just one more step in a strategy for survival.

Epilogue

Folk art is eminently feminine. Of course this could only be a metaphor; but the fact is that large numbers of women throughout the world work daily in the creation of folk art. It is beyond any doubt that there are many more women involved in folk art than elite art. There are folk arts in which only women are involved, as we have seen: there are others where only men work, and yet more in which both genders are occupied. But this art, in general, shares with women as a group the condition of social subordination. It also shares their undervaluation and anonymity, and hence the somewhat metaphorical affirmation that this art is feminine.[1]

Folk art is regarded as inferior but at the same time, when convenient, it is exalted. The same happens with women: Cinderellas all year long, then 'queens' of the household for a day – Mothers' Day.

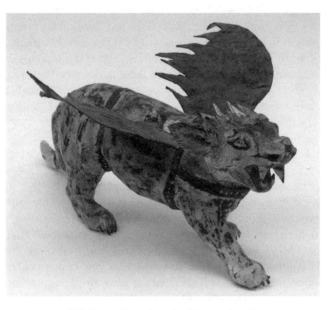

Alebrije, attributed to the Linares family.

There are deep-rooted differences that lend folk art its specific geo-cultural identities; yet at the same time the forms of folk art produced by different peoples the world over present considerable similarities, and it is not always easy to discern whether this is because of specific influences or a result of mere coincidence. Individuals or social groups from different countries and cultures with very similar concerns, interests, aims and tastes find similar modes of expression in art in spite of the different cultural and geographic contexts in which they live. I think that it is often possible to distinguish, as I have tried to show, forms of folk art and interests (real or socially imposed) that correspond to men or women as distinct social groups, although they may originate in different places and periods.

As we have seen in the examples of folk art creations dealt with in this book, artists of both sexes frequently create their works upon commission; when the market becomes restricted such commissions become increasingly essential for survival. Both the painted and embroidered ex-votos, the *alebrijes*, the *Friditas* of Josefina Aguilar of Ocotlán, the clay figures of Ocumicho, and in many cases the serapes of Teotitlán del Valle, are done to order. In the case of the Judases, commissions are further conditioned by the seasonal demand of Easter week.

Working to commission is, of course, by no means exclusive to folk art. Throughout history, 'high' art has been – and still is – also often executed to commission; this fact does not devalue its creations in the slightest. Besides, far from marking a difference between the two types of art, it points rather to a similarity. Whether working to commission imposes more limitations on imaginative freedom than working to market demand is another matter; however it is likely that in some cases – perhaps that of rugs and certainly that of embroidered ex-votos – this is so.

When the commission takes the form of a request for a copy from a model, the colours are often determined by the model (as with *Friditas*): in other cases (the serapes, for instance) the artists may or may not choose to follow closely the original. With *ocumichos*, the freedom of expression enjoyed by the women is considerable, and while the weavers of Teotitlán have greater liberty when executing a landscape (where they can give free rein to their imaginations) than when copying a Miró, even here they often feel free to diverge from the model's colours. With *Friditas* and *ocumichos*, one can appreciate that the women invest their full creative capacity and imagination in the same way as they do in other figures of their own complete invention. Or is it going too far, in any case, to speak of 'complete invention'?

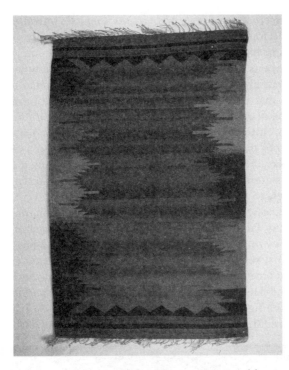

The 'Women who weave serapes' group, serape with *grecas*,
Teotitlán del valle, Oaxaca, 1999.

In all the instances I have referred to, art is the result of family-
collective labour; competition is very strong for all the artists.
Nevertheless, the only women who have sought a collective solution
are the weavers of the Teotitlán cooperative, where, though each
weaves her own cloth, output is marketed jointly. In the cases of
Josefina Aguilar and the artists of Ocumicho, competition is brutal: in
the former with her own sisters, in the latter because of competition
from the whole village, and solidarity has not been the solution to the
problem. In both instances the problems of competition are solved in
an individual family way and by means of the subordination of some
to others, because in both cases there is, for example, subcontracting
of part of the process to third parties. Those who cannot finish the
pieces alone (often for economic reasons) sell them to others who
carry out the painting and thus 'appropriate' the work of others.

The artists of Ocumicho, besides copying the images provided to
them, add something of their own. In their approach to reproducing

models, the creators of both *Friditas* and *ocumichos* introduce new elements quite foreign to the originals, which they modify and convert into works in harmony with the rest of their production. Something similar happens with the rugs from Teotitlán, for example those that present themselves as Eschers but in truth are very similar to the types of designs that the weavers have been doing for a long time. In all these forms of reproduction of 'cultivated' art, in some way there is an insertion into the style or kind of art that these makers habitually produce: into their own characteristic aesthetics. That a carpet has a Miró, a 'Navajo' design or a step-and-fret design copied from Mitla is of little significance, although their own original designs respond more closely to their imagination and tastes. In any event, there is a harmony among all the rugs; one doesn't feel at all that one is looking at something false or inauthentic, a plagiarism or arbitrary importation. One of the most interesting questions involved has to do with precisely that sensation of authenticity. One has the impression that the *Friditas* have always cohabited with the mermaids and the ladies of the night. The same thing happens with the Miró and Picasso rugs and with the figures from Ocumicho. Hernán Cortés, La Malinche, Robespierre, Marie Antoinette, the little devils, the snakes and all the

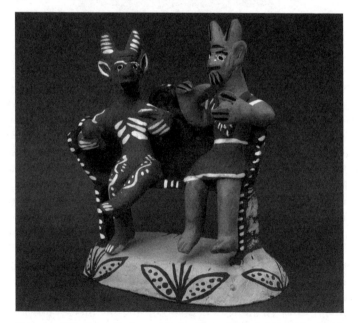

Couple of Devils, polychromed clay, Ocumicho, Michoacán, 2004.

other creatures that habitually people these creations are integrated into the harmonious whole which is the work of these folk artists. The syncretism this gives rise to is a fusion between folk and 'high' art forms, colour sense and subject matter. The form and the materials of folk art are used to execute themes that correspond to 'high' art. It is the same style, one might say, and of course the same clay that is used to make a mermaid or a Frida Kahlo painting. We can see something similar with the serapes: with identical material and often the same colours they weave an Escher, an Aztec calendar, or the step-and-fret motif. And with the *ocumichos*, in fact what mainly changes is the subject matter of the figures, as mentioned above. There is little doubt that in these three cases cited a greater variety comes into being, but all of them remain within the same style, the same vein.

The process of reception is very different as regards these syncretic creations. No one reacts to *grecas* as they do to a Picasso. Nobody regards a mermaid in the same light as a figure based on Frida Kahlo. In the case of *ocumichos*, besides copying certain models, there is a historical referent that, in general, surprises and intrigues the receptors, making them laugh: in short, a special and different kind of reaction is produced.

I believe that this folk art, which I have described as involving a process of syncretism, does not lose authenticity, nor even identity. It is certainly transformed, in the same way as folk art in general undergoes gradual change in any case, in countless different ways with the passing of the years and for a variety of reasons: but above all this syncretism represents an enrichment of folk art. The men and women who produce folk art are often, without abandoning their tradition, searching for new sources of renovation. The process I have described represents just that: renovation within the traditional.

At the same time, new and different receptors – above all abroad, but also in Mexico – have been reached, for example the public that attends museums and art galleries, and in the case of the *Friditas* the particular cult group who have been described as Fridamaniacs.

In 1940, Alfonso Caso warned of the terrible 'danger' that the introduction of alien elements into folk art could represent for its survival as such:

> One of the worst dangers that can exist for the folk arts is the presumptuous idea of introducing new motifs and models in order to modify production. Such has already occurred for example in the serapes of Oaxaca, where someone had the idea of providing the weavers with archeological drawings for them to copy [...].

Never intervene in folk art by providing models or 'improving' the inspiration of the artist; any intervention, even by the most educated and well-prepared people must lead to the decadence of folk art.[2]

In fact, often much more dangerous are the extreme poverty and the demands of capitalist society which oblige producers to increase production, introducing factory methods and reducing quality, with the aim of increasing sales. I believe that the first of these factors is not always a danger, but in fact may often turn out to be a blessing, a source of enrichment.

A final question is that concerning the artistic nature of folk art and the self-awareness of the artists, who have their own particular idea of the artistic nature of their creations. Josefina Aguilar, for example, tries to make her figures aesthetic, 'as beautiful as possible', and she likes them, but she considers them a kind of handicraft rather than art. The same is true of the female weavers of Teotitlán and the women of Ocumicho. Not one of them regards herself as an artist. Also many elite artists, likewise, do not regard those who make folk art as artists. I have already mentioned the opinion of Rodolfo Morales who refused to consider the Aguilar sisters as artists, describing them as craftswomen. The women of Ocumicho even speak disparagingly of their works as '*monos*', a word applied generally to dolls or any caricature or grotesque kind of figure: it never occurs to them to say they are art.

The concept of the aesthetic in the works of folk art to which I have referred is as elastic and relative as it is in 'high' art. Neither within folk nor elite art do universal values exist. Aesthetic values are indissolubly linked to the particular cultural context in which each type of art is created, the social classes and gender of the people who produce them. All of this plays a role as far as aesthetic evaluation is concerned.

Nonetheless, within the field of Western art history and criticism, certain rules – golden rules, one might say – of aesthetics do exist. If one tries to apply those same criteria to folk art they are often found to be of no practical use; and if one persists, one merely comes up with the judgement that folk art lacks aesthetic value, and more than a few commentators have wished to demonstrate this.[3]

While it is true that folk art is the result of a process consisting of creation, distribution and consumption, one should not therefore neglect the study of the artefacts themselves. But neither does this mean that the works should be seen in isolation from all that goes into their production, from their social context. The important thing

is to try to see all aspects of the process, and also of course make judgments of an aesthetic nature that will probably have to be based on different value codes, constituting what have been referred to as the aesthetics of folk art. In no way does this simply imply an undervaluation of folk art: in the same way as when one talks about a feminine aesthetic, this does not have to be understood as a 'sub-aesthetic' but simply one that is different and does not necessarily follow the aesthetic principles dominant in the West.

Although the examples I have discussed do not belong to the practical-utilitarian category of folk art, being creations whose functions in two cases are religious and in the others purely aesthetic, one cannot say that we are looking at a popular form of 'art for art's sake'. The creations I have referred to are executed in accordance with a tradition (there is no free selection of the art forms to be made; artists basically do what their mothers – or fathers – did, or what the community as a whole does) and basically they do it in order to put food on the table. As we have seen, however, they do also transcend tradition. It is a way of life and a way of surviving. The notion of art for art's sake simply does not exist among these artists who spend their lives creating and create in order to live.

Notes

Introduction

1 See Gene H. Blocker, *The Aesthetics of Primitive Art* (London,1994). This author stresses the fact that the philosophy of art – aesthetics – has simply ignored primitive art. His assertions are equally applicable to folk art. The philosophy of art simply does not contemplate folk arts: they just do not exist.

2 There are some books devoted exclusively to the ex-votos (see Works Cited).

3 Roberto Montenegro, *Retablos de México. Mexican Votive Paintings.* (Mexico City, 1950) p. 9.

4 I refer to the concept of surrealism in a broad sense and not to art belonging to the French surrealist movement initiated by André Breton in 1924 with his first *Manifesto*.

5 Michael Chibnik, *Crafting Tradition: The Making and Marketing of Oaxacan Wood Carvings.* (Austin, 2003) pp. 242–3.

6 As can be seen in Judith Bronowski's video *'Pedro Linares: Papier Maché Artist'*.

7 On this matter, see the interesting article by Rasheed Araeen, 'From Primitivism to Ethnic Arts' in *Third Text*, 1 (1987), 6–25. Also the book by Michael Chibnik, *Crafting Tradition*, where the author uses the concepts of tourist and ethnic arts without questioning them in the least.

8 See Colin Rhodes, *Primitivism and Modern Art* (London, 1994).

9 Edward W. Said, *Orientalism* (New York, 1979), p. 332.

10 Donald Preziosi, *Rethinking Art History: Meditations on a Coy Science* (New Haven, 1989), p. 46.

Chapter One: Folk Art and some of its Myths

1 Marta Traba, 'Relaciones actuales entre arte popular y arte culto', in Various Authors, *La dicotomía entre arte culto y arte popular. Coloquio Internacional de Zacatecas* (Mexico City, 1973), p. 62.

2 Ana Sojo, *Mujer y política* (San José, 1985), p. 21.
3 Umberto Eco, *The Name of the Rose* (New York, 1984), pp. 430–1.
4 Juan Ramírez de Lucas, *Arte popular. El arte que hace el pueblo de todos los pueblos de la tierra* (Madrid, 1976), p. 152.
5 Martín Letechipía, 'Piel de papel: fiesta, crítica social y artesanía ritual en Zacatecas', unpublished paper, *c.*2007, p. 1.
6 See, for example, Montserrat Galí, 'La historia del arte frente al arte popular', in *La expresión artística popular* (Mexico City, 1982), pp. 9–26.
7 Ernst H. Gombrich, 'The primitive and its value in art', *The Listener*, vol. 101, nos. 2598, 2599, 2600, 2601 (London, 1979).
8 As Marge Piercy expresses it in a poem:

> The work of the world is common as mud.
> Botched, it smears the hands, crumbles to dust.
> But the thing worth doing well done
> has a shape that satisfies, clean and evident.
> Greek amphoras for wine or oil,
> Hopi vases that held corn, are put in museums
> but you know they were made to be used.
> The pitcher cries for water to carry
> and a person for work that is real.

> *To Be of Use* (New York, 1969), p. 50

9 Marta Turok, *Cómo acercarse a la artesanía* (Mexico, 1988), pp. 28–9.
10 Assistentialism is a neologism that comes from the verb to assist, to help.
11 Griselda Pollock, *Vision and Difference: Femininity, Feminism and the Histories of Art* (London, 1988), pp. 55–6.

Chapter Two: Women and Votive Paintings

1 Ruth Lechuga, 'Procesos de cambio en el arte mexicano' (Mexico City, 1982), pp. 45–52.
2 Carlos Espejel, *Mexican Folk Ceramics* (Barcelona, 1975), p. 149.
3 Angelo Turchini, *Exvoto. Per una lettura dell'exvoto dipinto* (Milan, 1992), p. 14.
4 Joan Amades, *Costumari català* (Barcelona, 1952).
5 Gloria Fraser Giffords et al. *The Art of Private Devotion: Retablo Painting of Mexico* (Fort Worth, 1991), p. 54.
6 Gloria Fraser Giffords, *Mexican Folk Retablos: Masterpieces on Tin* (Tucson, 1979).
7 Important exceptions are: Patricia Arias and Jorge Durand, *La enferma eterna* (Guadalajara, 2002) and María J. Rodríguez-Shadow, 'Women prayers: the aesthetics and meaning of female votive paintings in

Chalma', in Eli Bartra (ed.), *Crafting Gender: Women and Folk Art in Latin America and the Caribbean* (Durham, 2003), pp.169–96.

8 Anita Brenner, *Idols Behind Altars* (New York, 1929), pp. 164–5.
9 Ramón Violant y Simorra, *El arte popular español* (Barcelona, 1953), p. 114.
10 Gerardo Murillo ['Dr. Atl'], *Las artes populares en México* (Mexico City, 1922), p. 91.
11 Joaquim Renart, 'Breu historial dels ex-vots catalans' (1932), p. 8.
12 Fina Parés, *Los exvotos pintados en Cataluña* (Barcelona, 1989), p. 429.
13 Marta Traba, *Relaciones actuales entre arte popular y arte culto* (Mexico City, 1979), p. 61
14 Joan Amades, *Costumari català*, p. 162.

Chapter Three: Judas was not a Woman, but...

1 The figures are filled with what are called *cuetes* (more correctly *cohetes*). The word means rocket, but in this case the fireworks are generally what would be called squibs or crackers.
2 One of the best works in existence about the Judas-burning fiesta in Mexico during the *Porfiriato* (1876–1910) and its political significance is that by William H. Beezley, *Judas at the Jockey Club and Other Episodes of Porfirian Mexico* (Lincoln/London, 1987).
3 Premio Nacional de Artes y Tradiciones Populares 1990.
4 Concerning the Linares family's *alebrijes*, see Susan N. Masuoka, *En Calavera. The Papier-Maché Art of the Linares Family* (Los Angeles, 1994).
5 Francisco Javier Hernández, *El juguete popular en México* (Mexico City, 1950), p. 95.
6 Joan Amades, *Costumari català* (Barcelona, 1982), p. 832. Gonçal Castelló 'Sobre moros i cristians', *Avui* (19 August 1993), p. 15.
7 Juan Ramírez de Lucas, *Arte popular. El arte que hace el pueblo de todos los pueblos de la tierra* (Madrid, 1976), p. 129.
8 Joan Amades, *Costumari català* (Barcelona, 1982), p. 831.
9 Quoted in Antonio García Cubas, 'Los judas', *Catálogo de la exposición Los Judas* (Mexico City, 1979), p. 5.
10 Florence H. and Robert Pettit, *Mexican Folk Toys: Festival Decorations and Ritual Objects* (New York, 1978), p. 97.
11 Francisco Javier Hernández, *El juguete popular en México* (Mexico City,1950), p. 94.
12 Frances Calderón de la Barca, *Life in Mexico. The Letters of Fanny Calderón de la Barca with New Material from the Author's Private Journals* (New York, 1970), p. 202.
13 See the photographs in Víctor Manuel Villegas, *Arte popular de Guanajuato* (Mexico City, 1964).
14 Beezley, *Judas at the Jockey Club* , p. 100.

15 Efraín Subero, *Origen y expansión de la quema de judas. Aporte a la investigación del folklore literario de Venezuela* (Caracas, 1974), p. 132.

16 Martín Letechipía, 'Piel de Papel. Los judas: fiesta, crítica social y artesanía ritual en Zacatecas', unpublished paper, *c.*2007, p. 14.

17 Interview with Elsa Linares, Mexico City, February 2004.

18 On the differences between male and female fiestas, see Dolores Juliano, *El juego de las astucias* (Madrid, 1992).

19 Mexican women won the right to vote in 1953.

20 See Enrique R. Lamadrid and Michael A. Thomas, 'The masks of Judas: folk and elite Holy Week tricksters in Michoacan, Mexico', *Studies in Latin American Popular Culture*, 9/191 (1990), 195.

21 From an interview I had with Doña Lupe, Mexico City, 1990.

22 See José D. J. Núñez y Domínguez, 'Los judas en México', *Mexican Folkways*, 5/2 (April 1929), 97.

23 Núñez y Domínguez, 'Los judas en México', 97.

24 Mentioned by Enrique R. Lamadrid, 'The masks of Judas', (1990), 195.

25 Daniel Rubín de la Borbolla, 'Arte popular mexicano', *Artes de México*, 43–4 (1963), 19.

26 All Gabriela Rosas quotations are from interviews that I carried out with her in Tacoaleche and Zacatecas, August 2009.

27 Martín Letechipía, 'Piel de Papel. Los judas: fiesta, crítica social y artesanía ritual en Zacatecas', unpublished paper, *c.*2007, p.23.

Chapter Four: Fantastic Art: *Alebrijes* and *Ocumichos*

1 See the video by Judith Bronowski, 'Pedro Linares: Papier Maché Artist', which contains a long interview with the artist. See also the book by Susan N. Masuoka, *En Calavera. The Papier-Maché Art of the Linares Family* (Los Angeles: 1994).

2 www.alebrijes.com.mx

3 See Masuoka, *En Calavera*, p. 31.

4 I visited the studio and interviewed Miguel and Elsa Linares in February 2004. I also interviewed Elsa Linares in July 2009.

5 Francesca Gargallo, 'Alebrijes y feminidad: el arte de Susana Buyo' in *Uno más Uno, Página Uno*, (29 July 1990), 1.

6 Gargallo, 'Alebrijes y feminidad'.

7 Interview with Miguel and Elsa Linares, February 2004.

8 Electronic communication of 1 March 2004.

9 Electronic communication of 1 March 2004.

10 This etymology is given in Alberto Medina et al., *Fiestas de Michoacán* (Morelia, 1986), p. 59. On the other hand, Louisa Reynoso, *Ocumicho* (Mexico City, 1983), p. 15, quotes the Spanish legal officials (*corregidores*) as saying that Ocumicho meant land of many *tuzas* (a *tuza* is a kind

of rodent that damages crops by burrowing under them like a mole). I assume this writer shares that opinion since she does not contradict it. Cecile Gouy-Gilbert, *Ocumicho y Patamban. Dos maneras de ser artesano* (Mexico City, 1987), p. 17, also subscribes to this etymology.

11 Nonetheless, according to the figures presented by Gouy-Gilbert, *Ocumicho y Patamban*, p.21, for 1984 the main economic activity was agriculture and the exploitation of timber resources (together approximately 50%), a quarter was accounted for by pottery and the other quarter commerce.

12 'Diablos, dragones y calaveras', *Mexico indígena* 1/3 (1985), 26.

13 Misael Torres, 'Diablos y carnavales en América'. *Artesanías de América*, 53 (2002), 23.

14 A building complex which consists of a Franciscan chapel, a barn turned into a hospital (which is really no more than a sickbay), a second barn with two storeys, and the living quarters of the two nuns who are normally there attending to curative tasks and the catechism.

15 María Antonia Pelauzy, *Artesanía popular española*. (Barcelona, 1977), p. 176.

16 Francesc Vicens et al., *Artesanía (Arte popular*. (Barcelona, 1968).

17 See Nestor García Canclini (1984), p. 123. See also the captions to the photos reproduced on pp. 144–5. The title of the book by Cecile Gouy-Gilbert *Ocumicho y Patamban* (1987), with its '*Dos maneras de ser artesano*' (and not *artesana*), commits the same error. The fact of being a woman does not necessarily free one's mind of androcentric habits.

18 Eduardo Galeano, *Memoria del fuego. III. El siglo del viento* (Mexico City, 1987), pp. 275–6.

19 Some months later in 1993, an exhibition was mounted with the same title, but with many more pieces, in Mexico City's Modern Art Museum.

Chapter Five: Frida Kahlo on a Visit to Ocotlán: 'The Painting's One Thing, the Clay's Another'

1 Rodolfo Morales, 1925–2001.

2 Conversation with Lois Wasserspring in September 1996.

3 All the quotes, as well as the ideas of Josefina Aguilar that I have paraphrased, come from interviews I carried out with her in November 1995 and April 1996.

4 From a conversation with Concepción Aguilar in November 1995.

5 Interview with Rodolfo Morales (1925–2001) in Oaxaca, 26 April 1996.

Chapter Six: The Paintings on the Serapes of Teotitlán

1　According to figures given by Lynn Stephen, *Zapotec Women: Gender, Class and Ethnicity in a Globalized Oaxaca* (Durham: 2005), pp. 112, 130, 132.

2　Lynn Stephen, *Zapotec Women*, p.44.

3　Interview with Isaac Vásquez, Teotitlán del Valle, Oaxaca, 26 April 1996.

4　To compare this experience of a spinning and weaving cooperative with a similar cooperative on the island of Arran (Scotland), see Lynn Ross, 'Co-operative Craft on Arran', in Gillian Elinor et al. (eds), *Women and Craft* (London, 1987), pp. 167–74.

5　Interviews with Josefina Jiménez in the city of Oaxaca, 27 April 1996 and in Mexico City, 4 December 2006. All the literal quotations and the ideas expressed by her were taken from these interviews.

6　Jeffrey H. Cohen, 'Textile production in rural Oaxaca, Mexico', in Kimberley M. Grimes and B. Lynne Milgram (eds), *Artisans and Cooperatives: Developing Alterative Trade for the Global Economy* (Tucson, 2000), p. 139.

7　Jeffrey H. Cohen, 'Textile production in rural Oaxaca, Mexico', p. 139.

8　It is interesting to note that almost all of the Navajo weavers are women.

9　See Ann Lane Hedlund, *Reflections of the Weaver's World: The Gloria F. Ross Collection of Contemporary Navajo Weaving* (Denver, 1992), which contains many photographs.

10　June Nash, 'Postscript to Market, to Market' in Kimberley M. Grimes and B. Lynne Milgram (eds.), *Artisans and Cooperatives*, p. 179.

Chapter Seven: From Humble Rag Dolls to *Zapatistas*

1　The principal languages in terms of numbers of speakers are: Tzeltal (279,015 speakers), Tzotzil, Chol, Tojolabal, Zoque, Kanjobal, Mame and Chuj. There are also several other languages spoken by less than a thousand inhabitants each. *Estados Unidos Mexicanos. Conteo de Población y Vivienda 1995. Resultados Definitivos Tabulados Básicos* (INEGI, 1997). According to the XII Censo General de Población y Vivienda 2000 (INEGI) the indigenous population of Chiapas was 28.36 per cent of the total.

2　Data taken from the same *Conteo de Población y Vivienda 1995*.

3　Clay *Zapatistas* are also made in Ocumicho.

4　Conversation with Joaquim Ibarz, 12 July 1998.

5　I spoke to some of the women selling *Zapatista* dolls in various places in Mexico City and they supplied me with much of this information.

6　http://www.imocorp.com.mx/CAMPO/zSIEM/ELEC_X_ANIO/ELEC_X_ANIO.asp?ANIO=2009#INFO According to George A. Collier,

Basta! Land and the Zapatista Rebellion in Chiapas (Oregon, 1994), p. 17, 89.9% voted for the PRI in 1988.

Chapter Eight: Embroiderers of Miracles

1 See INEGI, *II Conteo de Población y Vivienda*, 2005.
2 Victoria Novelo (ed.), *Artesanos, artesanías y arte popular de México* (Mexico City, 1996), p. 231.
3 Personal communication, August 2002.
4 The reconstituted *ejidos* (common lands) were a creation of the Mexican revolution intended to put land back into the hands of those who worked it. According to the *Diccionario del español usual en México* (El Colegio de México, 1996), an *ejido* is 'an institutionalized form of possession of land which consists of the government giving the property of a piece of land to a group of persons in order for them to farm it and obtain the benefits of its exploitation. In accordance with the latest modification to the constitution, the use of such lands and their change of ownership must be supervised and approved by the state'. But in this case, apparently, the *ejido* is not even legalized: there are no papers.
5 Interviewed in April 2002.
6 In the municipality of Allende in 2001 out of a total of 25,428 dwellings, 3,923 (15.4 per cent) had walls of adobe. A total of 1,480 houses had, in addition to adobe walls, earth floors. Houses with drainage represented 57.6 per cent of the total, which is low, especially if one compares it with the municipality of León, in the same state, where 91.8 per cent have drainage. Apparently there are parts of Guanajuato, such as the municipality of Atarjea (1,127 inhabitants), where the situation is much worse still, since only 9.3 per cent have drainage (INEGI 2001). In 2005 in Allende out of a total of 27,717 dwellings, 96.3 per cent had electricity, 85.9 per cent had water and 68.8 per cent had drainage. In León, by contrast, of a total of 262,323 dwellings, 96.3 per cent had drainage and in Atarajea, of a total of 1,106 dwellings, 30.1 per cent had drainage (INEGI, *Conteo de Población* 2005).
7 In 2005, 36.7 per cent of the population was aged under fifteen, while 56.8 per cent was between fifteen and sixty-four. Only 0.3 per cent of the population older than five years speak an indigenous language in spite of the fact that 37.88 per cent of the population is Otomí. Source: INEGI, 2005.
8 In the municipality of Allende, 17 per cent (13,798 persons) of the total population over fifteen (79,241 persons) is illiterate. 21 per cent of the overall female population of this age group (42,724 women) and 13 per cent of the overall male population of the same age group (36,517 men) is illiterate. Source: INEGI, 2001. The information for Allende on

education or the Economically Active Population (EAP) in the *Conteo de Población* 2005 (it should be folio 03) is missing: see: http://www. inegi.org.mx/est/contenidos/espanol/sistemas/conteo2005/default. asp?s=est&c=10398

9 Of a total of 134,880 inhabitants of the municipality of Allende, 64,507 (47.8 per cent) were men, and 70,373 (52.2 per cent) were women. Of a total of 79,241 inhabitants aged fifteen and over, there were 36,517 men and 42,724 women. Source: INEGI, 2001.

10 In 2000, the Economically Active Population (EAP) of the municipality represented 29.4 per cent of the total population. The primary sector in the same year only generated 12.8 per cent of employment, while the tertiary sector gave work to 47.6 per cent (INEGI, 2001).

Epilogue

1 According to the *Encuesta Nacional de Ocupación y Empleo* 2006, 1.9 per cent of the working population were artisans and 66.1 per cent of that group were women. Gender divison of labour can be seen in the fact that 74 per cent of artisans working with metal were men, while 97.6 per cent of those engaged in embroidery and ravelling were women. INMUJERES based on INEGI-STPS, 2006. http://www.e-mujeres.gob. mx/wb2/eMex/eMex_Cultura_y_Arte

2 Alfonso Caso, 'La protección de las arte visuales', *México Indígena*, 2/3 (July 1942), 27.

3 See Michael Owen Jones, 'The concept of "aesthetic" in the traditional arts', *Western Folklore*, 30/2 (April 1971).

Bibliography

Álvarez Santaló, C., María Jesús Buxó and S. Rodríguez Becerra (eds) (1989). *La religiosidad popular. III. Hermandades, romerías y santuarios.* Barcelona: Anthropos/Fundación Machado.

Amades, Joan (1982). *Costumari català.* Barcelona: Salvat/Edicions 62 (1st edn 1950), 2nd edn in facsimile, 5 vols.

―― (1952). *Els ex-vots.* Barcelona: Orbis.

Antología de textos sobre arte popular (1982). Mexico City: Fondo Nacional para el Fomento de las Artesanías/Fondo Nacional para Actividades Sociales.

Araeen, Rasheed (1987). 'From primitivism to ethnic arts', *Third Text* 1: 6–25.

Aratjara. Art of the First Australians (1993). Düsseldorf/Cologne: Kunstsammlung Nordrhein-Westfalen (catalogue)

Arias, Patricia and Jorge Durand (2002). *La enferma eterna. Mujer y exvoto en México, siglos XIX y XX.* Mexico City: Universidad de Guadalajara/El Colegio de San Luis.

―― (1990). 'La visión de los salvados. Los retablos de la Revolución y la Guerra Cristera', *Historias* 24: 155–60.

Arrebato del encuentro (1993). Mexico City: Museo de Arte Moderno. (Catalogue)

Arte popular mexicano. Cinco siglos (1996). Mexico City: Antiguo Colegio de San Ildefonso.

Arte popular mexicano (1974). Mexico City: Fondo de Cultura Económica.

Artes de México, 42 (1998). *Museo Ruth D. Lechuga*, Mexico City.

Artes de México, 53 (2000). *Exvotos*, Mexico City.

Baddeley, Oriana, and Valerie Fraser (1989). *Drawing the Line.* London: Verso.

Bank, Mirra (1979). *Anonymous Was a Woman.* New York: St Martin's Press.

Barbash, Shepard and Vicki Ragan (1993). *Oaxacan Woodcarving: The Magic in the Trees.* San Francisco: Chronicle Books.

Bartra, Eli (2005). *Mujeres en el arte popular. De promesas, traiciones, monstruos y celebridades.* Mexico: UAM.

―― (2003). *Frida Kahlo. Mujer, ideología, arte.* Barcelona: Icaria (3rd edn).

Bartra, Eli (ed.) (2004). *Creatividad invisible. Mujeres y arte popular en América Latina y el Caribe.* Mexico City: UNAM, Programa Universitario de Estudios de Género.

―― (2003). *Crafting Gender: Women and Folk Art in Latin America and the Caribbean.* Durham (NC): Duke University Press.

Battersby, Christine (1994). *Gender and Genius*. Bloomington/Indianapolis: Indiana University Press (2nd edn).

Beezley, William H. (1987). *Judas at the Jockey Club and Other Episodes of Porfirian Mexico*. Lincoln and London: University of Nebraska Press.

Berlo, Janet Catherine (1991). 'Beyond bricolage: women and aesthetic strategies in Latin American textiles', in M. B. Schevill, J. C. Berlo and E. B. Dwyer (eds) *Textile Traditions of Mesoamerica and the Andes: An Anthology*. New York/London: Garland.

Blocker, Gene H. (1994). *The Aesthetics of Primitive Art*. London: University Press of America.

Bonfil, Guillermo, José Joaquín Blanco et al. (1982). *Culturas populares y política cultural*. Mexico City: Museo de Culturas Populares/SEP.

Bonner, Frances et al. (eds) (1992). *Imagining Women: Cultural Representations and Gender*. Cambridge: Polity Press/The Open University.

Boullet, François and Colette (1986). *Ex-votos marins*. Paris: Éditions Maritimes et d'Outre Mer (2nd edn).

Bravo Ramírez, Francisco J. (1976). *El artesano en México*. Mexico City: Porrúa.

Brenner, Anita (1967). *Idols Behind Altars*. New York: Biblo and Tannen (original work published by Payson and Clark, New York 1929.)

Bryson, Norman et al. (1994). *Visual Culture*. Hanover: University Press of New England.

Calderón de la Barca, Frances (1970). *Life in Mexico. The Letters of Fanny Calderón de la Barca with New Material from the Author's Private Journals*, eds Howard T. Fisher and Marion Hall Fisher. New York: Anchor Books.

Caso, Alfonso (1942). 'La protección de las artes visuales', *México Indígena* 2/3: 25–9.

Carrillo y Gariel, Abelardo (1950). 'Imaginería popular novohispana', *Enciclopedia mexicana de art*. Mexico City: Ediciones Mexicanas.

Castelló, Gonçal (1993). 'Sobre moros i cristians', *Avui* (Barcelona, 19 August 1993).

Castrillón V., Alfonso (1978). '¿Arte popular o artesanía?', *Historia y cultura*. Lima: Museo Nacional de Historia, 10.

Chadwick, Whitney (1990). *Women, Art and Society*. London: Thames and Hudson.

Charlot, Jean (1949). 'Mexican Ex-votos', *Magazine of Art* 42/4: 138–42.

Chibnik, Michael (2003). *Crafting Tradition: The Making and Marketing of Oaxacan Wood Carvings*. Austin: University of Texas Press.

Claerhont, G. H. Adriaan (1965). 'The concept of primitive applied to art', *Current Anthropology* 6: 432–8.

Clifford, James (1988). *The Predicament of Culture: Twentieth-Century Ethnography, Literature and Art*. Cambridge: Harvard University Press.

Collier, George A. (1994). *Basta! Land and the Zapatista Rebellion in Chiapas*. Oregon: Institute for Food and Development Policy.

Contreras, Guillermo (n.d.). *Los judas*. Mexico City: Comex.

Cordry, Donald (1980). *Mexican Masks.* Texas: University of Texas Press.

Cordwell, Justine M. (ed.) (1979). *The Visual Arts: Plastic and Graphic.* Bristol: Mouton Publishers.

Covantes, Hugo (1984). *La pintura mexicana de la ingenuidad.* Mexico City: Galería Maren.

Covarrubias, Eugenio (n.d.). *Artesanías folklóricas de México.* Mexico City: Eugenio Fischgrund.

Creux, René (1979). *Les ex-votos racontent.* Paudex: Fontainemore. Paris: Flammarion.

Danly, Susan (ed.) (2002). *Casa Mañana: The Morrow Collection of Mexican Folk Arts.* Albuquerque: The Mead Art Museum/University of New Mexico Press.

Diablos, dragones y calaveras. Mexico Indígena (1985). NS 1/3.

Díaz-Castillo, Roberto (1981). 'El arte popular: un problema conceptual', *Plural* 11–1, 121: 35–9.

Diego, Estrella de (1992). *El andrógino sexuado.* Madrid: Visor.

Durand, Jorge and Douglas S. Massey (1995). *Miracles on the Border: Retablos of Mexican Migrants to the United States.* Tucson: University of Arizona Press.

——— (1990). *Doy gracias. Iconografía de la emigración México-Estados Unidos,* Guadalajara: Programa de Estudios Jaliscienses, Secretaría de Educación y Cultura, Universidad de Guadalajara, in association with INAH.

Eber, Christine and Brenda Rosenbaum (1993). '"That We May Serve Beneath Your Hands and Feet": Women Weavers in Highland Chiapas, Mexico'. In June Nash (ed.), *Crafts in the World Market: The Impact of Global Exchange on Middle American Artisans.* Albany: State University Press of New York.

Eco, Umberto (1984). *The Name of the Rose.* New York: Warner.

Egan, Martha (1991). *Milagros: Votive offerings from the Americas.* Santa Fe: Museum of New Mexico Press.

Ehlers, Tracy Bachrach (2000). *Silent Looms: Women and Production in a Guatemalan Town.* Austin: University of Texas Press.

Elinor, Guillian et al. (eds) (1987). *Women and Craft.* London: Virago.

Espejel, Carlos (1975). *Mexican Folk Ceramics.* Barcelona: Blume.

Esser, Janet Brody (1984). *Máscaras ceremoniales de los tarascos de la sierra de Michoacán.* Mexico City: INAH.

Exvoto (1968). México: Consejo Alemán de Bellas Artes (catalogue)

Farrer, Claire R. (ed.) (1975). *Women and Folklore.* Austin: University of Texas/American Folklore Society.

Fernández Arenas, José (1984). *Teoría y metodología de la historia del arte.* Barcelona: Anthropos (2nd edn)

Franco, Jean (1989). *Plotting Women: Gender and Representation in Mexico.* New York: Columbia University Press.

Friedlander, Judith (1978). 'The Traditional Arts of Women in Mexico', *Heresies,* 3–9.

Galeano, Eduardo (1987). *Memoria del fuego. III. El siglo del viento*. Mexico City: Siglo XXI (5th edn)

Galí, Montserrat (1982). 'La historia del arte frente al arte popular'. In *La expresión artística popular*. Mexico City: Museo Nacional de Culturas Populares, 9–26.

Gans, Herbert J. (1974). *Popular Culture and High Culture*. New York: Basic Books.

García Canclini, Néstor (1984). *Las culturas populares en el capitalismo*. Mexico City: Nueva Imagen (2nd edn)

—— (1989). *Culturas híbridas*. Mexico City: CNCA/Grijalbo.

García Cubas, Antonio (1979). 'Los judas'. In *Catálogo de la exposición Los Judas*. (Centro de Cultura Popular, Coyoacán). Mexico City: SEP, Dirección de Culturas Populares.

Gargallo, Francesca (1990). 'Alebrijes y feminidad: el arte de Susana Buyo'. *Uno más Uno, Página Uno* (Mexico City: 29 July 1990).

Gianturco, Paola and Toby Tuttle (2000). *In Her Hands: Craftswomen Changing the World*. New York: Monacelli Press.

Gibbs, Jerome F. (1954). 'The retablo ex-voto in Mexican churches', *El Palacio* 61/12.

Giffords, Gloria Fraser (1979). *Mexican Folk Retablos: Masterpieces on Tin*. Tucson: University of Arizona Press.

—— et al. (1991). *The Art of Private Devotion: Retablo Painting of Mexico*. Fort Worth: InterCultura. Dallas: The Meadows Museum Southern Methodist University.

Gombrich, Ernst (1979). 'The primitive and its value in art'. In *The Listener*, 101/2598–601, London: BBC.

Gouy-Gilbert, Cecile (1987). *Ocumicho y Patamban. Dos maneras de ser artesano*. Mexico City: Centre d'Études Mexicaines et Centraméricaines (Cuadernos de Estudios Michoacanos).

Graburn, Nelson H. H. (1986). *The Evolution of Tourist Art*. Aix-en-Provence: Centre des Hautes Études Touristiques (C/63, January 1986).

—— (ed.) (1976). *Ethnic and Tourist Arts Cultural Expressions from the Fourth World*. California: University of California Press, pp. 1–32.

Grimes , Kimberley M. and B. Lynne Milgram (eds) (2000). *Artisans and Cooperatives: Developing Alternative Trade for the Global Economy*. Tucson: University of Arizona Press.

Harvey, Marian (1987). *Mexican Crafts and Craftspeople*. Philadelphia: The Art Alliance Press.

Hedlund, Ann Lane (1992). *Reflections of the Weaver's World: The Gloria F. Ross Collection of Contemporary Navajo Weaving*. Denver: Denver Art Museum.

Hendry, Jean Clare (1992). *Atzompa: A Pottery Producing Village of Southern Mexico in the Mid-1950s*. Nashville: Vanderbilt University.

Hernández, Francisco Javier (1950). *El juguete popular en México*. Mexico City: Editorial Mexicana.

Heydn, Doris (1955). 'Firecrackers for Judas'. *Craft Horizons* (August–September 1955).

Hiller, Susan (ed.) (1991). *The Myth of Primitivism: Perspectives on Art.* London: Routledge.

Hollis, Susan Tower et al. (eds) (1993). *Feminist Theory and The Study of Folklore.* Urbana/Chicago: University of Illinois Press.

Hoyos Sancho, Nieves de (1950). 'Folklore de Hispanoamérica. La quema de Judas', *Revista de Indias* 10/41 (July–September 1950): 561–87.

Índice bibliográfico sobre artesanías (1988). Mexico City: SEP, Dirección General de Culturas Populares.

INEGI (1996). *Conteo de población y vivienda 1995. Resultados definitivos tabulados básicos.* Aguascalientes (Mexico): Instituto Nacional de Estadística, Geografía e Informática.

INEGI (2001). *XII Censo general de población y vivienda, 2000.* Aguascalientes (Mexico): Instituto Nacional de Estadística, Geografía e Informática.

Inzúa Canales, Víctor (1982). *Artesanías en papel y cartón.* Mexico City: FONART–FONAPAS.

Jauregui Nieto, Rosario (2002). 'Con el hilo entreverado, las mujeres tejen toda una historia de identidad'. *La Jornada,* 19 June 2002.

Joaquín, José Antonio (1982). *La tierra y los artesanos de Huancito.* Morelia: SEP/Instituto Nacional Indigenista (Etnolingüística, 40).

Jones, Michael Owen (1971). 'The concept of "aesthetic" in the traditional arts'. *Western Folklore,* 30/2 (April 1971)

Juliano, Dolores (1992). *El juego de las astucias.* Madrid: Horas y Horas, Cuadernos Inacabados, 11.

Kassovic, Julius Stephen (1980). 'The familiar and the grotesque: the roots of monster-making in a Mexican indian village'. In Marjorie M. Halpin and Michael M. Ames (eds), *Manlike Monsters on Trial.* Vancouver/London: University of British Columbia Press, pp.187–92.

Kauffman, Linda, S. (1989). *Gender and Theory: Dialogues on Feminist Criticism.* Oxford: Basil Blackwell.

Lackey, Louana M. (1982). *The Pottery of Acatlan: A Changing Mexican Tradition.* Norman: University of Oklahoma Press.

Lamadrid, Enrique R. and Michael A. Thomas (1990).'The masks of Judas: folk and elite Holy Week tricksters in Michoacan Mexico'. *Studies in Latin American Popular Culture* 9, pp. 191–208.

Lechuga, Ruth. (1982).'Procesos de cambio en el arte popular mexicano'. *La expresión artística popular.* Mexico City: Museo Nacional de Culturas Populares, pp. 45–52.

Lechuga, Ruth and Chloë Sayer (1994). *Mask Arts of Mexico.* San Francisco: Chronicle Books.

Lenz, Kriss-Rettenbeck (1973). *Exvoto.* Zurich: Atlantis.

Letechipía, Martín (*c.*2007). 'Piel de papel. Los judas: fiesta, crítica social y artesanía ritual en Zacatecas'. (unpublished paper)

Lepovitz, Helena Waddy (1991). *Images of Faith: Expressionism, Catholic Folk Art, and the Industrial Revolution.* Athens: The University of Georgia Press.

Lippard, Lucy R. (1995). *The Pink Glass Swan: Selected Essays on Feminist Art.* New York: The New Press.

Llompart, Gabriel (1972). 'Las tablillas votivas del Puig de Pollesa (Mallorca)'. *Revista de dialectología y tradiciones populares* 28/1–2: 39–54.

Los judas, exposición (1979). Mexico City: SEP, Dirección General de Culturas Populares (catalogue)

'Los retablos del señor del Hospital' (1926). *Forma* (Mexico City) 1/3: 17–20.

Luque Agraz, Elin and Mary Michele Beltrán (2003). *El arte de dar gracias. Selección de exvotos pictóricos del Museo de la Basílica de Guadalupe; The Art of Giving Thanks: A Selection of Pictorial Exvotos in the Collection of the Museum of the Basílica of Guadalupe.* Mexico City: Universidad iberoamericana/ Casa Lamm.

Martínez Peñaloza, Porfirio (1972). *Arte popular en México.* Mexico City: Jus (2nd edn).

—— (1973). *Arte popular y artesanías artísticas en México.* Mexico City: Jus.

—— (1980). *Tres notas sobre el arte popular de México.* Mexico City: Miguel Ángel Porrúa.

MacCannel, Juliet Flower (ed.) (1987). *The Other Perspective in Gender and Culture: Rewriting Women and the Symbolic.* New York: Columbia University Press.

Masuoka, Susan N. (1994). *En Calavera. The Papier-Maché Art of the Linares Family.* Los Angeles: UCLA/Fowler Museum of Cultural History.

Medina, Alberto et al. (1986). *Fiestas de Michoacán.* Morelia: SEP–Michoacán (Colección Cultural 7).

Messenger, Lewis C. Jr. (1989). 'Cultural continuity and transformation: bark paper and masks of Mexico as art, artifact and commodity'. *Studies in Latin American Popular Culture* 8.

Milagros de la frontera. Los mojados de la Virgen de San Juan dan gracias por su favor (1991). Mexico City: Secretaría de Relaciones Exteriores (2nd edn).

Millán, Márgara (1998). 'Las zapatistas de fin de milenio. Hacia políticas de autorrepresentación de las mujeres indígenas'. *Chiapas* 3 (Mexico City: UNAM, Instituto de Investigaciones Económicas), 19–32.

Miranda, Francisco (1983). 'Ocumicho, una comunidad en fiesta'. *Relaciones* 4/16: 33–46.

Monsiváis, Carlos (1996). 'Las artes populares. Hacia una historia del canon'. In *Arte popular mexicano. Cinco siglos.* Mexico City: Antiguo Colegio de San Ildefonso.

Montenegro, Roberto (1950). *Retablos de México. Mexican Votive Paintings.* Mexico City: Ediciones Mexicanas.

Mota, Ático Vilas-Boas da (1981). *Queimação de judas – Catarismo, Inquisição e Judeus no Folclore Brasileiro.* Rio de Janeiro: MEC–SEAC–FUNARTE.

Mulryan, Lenore Hoag (1982). *Mexican Figural Ceramists and Their Work*. Los Angeles: Museum of Cultural History/UCLA (Monograph Series 16).

Mummert, Gail and Luis Alfonso Ramírez Carrillo (eds) (1998). *Rehaciendo las diferencias. Identidades de género en Michoacán y Yucatán*. Zamora (Michoacán): El Colegio de Michoacán. Mérida (Yucatán): Universidad Autónoma de Yucatán.

Murillo, Gerardo [Dr. Atl] (1922). *Las artes populares en México*. 2 vols. Mexico City: Secretaría de Industria y Comercio–Editorial Cultura.

Novelo, Victoria (ed.) (1996). *Artesanos, artesanías y arte popular de México*. Mexico City: CONACULTA/Agualarga/Dirección General de Culturas Populares/Universidad de Colima/Instituto Nacional Indigenista.

—— (1982). 'La expropiación de la cultura popular'. In Guillermo Bonfil (ed.) *Culturas populares y política cultural*. Mexico City: Museo Nacional de Culturas Populares/SEP.

Núñez y Domínguez, José D. J. (1929). 'Los judas en México'. *Mexican Folkways* 5/2: 90–104.

Oettinger, Marion (1990). *Folk Treasures of Mexico*. New York: Harry N. Abrams.

Oppenheimer, Andrés (1996). *México: en la frontera del caos*. Mexico City: Javier Vergara.

Papousek, Dick (1997). 'El significado flotante de las artesanías en México'. In Germán Vázquez and Armando Correa (eds), *Visión americanista de la artesanía*. Quito: IADAP, pp. 53–67.

—— (1996). 'The production of meaning in Mexican popular culture'. In Ton Salman (ed.), *The Legacy of the Disinherited. Popular Culture in Latin America: Modernity, Globalization, Hybridity and Authenticity*. Amsterdam: CEDLA.

Paredes, Américo (1971). 'The United States, Mexico and Machismo'. *Journal of the Folklore Institute* 8/1: 17–37.

Parés, Fina (1989). 'Los exvotos pintados en Cataluña'. In C. Álvarez Santaló, María Jesús Buxó and S. Rodríguez Becerra (eds), *La religiosidad popular. III. Hermandades, romerías y santuarios*. Barcelona: Anthropos/Fundación Machado, pp. 423–48.

Parés, Fina (n.d.). *Els ex-vots pintats*. Barcelona: Els llibres de la frontera, Coneguem Catalunya 20.

Parker, Rozsika (1996). *The Subversive Stitch: Embroidery and the Making of the Feminine*. London: The Women's Press.

Pelauzy, María Antonia (1977). *Artesanía popular española*. Barcelona: Blume.

Pettit, Florence H. and Robert M. (1978). *Mexican Folk Toys: Festival Decorations and Ritual Objects*. New York: Hastings House.

Piercy, Marge (1969). *To Be of Use*. New York: Doubleday.

Porqueres, Bea (1994). *Reconstruir una tradición*. Madrid: horas y Horas (Cuadernos Inacabados 13).

Preziosi, Donald (1989). *Rethinking Art History: Meditations on a Coy Science*. New Haven: Yale University Press.

Quijano, Álvaro. 'Arte popular. Sueños sin bautizo'. *Memoria de papel* 4/11: 5–29.

Radner, Joan Newlon (ed.) 1993. *Feminist Messages: Coding in Women's Folk Culture.* Urbana/Chicago: University of Illinois Press, 1994.

Ramírez de Lucas, Juan (1976). *Arte popular. El arte que hace el pueblo de todos los pueblos de la tierra.* Madrid: Mas Actual.

Renart, Joaquim (1936). 'Breu historial dels ex-vots catalans'. *Esplai* 36/8.

Reynoso, Louisa (1983). *Ocumicho.* Mexico City: FONART/SEP.

Retablos y exvotos (2000). Mexico City: Museo Franz Mayer/Artes de México (Uso y estilo).

Rhodes, Colin (1994). *Primitivism and Modern Art.* London: Thames and Hudson.

Rivera, Diego (1979). *Arte y política.* México: Grijalbo.

Robinson, Hillary (ed.) (1987). *Visibly Female.* London: Camden Press.

Rodríguez-Shadow, María J. (2003). 'Women's prayers: The aesthetics and meaning of female votive paintings in Chalma'. In Eli Bartra (ed.), *Crafting Gender: Women and Folk Art in Latin America and the Caribbean.* Durham (NC): Duke University Press, pp. 169–96.

Rodríguez Rivera, Virginia (1967). *Mujeres folkloristas.* Mexico City: Instituto de Investigaciones Estéticas–UNAM.

Romandía de Cantú, Graciela (1978). *Exvotos y milagros mexicanos.* Mexico City: Cerillera La Central.

Ross, Lynn (1987). 'Co-operative Craft on Arran'. In Gillian Elinor et al., *Women and Craft.* London: Virago, pp. 167–74.

Ross, Patricia Fent (1955). *Made in Mexico: The Story of a Country's Arts and Crafts.* New York: Alfred A. Knopf.

Rubín de la Borbolla, Daniel (1963). 'Arte popular mexicano'. *Artes de México* 43–4, Mexico City.

Said, Edward W. (1979). *Orientalism.* New York: Vintage Books.

Saltzman, Rachelle H. (1987). 'Folklore, feminism, and folk. Whose lore is it?' *Journal of American Folklore* 100/398: 548–62.

Sánchez Lara, Rosa María (1990). *Los retablos populares. Exvotos pintados.* Mexico City: Instituto de Investigaciones Estéticas–UNAM.

Sau, Victoria (1986). *Aportaciones para una lógica del feminismo.* Barcelona: Lasal (Edicions de les dones).

Saunders, Lesley (1987). *Glancing Fires: An Investigation into Women's Creativity.* London: The Women's Press.

Sojo, Ana (1985). *Mujer y política.* San José: Departamento Ecuménico de Investigaciones.

Steel, Thomas J. (1974). *Santos and Saints.* Albuquerque: Calvin Hon Publishers.

Stephen, Lynn, (2005). *Zapotec Women: Gender, Class and Ethnicity in a Globalized Oaxaca.* Durham: Duke University Press.

Subero, Efraín (1974). *Origen y expansión de la quema de judas. Aporte a la investigación del folklore literario de Venezuela*. Caracas: Universidad Católica Andrés Bello.

Subias Galter, Juan (1948). *El arte popular en España*. Barcelona: Seix Barral.

Tice, Karin E. (1995). *Kuna Crafts, Gender, and The Global Economy*. Austin: University of Texas Press.

The Art of Private Devotion: Retablo Paintings of Mexico (1991). Fort Worth: Intercultura. Dallas: The Meadows Museum (catalogue)

Toneyama, Kojin (1974). *The Popular Arts of Mexico*. New York: Weatherhill. Tokyo: Heibonsha.

Toor, Frances (1939). *Mexican Popular Arts*. Mexico City: Frances Toor Studios.

Torres, Misael (2002). 'Diablos y carnavales en América'. *Artesanías de América* 53: 23–32.

Traba, Marta (1973). 'Relaciones actuales entre arte popular y arte culto'. In Various authors, *La dicotomía entre arte culto y arte popular. Coloquio Internacional de Zacatecas*. Mexico City: UNAM.

Turchini, Angelo (1992). *Ex-voto. Per una lettura dell'ex-voto dipinto*. Milan: Arolo.

Turok, Marta (1988). *Cómo acercarse a la artesanía*. Mexico City: Plaza y Valdés/ SEP.

Various authors (1987). *Comunicación y culturas populares en Latinoamérica. Seminario del Consejo Latinoamericano de Ciencias Sociales*. Mexico City: Gili.

Various authors (1979). *La dicotomía entre arte culto y arte popular. Coloquio Internacional de Zacatecas*. Mexico City: UNAM.

Vetterling-Braggin, Mary (ed.) (1982). *'Femininity', 'Masculinity' and 'Androgyny': A Modern Philosophical Discussion*. Totowa (NJ): Littlefield, Adams and Co.

Vicens, Francesc et al. (1968). *Artesanía (Arte popular)*. Barcelona: Polígrafa.

Villegas, Víctor Manuel (1964). *Arte popular de Guanajuato*. Mexico City: Banco Nacional de Fomento Cooperativo.

Violant y Simorra, Ramón (1953). *El arte popular español*. Barcelona: Aymá.

Wolf, Janet (1993). *Aesthetics and the Sociology of Art*. Basingstoke: Macmillan (2nd edn).

Zaldívar Guerra, María Luisa L. (1975). 'Modificaciones en el arte popular'. *Boletín del Departamento de Investigaciones de las Tradiciones Populares*, 2. Mexico City: SEP, Dirección General de Artes Populares.

Index

Abbey of Montserrat 29
aesthetic(s) 5, 154, 159n1, 160n7
 concept 156
 evaluation 156
 feminine 157
 function 18, 28, 41, 113, 157
 meaning 42
 nature 157
 of folk art 157
 point of view 6, 146
 principles 157
 purposes 21, 33
 value 156
Aguilar, Josefina 7, 98, 99, 102, 105,
 108, 110, 111, 112, 123, 152,
 153, 156, 163
 sisters, 14, 97, 100, 102, 107, 132,
 156
Agreda, Ángeles 138, 142, 144, 145,
 146
Alcatraces 98, 102, 103, 110
 see also calla lilies
Alebrijes 2, 14, 152
 and aesthetics 18
 and improvisation 73, 74
 and sex 73
 and signature 75
 as fantastic art 68
 concept, 69
 definition, 68
 division of work and 70
 function 69
 production 48, 62, 68, 72
 workshop 63
Amades, Joan 34, 45, 49, 160n4
Amates 14, 18

androcentric 1, 85, 163n17
anonymous 1, 14, 32, 37, 44, 149
 folk art 88
anonymity 32, 33, 44, 63, 151
 and folk art 149
Arrazola 68
art 1
 and feminism 1
 authentic 20
 contemporary 4
 cultivated 4, 6, 20, 76, 111, 112,
 113, 154
 definition 8
 elite(s) 1, 4, 6, 13, 14, 16, 17, 19,
 21, 22, 41, 42, 67, 69, 97, 108,
 112, 113, 117, 124, 127, 151, 156
 erotic 80
 erudite 4, 13, 14
 ethnic 5, 18
 fantastic 2, 67, 68, 77
 great 113
 greater 1, 4
 hybrid 97
 high 4, 6, 7, 14, 87, 97, 102, 111,
 113, 152, 155, 156
 history of 1, 32, 69, 83, 156
 indigenous 1
 mass 29
 naïve 15, 30, 41, 106
 original 6, 15
 primitive 16, 41, 127
 process 8
 religious 2, 30, 42
 savage 15
 surrealist 2, 67, 68, 77, 78, 79, 93,
 134, 159n4

theory of 1
 see also folk art
artisan(s) 13, 18, 22, 62, 63, 122
 women 65, 166n1
artisanal activity 22
artist(s) 8, 13, 14, 74, 79, 81, 89, 91,
 94, 99–102, 106, 107, 117, 144
 and commission 152
 and consumption 44
 design 124
 and fame 84, 85
 and gender 84
 and popular culture 13, 33
 and tradition 157
 as a minority 22
 competition 153
 elite 6, 7, 112, 119, 156
 experience 32
 figurative 30
 folk art 6, 14, 33, 44, 97, 102, 111–
 13, 134, 149, 155, 156
 identification 34
 inspiration 156
 Latin American 19
 liberty 92
 mind 72
 of Ocumicho 88, 94, 153
 retablo 32
 signature 86, 123
 single 11
 sisters Aguilar 156
 widow of 56
 women 84
 see also elite; folk art
artistic 6, 16, 20, 37, 45, 74, 76, 77,
 156
 communication 22
 creation 4, 7, 19–21
 creativity 127
 function 6
 photography 32
 production 11
 value 28, 51
 vanguards 19, 35
assistentialism 24, 160n10

authentic 18, 21, 84, 102
authentically Mexican 19
autheticity 154, 155

Barcelona 34, 39, 40, 49, 50, 88, 130
Bárcenas, Francisca (Doña Pancha)
 140, 141
Blanco, Teodora 14
Brenner, Anita 36
Bronowski, Judith 62, 159n6
Bustos, Hermenegildo 32
Buyo, Susana 72, 73

calla lilies 91, 98, 102, 103, 120
 see also alcatraces
Calderón de la Barca, Marchioness
 51, 52
Catalonia 27, 29, 39–42
Catholic 27, 30, 83, 137
 church 65
 tradition 50
Catholicism 30
Capitalism 32, 87
capitalist 87
 society(ies) 32, 156
 system 22
carpet(s) 2, 88, 120, 122, 124, 154
Carrington, Leonora 79
Caso, Alfonso 155, 156
ceramics 14, 18, 27, 102, 137
 see also clay
Chalma 35, 41, 43
Chamula(s) 129, 130, 131, 134
Charro 53, 57, 58
Chiapas 7, 127, 128, 132, 133, 146,
 164n1, 164–5n6
Chuj 131, 132
 language 164n1
clay 6, 63, 81, 84, 88, 97, 100, 102,
 104, 105, 109–11, 129, 155,
 164n3
 and women's work 100
 copy in 98, 113
 devil(s) 78, 86
 dish, 98

figures, 82, 88, 98, 104, 105, 110, 111, 132, 152
firing 98
Friditas 111
head 63
imitations 101
modelling 100
mug 11
pieces 99, 104
reproduction in 2, 97
sculptors 76, 84, 86, 88
see also ceramics
colonization, cultural 19
colonizer(s) 19, 20
colonized 19, 20
Comandanta Ramona 127, 132
competition 32, 87, 118, 122, 153
Cortés, Hernán 87, 91–3, 95, 154
Cotón 129, 131
craft(s) 2, 32, 47, 48, 61, 70, 74, 102, 104, 132
craftswomen 74, 101, 102, 123, 129, 130, 134, 137, 156
creativity 7, 11, 19, 72, 127, 149
artistic 127
Cuevas, José Luis 113
cultivated 76, 113, 137
art 4, 111, 112, 154
or high art 6, 20
see also elite art; high art

Diablitos 21
see also devil
dichotomies, hierarchical 12
desexualized 34
see also sexless
devil(s) 3, 4, 7, 52, 53, 57, 61, 62, 64, 75, 77, 78, 79, 80, 82, 83, 86, 88, 90, 91, 92, 94,95, 100, 154
devilish 90
see also diablitos
domestic 33, 102, 106, 119, 147
chores 24, 117, 140
labour 33
mishap 41

work 104
see also house employee
dominated 19, 20
domination 18

Ejido 138, 140, 165n4
commissioner 143
erotic 77, 79, 80
eroticism 79
ethnic identity 18
groups 18, 81, 83, 127
ethnicity 4, 24
elite(s) 15, 20, 21, 22, 23, 72, 113
artists 6, 7, 112, 119, 156
painters 124
Escher, M. C. 117, 124, 154, 155
see also artists
Espejel, Carlos 28
evil 2, 3, 57, 60, 69
ex-voto 140, 145
definition 27, 28
embroidered 2, 7, 137, 138, 140, 146–9, 152
history 27, 29, 30, 37
modern 29, 30
painted 2, 7, 18, 27–30, 32–5, 39, 40, 44, 83, 106, 137, 147, 152
traditional 140
see also retablos; votive paintings
EZLN *see* Zapatista Army of National Liberation

FAI (Fundación de Apoyo Infantil) 139, 146
Fallas 49
fame 14, 80, 84, 108, 111
famous 14, 53, 77, 87, 88, 94, 100, 108, 124
elite artists 7
European painters 117
Frida Kahlo 111
folk artists 97
Josefina 111
Linares 47

fantastic 67, 68, 69, 73, 77, 79
folk art 67
 see also art
femaleness 25
feminism 24, 107
 feminist 1, 5, 24
 art 42, 73, 107, 118
 history 1
folk art(s) 1, 2, 4, 12, 14, 16, 17, 19,
 22, 27, 41, 47, 51, 67, 77, 81,
 103, 106, 107, 113, 127, 155
 aesthetics 28, 156, 157, 159n1
 and art 2
 artists 6, 14, 33, 44, 97, 102, 111–
 13, 134, 149,155, 156
 and gender 1, 14
 and high art 4, 6, 111, 113, 152,
 155, 156
 and innovation 138
 and national culture 18
 and neutrality 4
 and women 1, 7, 8, 72, 151, 152,
 155
 characteristics 5, 11, 12, 13, 15, 20,
 21, 35, 37, 67, 69, 112
 coincidences 121
 collections 51
 consumption 21, 22, 35, 44, 134,
 141
 distribution 59, 86
 ephemeral 56, 135
 function 18, 21, 28, 42, 69, 113
 history 1, 3
 meaning 21, 22, 42, 108, 109
 myth 20
 politics 127
 production 34, 35, 49, 72, 75, 143,
 152
 repetition 108, 125
 shops 86
 signature 149
 surrealist 68
 workshops 63
 see also art, popular art; handicrafts
folklore 11, 20, 49

Fridamania 111
Fridamaniacs 155
Friditas 2, 3, 14, 21, 95, 98, 100, 101,
 106, 108–12, 124, 152, 154, 155

Gadbois, Karen 138, 139
Galeano, Eduardo 85, 86
Gauguin, Paul 16
gender(s) 1, 4, 18, 25, 33, 34, 37, 42,
 45, 47, 50, 62, 64, 151, 156
 and history 18
 blind 8
 definition 7
 difference(s) 4, 33, 34, 42, 44, 47,
 65, 74
 division of labour 3, 7, 14, 166n1
 identity 7, 25
 inequality 24
 neutrality 45
 see also identity
Giffords, Gloria Fraser 34
Goethe, J. W. von 16
Gombrich, Ernst H. 16
Guadalupanismo 89
Guanajuato 7, 35, 50, 51, 63, 137,
 138, 140, 146, 161n13, 165n6

handicrafts 20, 22, 74, 127, 133
 and folk art 11, 12, 63, 106
 use 18
 signature 86
 shops 51, 75, 98, 100, 134
 see also folk art
Hernández, Antonia 141
hierarchy, church 65
 differences 33
history 69, 88, 152
house, employee 142, 143
Huichol, Indians 19, 22
hybridization 6
hyper-realism 2, 31

Ibarz, Joaquim 130
iconography 56

identity 1, 7, 19, 24, 25, 33, 65, 104,
 110, 155
 art 11
 ethnic 18
 gender 7, 25
 individual 33
 national 18
 of women 44
 see also gender
ideology 20, 22, 127, 134
imaginary 45, 52, 79
 collective 44, 45
imagination 11, 19, 67–9, 74, 77, 102,
 111, 113, 127, 149, 152, 154
 women's 77
Indian(s) 19, 22, 29, 41, 62, 83, 86,
 89–94, 117
indigenous 16, 18, 19, 41, 128, 130
 art 1
 characteristics 39
 community 87
 Cora 53
 culture 102
 extraction 132
 families 102
 people(s) 40, 41, 63, 133
 population of Chiapas 161n1
 rights 135
 sensibility 39
 soul 39
 tradicional cultures 6
 Virgin 89
 language 100, 165n7
 mistress 92
 women 129
individualism 32
Iturbe, Mercedes 87

jealousy 100, 145
Jiménez, Josefina 118
Judas *see* Judases
Judases 2, 3, 47, 48, 49, 52, 53, 58, 59
 and ephemeral folk art 56
 burning 47, 48, 49, 51, 53, 54, 55,
 59, 60, 61, 63, 69

forms 48, 49, 50, 58, 60
 history 18, 49, 50, 51, 60, 61
 female 50, 53, 59, 63
 modern 52
 production 14, 47, 48, 49, 50, 51,
 53, 61, 62, 63, 64, 70
 selling 51, 152
Judas Iscariot 2, 47

Kahlo, Frida 2,7, 38, 67, 79, 88, 97–
 102, 104, 106–13, 132, 155
Kandinsky, Wassily 117

Latin America 18, 19, 20, 48, 98
Latin Amercanism 20
Linares, Elsa 54, 69, 72, 74
 family 47, 48, 53, 68, 71, 72, 73, 75
 Miguel 54, 69, 71, 72
 Pedro 2, 47, 62, 69, 159n6, 162n1
 studio 74

Machista 141
Majorca 3, 50, 53, 82, 83
Malinche, La 53, 154
Matisse, Henri 117, 124
Marquitos 129, 131, 132, 134, 135
masks 21, 47, 55, 56, 62, 65, 78
 manufacture 55
masquerades 55
Mestizos 41, 100
 mestiza 6
Mexicanness 19
miracle(s) 27, 37, 40, 44, 45, 84, 137,
 138, 147, 149
Miró, Joan 117, 119, 122, 124, 152,
 154
modern 101
 context 15
 ex-votos 29, 30
 Judases 52
 nation 18
 painting 102
 Western culture 6
modernities 82

modernizing, and process of
 production 101
monsters 68, 73
Montenegro, Roberto 2
Morales, Rodolfo 97, 102, 156
Mujeres en Cambio 138
muralist(s) 22
 movement 20
Murillo, Gerardo (Dr Atl) 39, 161*n*10

naïve 2, 30, 37, 39, 41
 style 40
Navajo(s) 121, 122
 designs 121, 124, 154
 rugs 122
 weavers 121, 164*n*8
neocolonized 19
neutrality 4, 8, 45
non-androcentric 47
non-sexist 3
Novelo, Victoria 137

Oaxaca 7, 14, 98, 99, 106, 115, 117,
 121
 folk art 103
 city 97, 101, 106, 118, 120
 shops 98
 serapes 155
 state 68, 97, 111, 127
 Valle of 102
Ocotlán de Morelos 97, 111
Ocumicho 2, 3, 7, 21, 75–80, 82–8,
 91, 92, 94, 95, 100, 101, 152,
 153, 154, 156
 ocumichos 2, 14, 18, 67, 68, 77, 82,
 83, 86, 152, 154, 155
oppression 20, 33
original 89, 91, 92, 93, 108–10, 112,
 113, 119, 120, 124, 152, 154
 function 51
 use 22, 89
originality 32, 111–13
Orozco, José Clemente 88, 92
Otomí 142, 165*n*7

Parés, Fina 42
patriarchal society 1, 33
people, the 4, 8, 13, 20 21, 22, 23, 33,
 36, 37, 40, 48, 51, 57, 58, 60,
 64, 65, 81, 106, 121, 144, 149,
 156
Peponas 50, 51
Picasso, Pablo 6, 16, 112, 117, 119,
 122, 154, 155
picturesque 1
Piñatas 47, 49, 69
political 21, 36, 57, 60
 ambition 106
 criticism 49, 56
 culture 128
 frontiers 18
 interest 42
 socio-political 32
 philosophy 24
politics 65, 127, 128, 134
 and folk art 127
 public 56
Pollock, Griselda 24
popular art 22, 23, 106, 113
 artist 65
 see also folk art; artist
populism 20
populist 22, 23
postmodern 65
pottery 2, 18, 22, 163*n*11
primitive 13, 15, 16, 31, 49, 67, 83,
 102
 painting 11, 112
 style 40
primitivism 17, 30, 159*n*7, 159*n*8
Purépecha village 76, 95
 Indians 83
 sculptors 8

rag dolls 49, 127, 129, 130
Ramírez de Lucas, Juan 49
Ramonas 129, 131, 132, 135
rape 24, 42, 94
realism 30, 32, 42, 79
repetition 83, 99, 108, 113, 125

repetitive 11, 108, 113, 127
religious 18, 21, 32, 34, 35, 37, 39, 41,
 60, 61, 65, 69, 79
 function 6, 11, 22, 28, 41, 147, 157
 systems 6
Retablos 27, 28, 31, 34, 35, 37, 40, 137
 painted 38
 see also ex-voto
Rivera, Diego 20, 22, 44, 88, 98, 102,
 108, 117, 124
Rosas, Gabriela (Gabi) 62–5
Rubín de la Borbolla, Daniel 61

San Miguel de Allende 9, 53, 137,
 138, 142, 146
Serapes 3, 95, 152
 and designs 121
 and natural colours 106
 production 7, 115, 116, 117
 selling 115, 125
 weaving 14, 115, 155
 Women who Weave 118
sex(es) 4, 8, 41, 42, 54, 73, 92, 102,
 120, 125, 152
 act 53
 and human body 7
 -less 8, 73, 91
 male 132
 see also desexualized
sexed 74
sexual differentiation 25
 division of labour 117
 violence 94
sexism 65
signature(s) 32, 33, 63, 75, 77, 86,
 122, 123, 146
signed 32, 33, 98, 100, 104, 122, 123,
 149
 un- 86, 147
Siurells 3, 82, 83
socialist realism 32, 42
Subcomandante Marcos 127, 132
Surrealism 30, 67, 78, 79, 159n4
syncretism 6, 7, 88, 95, 106, 111, 117,
 124, 155

Tamayo, Rufino 117, 122
Tehuana 106
Teotitlán del Valle 2, 7, 88, 101, 115,
 117, 152
Toledo, Francisco 117, 122
tradition(s) 28, 49, 104, 157
 and renovation 155
 and repetitive work 108
 and folk art 35
 and red devil 53
 Catholic 50
 cultural 122
 family 97
 invented 2
 of burning Judases 47, 50, 61
 of Mexican curios 133
 of painted ex-votos 7, 39
 origin 30
 popular 63
 work for 13
traditional 14, 32, 54, 63, 101, 120,
 124, 155
 activities 7
 costume 78, 129, 131, 133
 clothing 53
 cultures 6
 designs 117
 devil 62
 ex-votos *see* ex-votos
 historiography of art 14
 Judas 47, 52
 pigments 124
 sexual division of labour 117
Tzotzil, speakers 128, 164n1

ultramodern painting, 37
unique 15, 21, 112, 120
 artistic creation 21
 works 6, 108, 112, 113
uniqueness 32, 112

Varo, Remedios 79
Vassarely, Viktor 117
Vásquez, Isaac 117, 118, 120, 121,122,
 123, 125

Ventura Olivares, Guadalupe 59
Violant y Simorra, Ramón, 37
violence 41, 42, 43, 44, 55, 94
Virgin of Guadalupe 35, 89, 90, 91,
 148
Virgin of Montserrat 39
votive paintings 2, 14, 27, 160n7
 see also ex-voto

Wasserspring, Lois 98
weaving 14, 115–20, 125, 142
 cooperative 164n4
woman 24, 345, 43, 47, 50, 53, 56, 63,
 73, 86–8, 91, 92, 94, 106, 112,
 138, 142, 143, 163n17
 selling lilies 102
 public 112
women 1, 3, 4, 7, 8, 12, 13, 18, 19,
 24, 33, 34, 42, 44, 45, 47, 53,
 54, 56, 59, 63, 69, 71, 74, 76,
 77, 78, 81, 82, 86, 87, 98, 100,
 101, 111, 112, 116, 120, 127,
 128, 131, 137, 140–3, 146, 147,
 151, 152
 and *alebrijes* 73
 and Catholic tradition 50
 and folk art 1, 7, 8, 72, 151, 152,
 155
 and embroideries 138, 139, 144,
 145
 and Judases 59, 70, 71
 and politics 56
 and power structures 56
 and rag dolls 132, 134
 and *siurells* 83
 and signature 86
 artisans 65, 166n1
 art of 77, 149
 artists 84, 117
 as a colonized group 19

cooperative 118, 119, 122, 123
Chamula 129, 134
difference between men and 64
dominated 20
market 100, 110
hands 86
identity 44
imagination 77, 152
Indian 93
indigenous 129, 130
in society 7
of Ocumicho 77, 80, 88, 156
painters 34, 68
rape 24, 94
representation of 54
rights 24
selling Judases 59
selling rag dolls 130, 133
social subordination 24
suffering violence 41, 43
traditional activities 7
Tzotzil 129
vote 162n19
weavers 14, 115–17, 120, 153,
 164n8
women's studies 5
work 25, 77, 100, 107, 117, 143
 see also folk art
workshop(s) 33, 63, 22, 123, 125, 141
 craft 104
 family 33, 34
 Zapotec 122

Zapatista(s) Army of National
 Liberation 127, 133, 134, 135
 dolls 2, 129, 130, 132, 134
Zapotec 122
 diamond 121
 Navajo 122
 speaking 115, 118